# LOUISIANA'S ART NOUVEAU

# LOUISIANA'S ART NOUVEAU

## The Crafts of the Newcomb Style

SUZANNE ORMOND
and
MARY E. IRVINE

*with a foreword by John Canaday*

Photographs by Larry Songy

Pelican Publishing Company

GRETNA

1976

Library of Congress Cataloging in Publication Data

Manufactured in the United States of America
Designed by Barney McKee
Published by Pelican Publishing Company, Inc.
630 Burmaster Street, Gretna, Louisiana 70053

*To those remarkable and talented people
who made the Crafts of the Newcomb Style possible,
especially Sadie Irvine*

# CONTENTS

# FOREWORD

In an odd kind of way I studied ceramics at Newcomb College under Sadie Irvine. I am proud of that, but let me make it clear immediately that any attempt to relate the work I produced during that summer to the work illustrated in this book would be foolhardy. I never learned to throw on the wheel, in spite of everything Sadie could do. My pots always collapsed when put out to dry, which was fortunate, for they were always ugly, having refused to take on the shapes I struggled to force them into.

I had two periods of residence in New Orleans of two years each, the first during the school years 1934–35 and 1935–36 as an assistant professor at Newcomb when I was fresh out of the Yale School of the Fine Arts and thought I knew a lot more than I did, and the second in 1950–51 and 1951–52 when I returned as director of the Newcomb Art School. During the fourteen-year interval I had learned that I wrote and lectured a lot better than I painted, and had abandoned any serious efforts to be a producing artist. I still believed, though, and I still do, that direct studio experience is of great value to an art critic or historian and is imperative if the director of an art school is to understand the correlation between the lecture room and the studio.

Thus it seemed reasonable to me that in a school famous for its pottery the director should have some literally firsthand acquaintance with the craft, and I enrolled as a beginner in Sadie's summer class, although I was nominally her boss. (Nominally is the word, for nobody ever really bossed Sadie.) Drastic changes in the design of Newcomb pottery had been effected during the fourteen years I had spent teaching elsewhere. The pictorial decorative style with its Art Nouveau affiliations had been replaced by an approach equally sound aesthetically but much less original. Traditional forms of Chinese and Japanese ancestry were left unornamented, and the powdery blue Newcomb glaze was rejected for new ones that, again, held to traditional rather than innovative standards of aesthetic appeal.

What had been lost sight of was that the old Newcomb pottery had been innovative. By 1930 it was at that awkward age when a decorative style has gone out of fashion but has not yet acquired the status of a historical style that can stand comparison with others. Sadie had already realized this, and welcomed the new program when she could have made things very difficult for then-director Robin Feild. She recognized that Mr. Feild's goals were legitimate—aesthetically and historically sound—and she worked within the new program as effectively as she had worked within the old.

I did not realize until I became a Newcomb student during that brief period of my second New Orleans incarnation that the new Newcomb pottery was not a simple rejection of the old but the result of a necessary period of looking around, of analyzing sources and foundations from which new styles, for all their appearance of spontaneous generation, develop. Elsewhere in this book it is pointed out that the revival of interest in early Newcomb pottery is part of the general revival of interest in other art-crafts of its vintage, such as Tiffany glass, now dear to collectors. That the interest is extending into the later period of Newcomb pottery manifests a most rewarding recognition of the kind of creative craftsmanship that Newcomb College has always represented.

I don't like the word "inspiration" but do not know exactly what word to use to characterize the relationship of Sadie Irvine's Art Nouveau generation to the subsequent generations of Newcomb craft-artists. I think that rather than an inspiration, they were rational proof that the true craftsman is a flexible and adaptable creator holding to the single rigid and inviolable rule that quality, whatever form it takes, comes first.

JOHN CANADAY
New York City

# PREFACE

For years we had tried to interest people in the value of preserving the Crafts of the Newcomb Style, but somehow our idea was premature. In May of 1970 we met and discovered that we had the same thoughts on the subject; however, we had been traveling different paths. We joined forces that day and our friendship developed from that meeting.

Sadie Irvine was frail and dying that spring of 1970 and was to pass away the following September. It was in May of that year also that we were given the inspiration by the Louisiana Crafts Council to form the foundation and proceed with a collection. In April of 1971 the Louisiana Crafts Council had a large memorial show of Sadie Irvine's work. This show provided an immediate response from the community. By March of 1972 all the crafts were assembled and housed in their own room at the Louisiana State Museum. For the first time a complete collection was on view, and that collection has grown ever since to a large number of fine examples.

Anyone who has ever sought information about the movement and the people who made it happen knows that little was available. True, many articles in newspapers and magazines had been written from time to time, but they were sketchy, containing little information and many inaccuracies. With the collection well displayed and housed in the museum, we felt that it was our duty to write a definitive book. Many questions had been asked of us, and we had lectured to groups, willingly answering their questions. But as time went on, we realized that all the research and knowledge we had garnered should be preserved.

We had our problems in writing the book, as records had not been kept and most of those deeply involved had died. We did interview countless people, many whose memories had dimmed with age. Their relatives were very helpful, and we uncovered many new facets unknown before our research. These we share for the first time. We were saddened that some of the persons

we interviewed passed on while the book was being written, as their contribution was most helpful to us.

Although this book represents an enormous amount of time, energy, and just plain hard work, it has brought us a great deal of satisfaction and happiness. We did not enter the writing with previous literary experience, but we have used whatever talents we possess to bring about a historically correct book.

# ACKNOWLEDGMENTS

A work such as this cannot be accomplished without the aid, assistance, and co-operation of many people, including our husbands, John William Ormond and Dr. Richard Wynn Irvine, and the two Ormond children, Suzanne Lisa and John Winkler, for their patience and good nature throughout the research and writing of this book. Especially Wynn Irvine, without whose recollections of the movement, lived through daily contact with his sister, Sadie Irvine, our task would have been more difficult. A very special affection and thank-you for all the extra services unselfishly rendered.

We gratefully acknowledge Walter B. Lowrey for his editorial direction and counsel and the expert knowledge that helped in more ways than we can describe.

We are particularly indebted to the board and membership of the Louisiana Crafts Council and especially the past presidents, Hannah Betty Blumenthal, Eleanor N. Corbin, and Betty Fosberg, for their foresight and continuing interest.

We wish to thank the Louisiana State Museum; its past director, Peggy Richards; Frieda Morford, administrator; Robert Rigg Macdonald, director; Aline H. Morris, chief librarian; and Rose Lambert, without whose assistance and research knowledge this writing could not have been accomplished; and the staff, Shirley Akers, Hazel Browinski, Tamra Carboni, Vaughn Glasgow, John Harter, Frances Heldner, John Kemp, Linda King, Terence McGough, Ora Ann McKenzie, and Ghislaine Pleasonton.

We wish to thank Dr. James F. Davidson, dean of Newcomb College, for his cooperation with the many demands on his time and attention; Dr. Jessie J. Poesch, chairman of the Newcomb College Art Department, for her suggestions; Dr. John H. Gribben, library director, Tulane University, and his staff for all the research ramifications, including: Margery B. Wylie, head of the Humanities–Fine Arts Division, and her assistant, Mary Ann Arthur; Doris H.

ACKNOWLEDGMENTS  Antin, University Archives; Helen R. Burkes, Special Collections; and Marjorie E. LeDoux, head of the Latin American Library.

And very special thank-yous for much information to Crozat J. Duplantier, director of University Relations, Tulane University, and his staff member Adelaide B. Hawn, news editor for University Relations; Beatrice M. Field, director of Alumni Activities, and Anne B. Smythe, assistant to the director of Alumni Activities; James E. Llamas, director of Alumni Publicity; James D. Schneider of Alumni Records and his secretary, Carrie Rickerts; the late Hazel D. Bollier, executive secretary of the Newcomb Alumnae Association, and her secretary Kathleen P. Seaver; Mildred A. Mouch, assistant to the dean of Newcomb College; Dorothy T. Bacher, secretary, Dean's Office, Newcomb College; Catherine W. Smither, Records Office, Newcomb Art School; and Marjorie G. Fischer, supervisor of Records, Office of Student Records and Registration.

We are grateful to Maia Weston Luikart, who traveled to New Orleans for the purpose of identifying and naming the colors of glazes in the newer pottery; Alberta "Rusty" Collier, art editor of the *Times-Picayune*, and Luba B. Glade, art editor of the New Orleans *States-Item*, for their encouragement and kindness; Leonce W. Many for her help in identifying lettering styles; Eleonor N. Corbin for helping us identify embroidery techniques; Marta Lamar for identifying and naming the flowers used in some of the motifs; and Bethany B. Ewald for research.

The Friends of the Cabildo, the Historic New Orleans Collection and its director, Stanton M. Frazar, we gratefully thank for their cooperation.

And finally a very special thanks and appreciation to our typists, Mildred L. Covert and Mrs. Peter W. Many, for their quick, accurate, and painstaking typing; without them this book would never have been completed.

# LOUISIANA'S ART NOUVEAU

# Markings on a Typical Newcomb Guild Pot

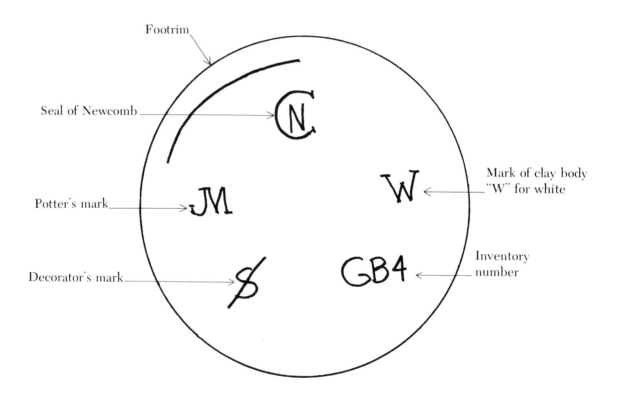

Footrim

Seal of Newcomb

Potter's mark

Decorator's mark

Mark of clay body
"W" for white

Inventory
number

# I

# BEGINNINGS IN THE
# COTTON CENTENNIAL

The Crafts of the Newcomb Style have their roots in the World's Industrial and Cotton Centennial of 1884–85. This centennial was important not only because it provided an economic shot in the arm to the industry of New Orleans, but also because it educated its citizens in the production of various crafts. Most influenced by the centennial were the women of New Orleans who afterward, strongly dosed with suffragette politics and doctrine, for the first time sought to fulfill their economic desires.

The decennial census of 1880 listed New Orleans as being the tenth largest city in the United States in population, and in geographical area the largest in the world (London was six square miles smaller). New Orleans could boast a 155-square-mile area and 270,000 people. The city needed an exposition for many reasons. Unlike other large cities, New Orleans had almost no manufacturing industry that could employ vast numbers of people; it had long relied instead on its port operations in the shipment of agricultural products. The Civil War and the Reconstruction that followed had seriously hampered this commerce. Politically the city had recovered from Reconstruction, but economically it had remained paralyzed. In 1882 the National Cotton Planters' Association conceived the idea of a centennial celebration to mark the anniversary of the first appearance of cotton in international commerce, when six bags of cotton (less than one bale) had been shipped to a European port from Charleston, South Carolina.

By an act of Congress dated February 10, 1883, the National Cotton Planters' Association was placed in partnership with the government of the United States to arrange an exposition. The partnership selected New Orleans as its site. Needless to say, the city was overjoyed at the prospect of international attention.

The city of New Orleans had acquired a large tract of 245 acres of unimproved land bordering on the Mississippi River. This land, four miles upriver

from Canal Street (the main business street of New Orleans), had been purchased for $800,000 in 1871, the city intending to use it for a new city park. The property had become famous as the Foucher–de Boré Plantation, where sugar was first granulated, and General Ben Butler had quartered his Union troops on the plantation in 1862. The acreage became the logical site for the exposition for two reasons: the ground was high, and it was free. New Orleans has always suffered from too much swampy land, and only the land near the river was usable in the nineteenth century. The city developed along the Mississippi River, and the river became a sort of water main street.

Grandiose plans were laid to make the exposition the most spectacular event in the world's history. The *Visitor's Guide to the World's Industrial and Cotton Centennial* stated that "the Exhibition Buildings are connected with the whole United States, by leading railroads entering New Orleans, and into an elegant depot at the grounds from Canal Street, the Broadway of New Orleans, by six street railroads, and by an elegant line of steamers leaving the foot of Canal Street, every 30 minutes." None of these things was to come about as planned. In the *Sunday States* of December 14, 1884, the following appeared: "Leaving town Saturday evening at 5:15 o'clock, the reporter reached the entrance grounds at 6:45, having thus taken an hour and a half to accomplish the journey, of which time he was off the rails for perhaps 25 or 30 minutes. Deposited at the entrance, he found a floating sea of mud intervening between that point and the gates of the building." A month before the exposition was to open, many of the major projects, including the wharf on the Mississippi River, had not even been started.

Transportation was but one of the problems facing the exposition. Many buildings were in the early construction stage, financial arrangements were being questioned, and scandal began to surface. The proposed grand scale of building, which would rival anything seen before in the world, was too ambitious. The Main Building, the largest exhibition structure built at the time, was placed in the center of the acreage and covered thirty-three acres. This wooden structure was 1,378 feet long and 905 feet wide and was covered by a continuous roof, composed primarily of glass. The interior was surrounded by wide galleries twenty-three feet high, which were reached by twenty elevators and stairways. In the center of the building was the Music Hall, with seating for eleven thousand persons and a platform capacity for six hundred musicians. This building housed general exhibits, foreign exhibits, and industrial and agricultural exhibits. The *Visitor's Guide* said, "When the visitor has traversed all the avenues on the grand floor and galleries, he will have walked 25 miles."

The second largest building was the Government and States Building. It was originally conceived as the largest building, but the foreign exhibits grew in such proportions that the Main Building had to be enlarged. The Government and States Building measured 885 feet long and 565 feet wide and was erected

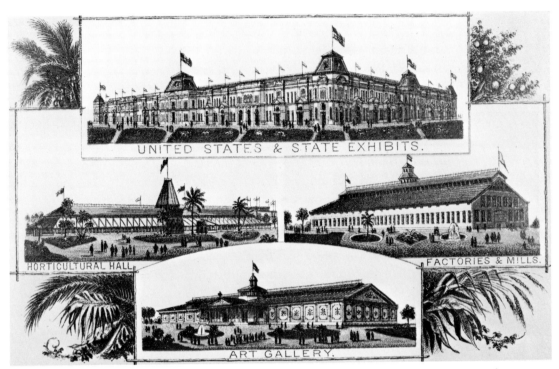

Buildings at the World's Industrial and Cotton Centennial, 1884–85 (now Audubon Park). Buildings were destroyed in 1886. (Louisiana State Museum Collection)

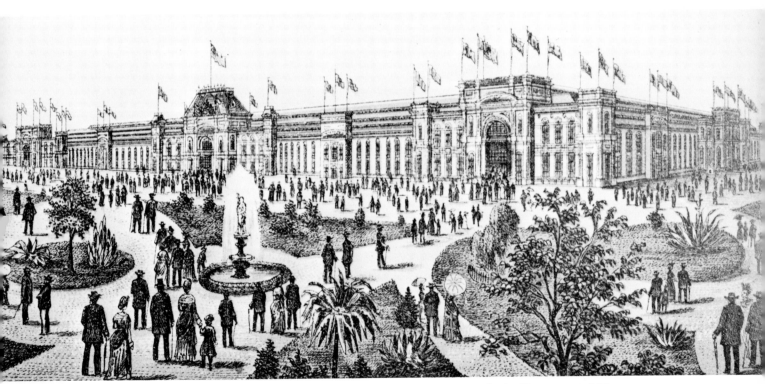

Main Building at the World's Industrial and Cotton Centennial, 1884–85. The building occupied 33 acres, measured 1,378 feet long by 905 feet wide, was made of wood, and had a glass roof. It was destroyed in 1886. (Louisiana State Museum Collection)

just north of the Main Building, with its entrance in line with the Main Building. The interior space was unbroken and was encircled by a gallery forty feet wide. The exterior of the structure was forty-three feet high and was broken only by imposing square towers. In this building were housed the exhibits from various United States government agencies, the states of the United States, and the Woman's Department. The Horticultural Hall was next in importance. It was the largest conservatory in the world at that time, measuring 194 feet long by 111 feet wide. It was mostly glass, in the London Crystal Palace tradition. Besides these major buildings, there were vast numbers of other structures, exhibit buildings, offices, restaurants, and several acres of buildings for livestock, dogs, and horses.

When the exposition was over (the North, South, and Central American Exposition of 1885–86 used the buildings), all but one building on the grounds had to be demolished; the Horticultural Hall survived until the great hurricane of September, 1915. The lumber and other materials were salvaged and sold for the construction of many present-day houses in uptown New Orleans. There is one small building outside the grounds that survives today. Now a residence, this structure lies between Calhoun Street and Exposition Boulevard on Hurst Street. A gingerbread double-shotgun cottage indigenous to New Orleans, it was used as the street-railroad ticket office. It was divided by a center wall, one side being for whites and the other for Negroes.

In spite of all construction planning and the vast financial projections, the exposition fell far behind its construction schedule. Finally, by an act of Congress, an opening date was set for December 16, 1884. The city was elaborately decorated, and there were marching bands and a huge military parade to celebrate the opening day. The ceremonies took place in the Music Hall of the Main Building. The president of the United States, Chester Arthur, was in personal communication with New Orleans by telegraph. Electric communication was effected between the East Room of the White House and the Main Building of the exposition. When President Arthur touched an electric key and gave the signal to illuminate the Main Building, electricity came to New Orleans for the first time.

The coming of electricity had to take a back seat to the prominence of the Woman's Department. The women of New Orleans would never be the same after the exposition exposed them to the doctrines of the woman's suffrage movement. Many New Orleans women had learned to hold their families together, financially, when they became widows of the Civil War. Now these women were eager to gain more independence.

Colonel F. C. Morehead, one of the exposition founders, was anxious to have a separate exhibit of women's work. Colonel Morehead, much to the chagrin of his male colleagues of 1884, stated publicly that women should have the power to earn a living and should get equal pay with men for equal work. Colonel

6

Morehead had witnessed the effects of such a venture at the Merchants and Mechanics' Institute Fair in Boston in 1883. Mrs. Julia Ward Howe, noted author of "The Battle Hymn of the Republic" and president of the prestigious New England Woman's Suffrage Association, had been president of the successful woman's department at the Boston fair. Mrs. Howe had many qualifications that would appeal to the local board of directors. She had a link with New Orleans through her only brother, Francis Marian Ward, who had lived and died in New Orleans; he died of yellow fever and was buried in Girod Cemetery (now destroyed for the Union Passenger Terminal). A burning desire of Mrs. Howe's was the uniting of the North and South emotionally. Her prime motivation, however, is expressed in a book by Louise Hall Tharp about the Ward family, called *Three Saints and a Sinner*, on page 351:

> But Mrs. Howe, released from all danger of having to chaperone Maud and Mrs. Gardner in Japan, breathed a sigh of relief. She was free to go to New Orleans, where she organized the Woman's Department for the New Orleans Exposition. Numberless letters went out beforehand as Mrs. Howe carried out an idea of hers. She wanted to "bring into notice and demand, the remote and hidden handicrafts still in the mountain regions." This was a totally new idea in an age that was much in love with the machine. Jigsaw cutouts were stuck to the surfaces of wood to simulate hand carvings; machine embroidery was admired not only because it could be produced cheaply but because it was so wonderful that a machine could do such things. It was not easy to regain acceptance of handcraft, but thanks to Mrs. Howe a new appreciation began to stir faintly. If it can be said that times of crisis produce the man for the hour, then Julia Ward Howe was the woman for the 1880's.

Commissioners from each state were chosen to collect exhibits. The New Orleans officers were appointed by the president of the board of the Christian Woman's Exchange. Mrs. Jenny Caldwell Nixon, who later became the first faculty member of H. Sophie Newcomb Memorial College, was named chief commissioner of the Louisiana Woman's Exhibit. Miss Isabel Greely, daughter of Horace Greely, was secretary of the Woman's Department. Mrs. Howe opened an office in Boston, at 5 Park Street, and started traveling the eastern United States lecturing and promoting the World's Industrial and Cotton Centennial to be held in New Orleans. Her daughter, Maud, was to work as her assistant.

In Mrs. Howe's opening speech at the exposition, she stated, "All that the best and wisest men can imagine for the good of the human race can be wrought if the best women will only help the best men." She had no way of knowing just how prophetic these words would be.

Mrs. Howe and Maud arrived in New Orleans on December 11, 1884. The two ladies were met by Richard Nixon, secretary of the board of managers, and Dr. Charles DaBrey, chief of the Government and States Building. Mrs. Howe and Maud took lodgings at the Hotel Royal between Chartres and Royal streets, where the Royal Orleans Hotel stands today, paying four dollars a day

for food and rooms. Mrs. Howe complained all through her stay that her accommodations were poor and uncomfortable.

Mrs. Howe was horrified to discover that in the Government and States Building, the floor hadn't been laid in the gallery of the Woman's Department. She also discovered that the management of the Cotton Centennial was in grave financial difficulties. Since she had personally selected the exhibits, she felt a moral responsibility for their proper care and safety. She found it necessary to assume the financial obligations for the Woman's Department.

Woman's Day was set for March 4, 1885, and outdid all other openings at the exposition. The exercise took place at the brightly decorated pavilion of the Women's Christian Temperance Union. Mrs. Howe made a speech alive with pronouncements about the capabilities of women: "Good work, when recognized, acts as a spur to human energy, so often overcome by indolence and the vis inertiae. Those who show how women can excel are examples to shame those who do not try. They lay upon their sex an obligation to stronger endeavor and better action, and society gains thereby."

Mrs. Susan B. Anthony spoke on March 17, 1885, Mississippi Day, again furthering this distaff cause. In an interview with the *Daily States*, she explained:

> . . . Teaching, homework, factory work and needle work—this was everything open for woman by which she could earn a dollar; but now there are some three hundred avocations in which women are engaged. They can be found in the schools, shops, factories, mills, offices of capitalists or government. In former times you couldn't find women working side by side with men, as you do now. . . .
>
> The only thing we have to complain of is that women are everywhere paid inferior wages, and are compelled to submit to it. Then, in the department of education, there was, when we began, just one college open to women, and that was Oberlin, Ohio, but it admitted both negro and white women.

If any one thing can be said to have been the major result of the exposition, it was the great strides gained in the education of women. Maud Howe established a fourteen-hundred-volume library in a quiet corner of the Woman's Department, where the lady commissioners and their guests could relax and read books, periodicals, and papers. It was one of the largest collections of work by women ever compiled. The entire library was given to the Southern Art Union Library in New Orleans at the close of the exposition in June of 1885.

In the memoirs of Maud Howe, *Three Generations*, she states: "During the Exposition of New Orleans, New Orleans became a cosmopolitan center, as did Philadelphia in the Centennial of 1876 and Chicago during the World's Fair of 1893. It was said that one of the by-products of the Exposition was the great number of intelligent and agreeable persons it brought to the city."

The exhibits themselves provided the most positive national stimulus. The Woman's Department Exhibition was established as a shrine to the skill and genius of women. There were not only patented inventions, literary successes,

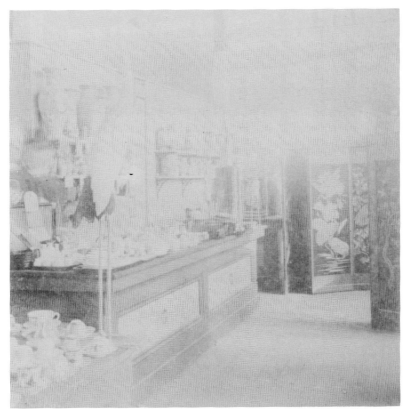

Japanese exhibit in the World's Industrial and Cotton Centennial, 1884–85, shows pottery and porcelain art objects. (Mugnier Collection, Louisiana State Museum)

and native handicrafts exhibited, but also examples of every decorative art. Fine needlecraft, china painting, sculpture, portraits, hammered metals, etchings, woodcarving, jewelry making, bookbinding, and pottery were shown by every state. There were also the foreign exhibits that introduced the women to age-old artistic disciplines. The large Japanese and Chinese exhibits displayed their pottery and porcelain, which afforded a close inspection of their decorating techniques. Master oriental craftsmen came to New Orleans to demonstrate their brush techniques for underglazing and overglazing on their ware. Art Nouveau later would take its inspiration from the Japanese scroll and pottery painting. The knowledge gained by the women at the exposition was to be employed later in the early crafts of the Newcomb style.

Julia Ward Howe established a series of lectures and demonstrations in conjunction with the education section of the Woman's Department in order to foster the interest already shown by the large crowds of women who came daily to the exposition. She fortified the series with practical academic classes. For those women interested in furthering their art education, she hired William Woodward, professor of architecture and painting at Tulane University. Wil-

liam suggested that his brother, Ellsworth, be hired and brought to New Orleans to assist him.

Ellsworth Woodward, newly married and twenty-four years old, arrived in New Orleans in January of 1885. He started at once to teach painting, designing, woodcarving, stenciling, brasswork, and clay modeling. So popular were Ellsworth Woodward's classes at the exposition that ladies would arrive hours in advance of the time set for class and sit patiently to make sure they had a chair in the classroom. Long lines formed outside the classroom in the hope that some would vacate their chairs and their places could be taken.

The exposition, which closed in June, 1885, was just the beginning of things to come for the women of New Orleans. They had found new skills and had become determined to gain an education in order to enter the mainstream of business and community life. The Cotton Centennial was a disaster financially, but the women of New Orleans, at least, derived tangible benefits.

# 2

# LADIES' DECORATIVE ART LEAGUE AND NEW ORLEANS ART POTTERY

With the closing of the World's Industrial and Cotton Centennial in June, 1885, Ellsworth and William Woodward found themselves with an eager group of ladies anxious to continue their art training. The yellow fever epidemics that had plagued New Orleans since 1718 forced all who could afford to leave town to do so in the summer months. Whole families would exit the city for the Smoky Mountains and places as far north as Maine. There are no records to say whether William and Ellsworth Woodward remained in New Orleans the summer of 1885, but there is proof that in the early fall of 1885 they rented a building at Saint Joseph and Baronne streets to found a league for the purpose of continuing the art training started at the Cotton Centennial.

With about thirty women who had been the pupils of Ellsworth and William Woodward at the Cotton Centennial classes, an organization was chartered and named the Ladies' Decorative Art League. It is not clear what the fees were or who sponsored the league, but the New Orleans city directory shows its existence in 1885. There are no records indicating what type of training was given. One can only surmise that the training was an extension of the courses given at the Cotton Centennial.

The New Orleans Art Pottery came into being the next year (1886). The Art Pottery was chartered and rented space across the street from the Ladies' Decorative Art League. Ellsworth Woodward wrote a paper explaining the reasons for founding the New Orleans Art Pottery. He felt that the teaching of design or clay modeling without the practical use of kilns and glazes was only academic.

The city directory lists the New Orleans Art Pottery's officers as Samuel L. Gilmore, secretary, and William Woodward, treasurer. Samuel L. Gilmore, a prominent attorney in New Orleans, resided at Saint Charles and Henry Clay avenues, one block from the Cotton Centennial grounds. No other officers were listed, but we can assume that perhaps Ellsworth Woodward was the

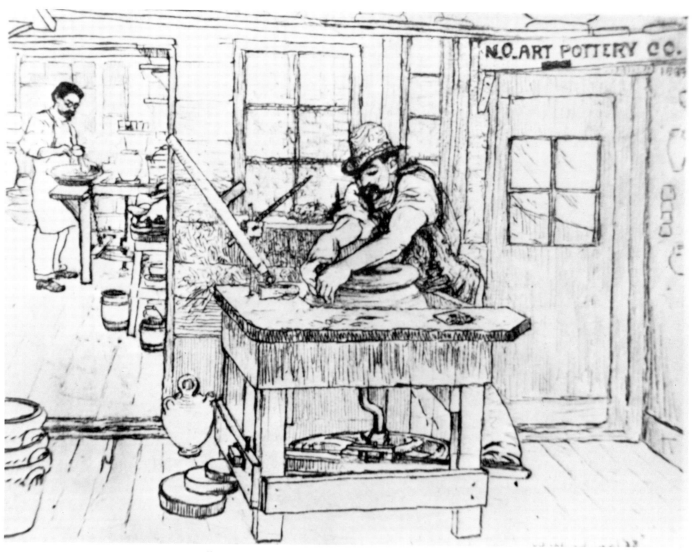

William Woodward etching of New Orleans Art Pottery Company, at Baronne and Saint Joseph streets. Left in background is Joseph Meyer; in right foreground at potter's wheel is George Ohr. 1888. (Louisiana State Museum Collection)

president. The New Orleans Art Pottery was a corporation with a hundred shareholders who had paid ten dollars a share for stock. The corporation hired two potters, Joseph Fortune Meyer and George Ohr, to run the business and make the ware.

Joseph Fortune Meyer was born in France and had come first to Biloxi, Mississippi, with his father when he was about nine years old, in 1857. One of Joseph Meyer's playmates in Biloxi was George Ohr. As young men these two had worked for the father of Joseph Meyer, François Antoine Meyer, after the elder Meyer moved to New Orleans. François Meyer had a pottery business in

the old French Market in the Vieux Carré. Later he opened a shoe store at 1431 Saint Bernard Avenue. Records show that François Antoine Meyer died December 29, 1870, and that Joseph Meyer continued the shoe business after his death.

Joseph Meyer and George Ohr set up the New Orleans Art Pottery in 1886. The building, a small two-story brick structure, had the old city address of 249 Baronne Street (numbering changed in New Orleans in 1894), across the street from the Ladies' Decorative Art League. This easy access to the league classrooms made it possible for the ladies to have drawing classes and then apply their designs to the clay ware without traveling a long distance.

The few remaining records show that the clay was brought from Bayou Tchulakabaufa, in Biloxi, by schooner into New Orleans' New Basin Canal, an open waterway that ran from Lake Pontchartrain to the foot of South Rampart Street and Howard Avenue (then Delord Street). In the 1950s the New Basin Canal was filled in to make way for railroad tracks and Interstate 10. The site of the terminal point of the New Basin Canal is now the Union Passenger Terminal.

This clay was pure white when fired to a low temperature and produced a pleasant base for transparent lead glazes. The coal that was used for fuel in the kilns was probably available in the general neighborhood. There were no transportation problems in getting the raw clay materials, since only four city blocks separated the New Orleans Art Pottery from the terminal of the New Basin Canal.

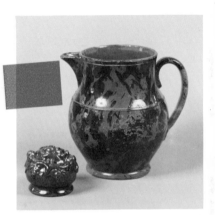

The New Orleans Art Pottery produced large garden pots and jardinieres for the women of the Ladies' Decorative Art League to decorate. The pieces in the collection of the Louisiana State Museum show decoration of Louisiana plant material. No records exist to show how much ware was made and sold, but it is known that the New Orleans Art Pottery was not a successful business venture. However, the Ladies' Decorative Art League and the New Orleans Art Pottery did provide the link between the Cotton Centennial and Newcomb College, and in so doing performed a significant service to the local women.

Pitcher made by Joseph Meyer in red clay body with black and transparent lead glaze; circa 1890; 9½″ tall. Bud vase by George Ohr in red clay with shiny black glaze; circa 1890; 3″ tall. (Louisiana State Museum Collection)

The *Daily States* of January 4, 1886, carried an advertisement for free evening art classes for women under the supervision of Tulane University, at the Tulane Manual Training School, corner of Lafayette and Dryades streets (now O'Keefe Avenue). The advertisement lists the same arts and crafts to be taught as the ones taught at the Cotton Centennial: drawing, brass hammering, terra-cotta ornament, stenciling, woodcarving, and leather stamping. The object of the teaching was a possible pecuniary return. Whether the Woodward brothers taught these classes is unknown.

In September of 1887 Newcomb College opened, and Ellsworth Woodward took a position with the new college as the head of the art department. The new college was located just a few city blocks from the New Orleans Art Pottery and

the Ladies' Decorative Art League. Some of the students in the Ladies' League remained, while others enrolled as special or full-time students at the new college. The New Orleans Art Pottery limped along until 1890, when it was turned over to the Art League Pottery Club. In the *Daily Picayune*, January 5, 1890, page 6, this item appeared: "The Art League Pottery Club, successor to the New Orleans Art Company, has recently been organized at 240 Baronne Street with Prof. W. Woodward as president, Miss M. Heinfort, secretary, and Mrs. J. D. Wardlaw, treasurer, to enable the enthusiastic clay workers to continue their practices in this art. The club has just taken out its first spring specimens of which are to be seen in the window at the Christian Woman's Exchange."

In the world of arts and crafts, success cannot always be measured in terms of the money reaped from a venture; the success, many times, lies in the enthusiasm generated. The Woodwards, Joseph Meyer, and George Ohr had kept the interest generated by the Cotton Centennial alive long enough to provide the link between the Cotton Centennial and the founding of an art department at Newcomb College.

# 3
# THE FOUNDING
# OF THE COLLEGE

Newcomb College was founded in 1886 as a part of Tulane University with an endowment from Mrs. Josephine Louise LeMonnier Newcomb, who was born in Baltimore on October 31, 1818. She had met Warren Newcomb while living with her brother-in-law and sister in New Orleans, and married him on December 15, 1845. They lived in New Orleans only a short time before moving to Louisville, Kentucky, and then to New York City.

Josephine Louise and Warren Newcomb had two children, a boy who died in infancy and a daughter, Harriott Sophie, born July 29, 1855. Harriott Sophie was named for her two grandmothers, Harriott for her paternal grandmother and Sophie for her maternal grandmother. Mr. Newcomb died August 18, 1866, leaving a large and valuable estate. His money had been made in the brokerage of rice, sugar, and molasses—sometimes he bought the whole output of a planter—which he shipped with imported coffee to his brother's wholesale business in Louisville, Kentucky, for resale. In his will, he left to his daughter, Sophie, an estimated $200,000, and to his wife about $450,000. On December 16, 1870, Harriott Sophie, age fifteen, died of diphtheria.

For years Mrs. Newcomb searched for a suitable memorial to her dead child. Eventually, through Mrs. Tobias G. Richardson, she became interested in the idea of establishing a women's college in connection with Tulane University. Mrs. Richardson was the wife of Dean Tobias G. Richardson, who headed the Tulane Medical School from 1865 to 1885. She visited Mrs. Newcomb frequently, both in New Orleans and in New York City, in connection with the project, and Mrs. Newcomb made the original donation for the college in the amount of $100,000. In a letter to the Board of Tulane University she wrote the following on October 11, 1886: "I hereby donate to your Board the sum of $100,000.00 to be used in establishing the H. Sophie Newcomb Memorial College, in the Tulane University of Louisiana, for the higher education of white girls and young women."

15

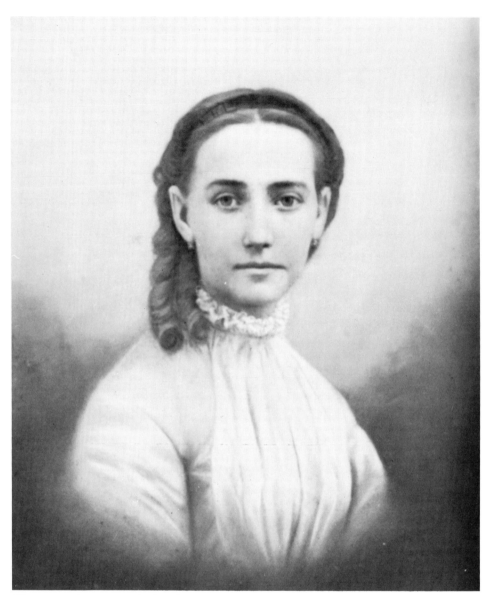

Harriott Sophie Newcomb, for whom Newcomb College is named and dedicated. (Newcomb College)

In September of 1887 Newcomb College opened its doors. The Board of Tulane University selected a young high school principal from Saint Louis, Brandt Van Blarcom Dixon, to be the first president of Newcomb College. Dr. Dixon and the Board of Tulane University had their work cut out for them, since it was Mrs. Newcomb's desire that the college begin at once. In less than a year's time from October, 1886, when Mrs. Newcomb gave her donation for the founding of the college, the doors were opened to students.

Newcomb College has had three different campuses since 1887, the first on

16

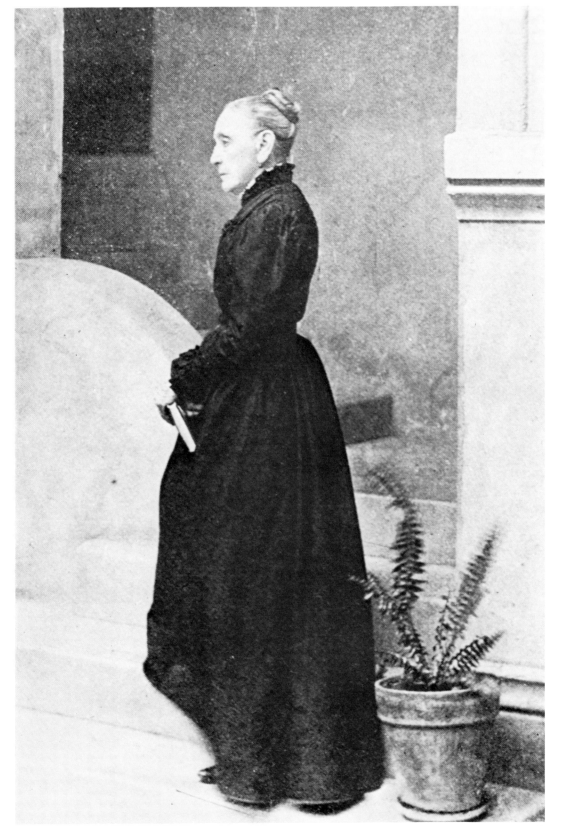

The founder of Newcomb College, Mrs. Josephine Louise Le Monnier Newcomb, always wore black and stayed in mourning from 1886 until her death in April, 1901. (Louisiana State Museum Library)

Camp Street (1887–90), the second on Washington Avenue (1891–1918), and since 1918 the present campus on Broadway. The first campus was a building situated on the upper lake corner of Camp Street at Howard Avenue, which in 1887 was named Delord Street. The house, a brownstone mansion, had just been vacated by the Harmony Club. The Harmony Club, whose members were the elite Jews of New Orleans, had built new quarters on the lower river corner of Saint Charles and Jackson avenues. The brownstone building, known as the Hale Mansion, was suitable in size and location and ideal for the newly formed college.

Records reveal that in the fall of 1887 the enrollment of Newcomb College, in its first session, was fifty-nine students in academic studies and ninety-one in

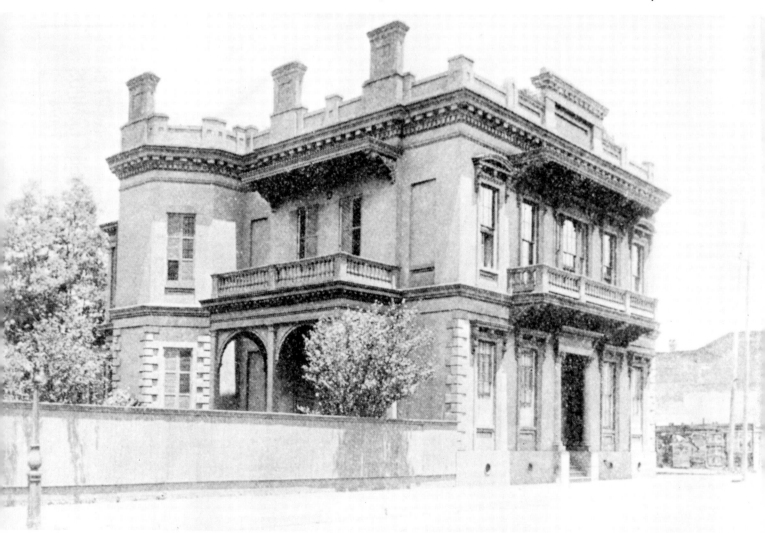

First home of Newcomb College on Camp Street at Delord (now Howard Avenue). The building was known as the Hale Mansion before Newcomb acquired the property. Newcomb College occupied the building from 1887 to 1890. The building was destroyed and a warehouse stands on the location. (Louisiana State Museum Library)

18

the "so called special and art classes." Dr. Dixon had to look long and hard in New Orleans to find a suitable faculty to staff his new institution of higher learning. New Orleans was not known in those days as an educational center, but with luck Dr. Dixon put together some people who were to become well known in later years. One of the first persons hired was Mrs. Jennie C. Nixon, who had been commissioner of the Louisiana State Division of the Woman's Department at the World's Industrial and Cotton Centennial in 1884–85. Mrs. Nixon was appointed professor of English and rhetoric. A widow with small children, she had the same point of view as Julia Ward Howe about a woman's role in education, government, and community affairs. The stamp that Mrs. Nixon put on Newcomb College was to be felt for many years. The early faculty members of the college had a strong influence in the movement later to be called the Crafts of the Newcomb Style.

It was Dr. Dixon who hired the Woodward brothers, Ellsworth and William, to organize the art department for the new college. The Woodwards brought with them to the Hale Mansion some of their students at the Ladies' Decorative Art League and the New Orleans Art Pottery. The link between Newcomb College and the Ladies' Decorative League was an important step in the development of the arts and crafts movement. It was not difficult for the Woodwards to divide their time between the two locations, since geographically they were only five city blocks apart. The Hale Mansion had no room for a pottery operation, and only painting, drawing, and design classes were held there.

Dr. Dixon realized almost at once that girls and women of New Orleans were not prepared for higher education in the year 1887, and that in order to build a viable college they would have to have a high school to train students to enter Newcomb in the future. A high school was formed the next year to prepare women for higher education.

Newcomb College was accepted at once by the community. In a few short years it outgrew the Hale Mansion on Camp Street, where it was impossible to teach crafts seriously, and Dr. Dixon and Mrs. Newcomb set out to find larger quarters. The Robb-Burnside Mansion on Washington Avenue had been placed on the market, and it was selected as the site for the new campus, but the Board of Tulane University turned down Mrs. Newcomb's request for the Robb-Burnside Mansion property. When Mrs. Newcomb found out that the Tulane board had secretly purchased the Robb-Burnside Mansion site for a high school for Tulane University, she was horrified. Tulane University wanted to follow Newcomb College's example by starting a boy's preparatory department. Mrs. Ida Richardson was asked to intercede on behalf of Newcomb College with the Tulane board. Mrs. Richardson instructed Mrs. Newcomb to write a letter and enclose a check in payment for the property and improvements. After much flurry and many board meetings, along with some heated

19

words between Mrs. Newcomb and the Tulane board, the property was turned over to Newcomb College in February, 1890.

The grounds and mansion occupied the squares bounded by Washington Avenue, Sixth, Camp, and Chestnut streets, and bore the municipal number of 1220 Washington Avenue, geographically in the middle of New Orleans' historic Garden District. The site was later sold to the Baptist Theological Seminary, which used the old Washington Avenue campus until the 1950s, when it moved into new quarters in the Gentilly section of New Orleans. The land was then subdivided into lots, and handsome homes now stand on the site of the Robb-Burnside Mansion. The Garden District in the nineteenth century was a fashionable place to live, and remains so even today. Mrs. Newcomb,

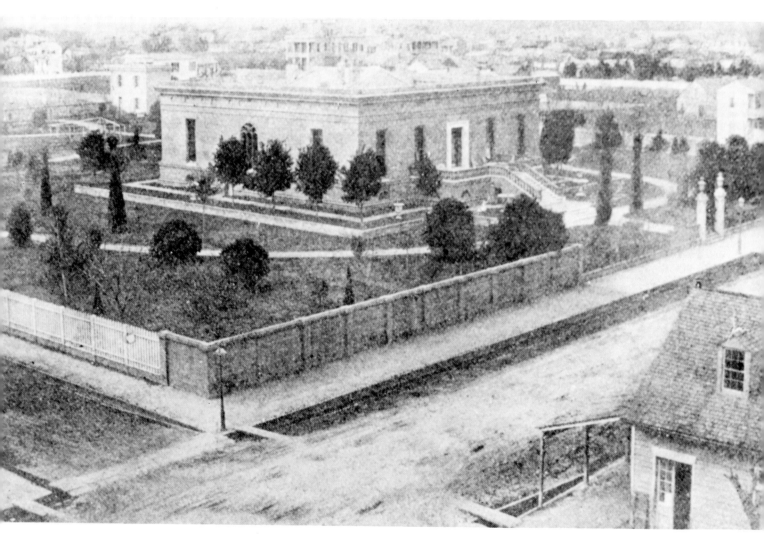

Aerial view of Robb-Burnside building after its completion in 1860. Photograph shows young oak trees that remain today. Bottom left part of photograph shows intersection of Camp Street, and wide front street is Washington Avenue. (Louisiana State Museum Library)

desiring suitable surroundings for cultured young ladies, did not like the Hale Mansion, because it was in a business area and men gathered to watch the young ladies take their exercise. This was distressing to her proprieties.

A top story had to be added to the Robb-Burnside building to provide the needed classroom space. The work was undertaken in the spring of 1890. With the work starting on Washington Avenue, Newcomb College rented the Hale Mansion on Camp Street, fully expecting work to be completed in time for the fall session of 1890. However, delays occurred, and without the campus or the school furnishings, which were in storage on Washington Avenue, the college was forced to use the basement of Trinity Church on Jackson Avenue in the fall

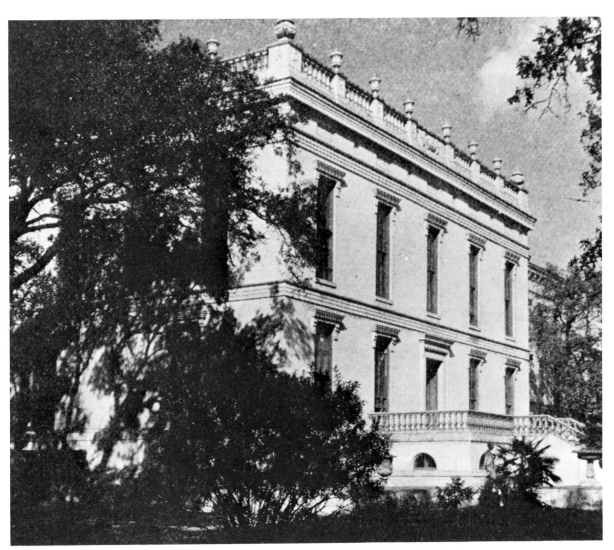

The second home of Newcomb College in what was formerly called the Robb-Burnside Mansion. In 1890 the college added the top story, used originally for drawing classes. The street address was 1220 Washington Avenue; the building was destroyed in 1953. (Louisiana State Museum Library)

21

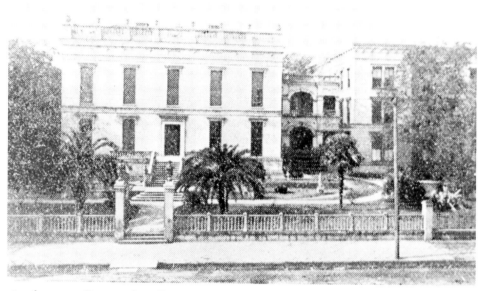

Another view of Newcomb Hall and the Arcade and Academy buildings that were added to the Robb-Burnside Mansion at 1220 Washington Avenue. Buildings were destroyed in 1953. (Louisiana State Museum Library)

of 1890. Finally, in January of 1891, the new location was ready, and Newcomb College moved into its first real campus.

The college could now expand, and undertake the teaching and production of applied crafts. The art department in the hands of Ellsworth Woodward was gaining support. The enthusiasm for the study of art and decoration was apparent from the number of students who desired to take courses, as evidenced by the records of enrollment in 1890–91: sixty-three academic, thirty-one art, fifty-five preparatory, and twenty-five in special literary studies. The newly constructed upper story became the art department, and in this large room measuring fifty-four by eighty feet Ellsworth Woodward was free to add additional art courses. He believed in a strong background in drawing as a means to accomplish a good finished piece. He coined a slogan that said, "Art is work well done." This was the philosophy behind the movement later to be known as the Crafts of the Newcomb Style.

The years spent on the Washington Avenue campus were the golden age of the college. It was at this campus that Mrs. Newcomb's dream of a place where women could be educated to earn a living—women who would go into the mainstream of business and community life, women who could become leaders in whatever field they chose—was finally realized.

The New Orleans Art Pottery and the Ladies' Decorative Art League were disbanded, and most of their functions were assumed by the college at the new

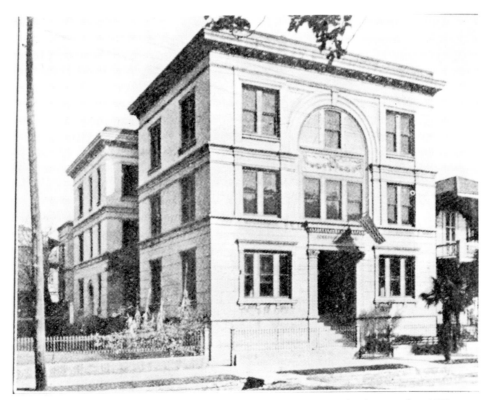

Residence hall named for the founder, Josephine Louise Newcomb, that stood at 1231 Washington Avenue (now destroyed). A new Josephine Louise House stands on the present Broadway campus. (Louisiana State Museum Library)

A view of 2828 Camp Street, the Newcomb Guild building, designed and built in 1901. (Louisiana State Museum Library)

campus, a necessary step in making the college solely responsible for the teaching of crafts. All the students from the league were encouraged to enroll at Newcomb as special art students. At first William Woodward organized a group that he called the Five or More Club, the name stemming from the number of students required to form a class. The group did some interesting claywork, but more in sculpture than in pottery.

The upper story of the Robb-Burnside Mansion was perfect for drawing, painting, and design classes because of the good source of light from the north sky, but Dr. Dixon and Mrs. Newcomb were fascinated with the art of pottery making, and both felt it should be part of the art department's curriculum. In order to include it, they had to outfit the basement–boiler room of the Robb-Burnside building. A pottery department, unlike drawing, painting, and design departments, requires a large space to prepare clay, house kilns, and store materials. It also requires space for worktables, potter's wheels, various types of shelving, and general storage. All these things are necessary in order to manufacture pottery.

The first potter hired was a Frenchman named Gabry, who had worked for the Louisiana Porcelain Works on Carondelet Walk (now Basin Street). Gabry's tenure was short, as he drowned himself in the Mississippi River. There is one reference to an early potter named George Wasmuth. Details are scanty on both these men.

Newcomb College then hired the two potters of the old New Orleans Art Pottery, Joseph Fortune Meyer and George E. Ohr. Although they approached their craft in very different ways, each was an excellent wheel technician. Neither man had formal training; rather, they had learned their craft through the time-honored apprentice system. Of the two, Joseph Meyer was more sensitive to the art of pottery. He could throw almost any shape rapidly and well. He could throw a great many pots in one day and trim an equal number. This he did for almost thirty-five years at Newcomb College. The clay bodies and glazes in this period were the same as those used at the New Orleans Art Pottery: white low-fired clay bodies with transparent low-fired lead glazes. The college continued the practice of importing by schooner the clay dug from Bayou Tchulakabaufa in Back Bay, Biloxi, Mississippi. When this clay was mixed with Louisiana red brick clay, a nice soft terra-cotta clay body was obtained.

Pottery was the first of the crafts to be taught. Later the others came in the order of embroidery, brasswork, jewelry, and bookbinding. Meyer fired the kilns, made the glazes, and performed all other jobs necessary to make a pottery function. The early pieces made in the boiler room on Washington Avenue, although not as familiar to the general public as pieces produced later, were a noble first step.

In the spring of 1891 the art department had generated such enthusiasm that

24

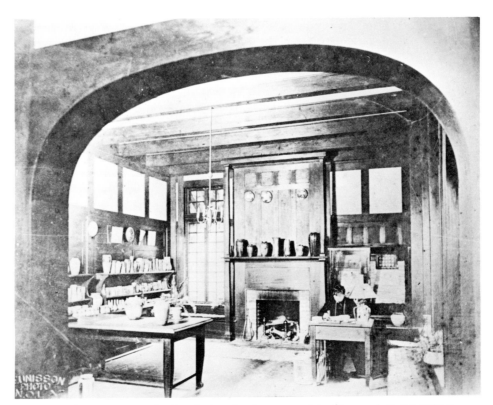

Miss Desirée Roman, seated at her desk in the showroom of the Newcomb Guild, 2828 Camp Street. Miss Roman was the clerk of the pottery, a position she held until 1935. (Louisiana State Museum Library)

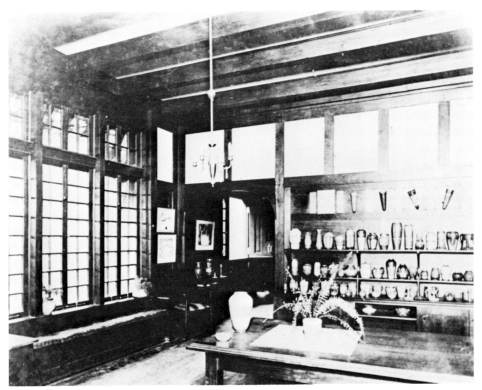

Another view of the salesroom in the Newcomb Guild building at 2828 Camp Street. Photograph shows finished pottery that was sold by the guild. (Louisiana State Museum Library)

Seal of Newcomb College showing the live oak tree, the symbol of the college; the design is attributed to Ellsworth Woodward; 1887–1919. (Louisiana State Museum Library)

the graduating class of that year declared brown and blue to be the college's colors. These two colors became in later periods the foundation colors of most of the crafts produced.

Student enrollment increased every year in the art department, adding to the responsibilities of an already overburdened small faculty. By 1894 the demands placed on the time and energies of men like Meyer and Ohr were excessive. They not only had to make and fire the pottery, but they also were charged with supervising the design phase. Dr. Dixon, at the urging of Ellsworth Woodward and Mrs. Newcomb, decided to hire a full-time chief decorator, whose sole duty was to supervise the design and decoration part of the pottery making. Through the Rookwood Pottery in Cincinnati, Ohio, the name of Mary Given Sheerer was obtained. Dr. Dixon traveled to Covington, Kentucky, in the spring of 1894 to interview her for this position. Mrs. Newcomb had instructed the college that whenever possible a woman should be hired in preference to a man with comparable qualifications. Miss Sheerer

# Professors and Instructors

BRANDT VAN BLARCOM DIXON, A.M., LL.D., President of Newcomb College, and Professor of Philosophy.
ELLSWORTH WOODWARD, Professor of Drawing and Painting, and Director of Art Instruction.
WILLIAM WOODWARD, Professor of Drawing and Painting.
JANE CALDWELL NIXON, Professor of English and Rhetoric.
EVELYN WALTON ORDWAY, B.Sc., Professor of Chemistry.
MARIE AUGUSTIN, Professor of French.
MARY LEAL HARKNESS, A.M., Ph.D., Professor of Latin.
FREDERICK WESPY, Ph.D., Professor of German.
MARY CASS SPENSER, M.Sc., Professor of Mathematics.
CLARA GREGORY BAER, Professor of Physical Education.
JAMES ADAIR LYON, Jr., A.M., Professor of Physics.
PIERCE BUTLER, Ph.D., Professor of History.
SUSAN DINSMORE TEW, Ph.D., Professor of Greek.
GERTRUDE ROBERTS SMITH, Professor of Drawing and Painting.
MARY GIVEN SHEERER, Professor of Ceramic Decoration.
IMOGEN STONE, A.M., Assistant Professor of English.
JOHN PETER PEMBERTON, Instructor in Drawing.
SUSAN WILLIAMS MOSES, A.M., Assistant Professor of Languages.
JOHN LEO HENNESSY, Instructor in Spanish.
LAURA ALICE McGLOIN, A.M., Instructor in Biology.
JULIA CAROLINA LOGAN, Instructor in English.
CLARISSE CENAS, Instructor in French.
KATHERINE KOPMAN, Instructor in Drawing.
AMÉLIE ROMAN, Instructor in Drawing.
MARY WILLIAMS BUTLER, Instructor in Drawing.
LOUISIANA JOHN CATLETT, Instructor in Mathematics.
ABBIE RICHMOND, A.M., Instructor in English.
VIOLA DENESA SIRERA, A.M., Instructor in German and Latin.
ADELIN ELAM SPENCER, A.M., M.Sc., Instructor in Chemistry.
MYRA CLARE ROGERS, A.M., Instructor in Latin.
LUCY CHURCHILL RICHARDSON, Instructor in Physical Education.
KATHARINE MARGUERITE REED, A.M., Instructor in History.
BERTHA ELINOR FRANKENBUSH, A.M., Instructor in Mathematics.

Roster of faculty at Newcomb College about 1916. (Louisiana State Museum Library)

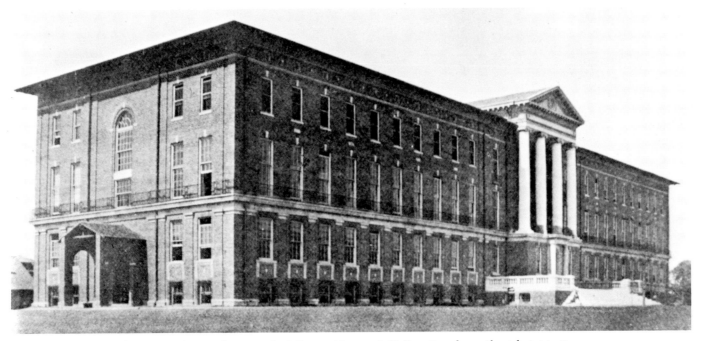

The present home of Newcomb College—Newcomb Hall on Broadway, the Administration Building; photograph taken after completion of the building. (Louisiana State Museum Library)

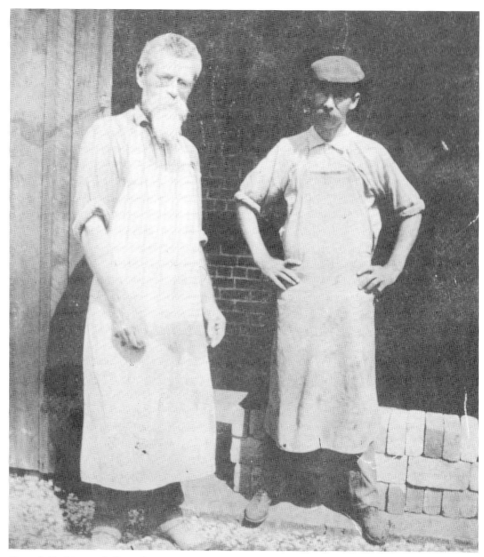

Joseph F. Meyer (left) with long white beard and George Ohr (right) with cap. Taken at Newcomb College near the kiln about 1897. (Walther Collection)

accepted the college's offer to become the chief decorator and arrived in the summer of 1894 to take up her duties, which she performed for the next thirty-five years.

Miss Sheerer had been trained at the Art Academy of Cincinnati and had worked for the Rookwood Pottery as a decorator. When she arrived at Newcomb College, the art department was just beginning to grow, and the pottery section was only a tiny part. She set to work, using the knowledge gained at Rookwood Pottery, to experiment with local clays. In cooperation with Joseph Meyer, who had a great deal of kiln-firing knowledge, she created a new kind of pottery. Miss Sheerer's arrival at the college marked the first definitive step in the founding of a guild.

The campus on Washington Avenue continued to build new buildings. One of the loveliest was the Memorial Chapel. Mrs. Newcomb personally supervised the design and construction down to the smallest detail. The chapel was a tribute to her daughter, Sophie. Mrs. Newcomb was a deeply religious person and believed that prayer was a vital part of everyday living. With Dr. Dixon, she planned the entire building and its future use. The chancel of the chapel, behind the altar, had a triple window illustrating the Resurrection. In one of the windows an angel was the portrayal of Sophie, reflecting Mrs. Newcomb's wish to reveal that the college itself was the resurrected spirit of her beloved daughter. At the other end was a large rose window, and along one side Mrs. Newcomb had two memorial windows done in memory of her husband and her mother. The other windows were added as gifts of graduating classes. All these

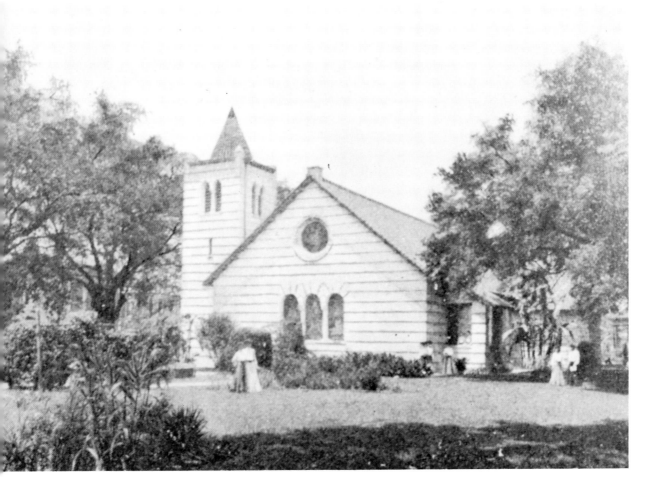

Exterior view of the chapel that housed the famous Tiffany windows. The chapel was built in 1894 and destroyed in 1953. The windows will be placed in the new chapel on Broadway. Early graduating classes gave windows, and daily worship was held when the college was on Washington Avenue. (Louisiana State Museum Library)

29

stained-glass windows, excellent examples of this medium, were executed by the Tiffany Glass Company of New York. Mrs. Newcomb had a special brass tablet made for the dedication in the spring of 1895, bearing this inscription: "In memory of Harriott Sophie Newcomb, only daughter of Warren and Josephine LeMonnier Newcomb, aged fifteen years, this chapel is erected, and this college has been founded."

The craftsmen of Newcomb were to do the candlesticks, embroidery, and vestments of the chapel in the Newcomb style. The chapel became a favorite subject for paintings done by the Woodwards and many other artists. Many students and graduates had their marriages celebrated in the chapel, and occasionally a funeral was held for an alumna. Those who attended college between 1895 and 1918 found the chapel a joyous place in which to worship.

Dormitories, new classroom buildings, and the art department building

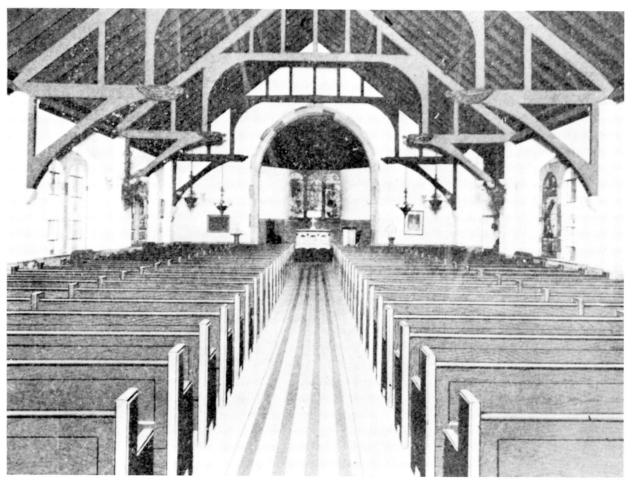

Interior view of the chapel once located at corner of Sixth and Chestnut streets. The building was destroyed in 1953. (Louisiana State Museum Library)

were also erected in the 1891–95 period. The college was growing both in enrollment and in academic reputation.

In 1895–1900 the crafts began exhibiting the character that later evolved into the Newcomb style. Active experiments were started in October, 1895. In one end of the basement room of the Robb-Burnside building a round kiln was built that contained four small firing chambers. The other end of the room had kickwheels, drying shelves, tubs and basins for clay, damp boxes to store the clay, decorators' tables, glazing materials, scales, chemicals, and a grinding mill. In Miss Sheerer's notes about the period, she wrote that the interest and high enthusiasm of the students overcame the crowding of so much equipment into such a small area.

The clay obtained from Back Bay, Biloxi, and the local brick clay had to be washed and sieved by hand in large settling basins to remove the grit and organic materials. In order to remove the water and make the clay plastic, the clay slurry was placed in plaster-of-paris molds, which provided natural dehydration. At first Miss Sheerer allowed Meyer to continue using his formulas for the glazing. Since he had no formal training in chemistry, he used batch recipes handed down to him by his father, François A. Meyer. These transparent low-fire lead glazes were weighed out with buckshot, which Meyer would count in proper numbers to make the glazes. An example might have been eighty-six buckshot of white lead or thirteen buckshot of whiting, as the chemical compounds were counted out to complete the recipe. Miss Sheerer started testing underglazes and clay slips on both the white and terra-cotta clay bodies. On the white clay, sometimes the entire background was sprayed with underglaze. This technique of spraying was used on the bone-dry ware with an atomizer of the insect gun variety, but the technique had to be abandoned to get better drying time between coats of the underglaze without damaging the pot. Soon Miss Sheerer discovered that there was less shrinkage if the underglaze was applied to bisque fired ware. (Bisque is unglazed fired ware; Newcomb fired its bisque to Cone 012 [875 degrees C.] for hardening.)

There was an advantage to using bisque ware in that the delicate colors used in the palette could be better seen on a firm surface. The first designs used on the ware were fruits, trees, and birds, with an outlining in black underglaze to add emphasis to the design motif. Underglazing on the bisque ware required an additional firing to calcine or frit the underglaze compound; this firing temperature was generally lower than the bisque temperature. The final firing was a transparent low-fired lead glaze. The pieces took on a watercolor effect, and the soft, muted tones were perfect for the foliage and flowers that were indigenous to New Orleans and Louisiana. These early pieces were brittle and tended to break and chip easily because of the nature of the low-fired clay body. Very few examples of this period remain, owing to the fragile nature of the clay

used. In spite of this, many pieces were produced in the small quarters allotted to the pottery in the basement of the Robb-Burnside building.

The great experiment had begun; it was producing and functioning as a pottery. In two letters written to the college, the value of the movement is best expressed:

Museum of Fine Arts
Boston, Massachusetts
July 15, 1899

Newcomb Pottery:

I must express my admiration for the very beautiful essays of your oven. It always seems strange to me that in a nation of 70,000,000 of people there are so few potteries worthy of recognition.

Now the South enters the lists, and in your work we have forms and glazes which must appeal to the critical eye of the old potters of Japan. I congratulate you most heartily on your success and wish you all prosperity in your enterprise.

Edward S. Morse

Brooklyn, New York
November 15, 1899

All who have at heart the development of art industries, who recognize the value of beauty in its relation to every day life, will be interested in the Newcomb pottery.

It is a serious effort in the direction of uniting art and handicraft.

The examples I have seen were beautiful in form and color, simple in design, and of excellent workmanship.

Arthur W. Dow

The philosophy behind the Newcomb movement can best be summed up in Ellsworth Woodward's words in an article for *Art Education* in May, 1898:

. . . The Newcomb Pottery has been established two years and a half—school years—and although the work is still tentative, the mechanical difficulties not being entirely overcome, it begins to exhibit traits of character and individuality that promise well for its maturity.

No special haste is felt to be needed in fixing upon the character that the ware shall assume, as the belief is entertained that if no formative pressure is employed, its development will proceed along the lines of least resistance, and arrive finally at the most natural expression of locality.

Although a part of the art school, the pottery from its nature and object is somewhat outside the usual methods of school work. As it is not a training study it can not enter into the fundamental work of the students. It is rather like a professional course for which the pupil fits herself by previous study. It is in short a business in which theoretical study finds its practical application in concrete results.

In the shape of vases it is not possible to avoid imitation, the best forms having been for centuries established. Imitation in other respects is, however, carefully guarded against. All designs are adaptations of the local flora, insects, landscapes, etc., with the greatest possible liberty of treatment in their application. The distinguishing color of

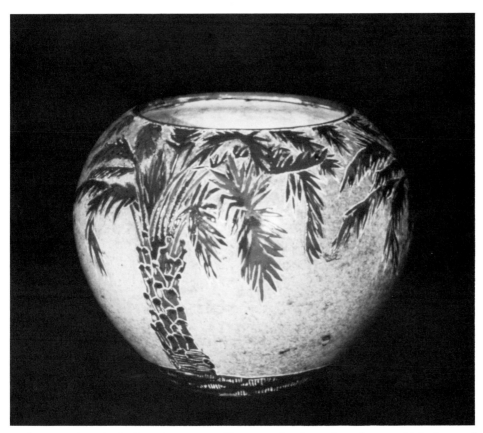

Early pot in white clay body, palm tree motif done in underglaze colors of green with background of medium blue, incised lines filled with black underglaze. Shiny transparent glaze covers surface. Decorated by Selina E. Bres. Bears marks of SEB, no potter, NC, 10 & 21; 1895; 7″ tall. (Private collection)

the ware is blue and bluish-green upon white and buff, and again black and yellow and green upon dark red of terra-cotta.

The sale of this unique pottery has been from the first most flattering, its artistic merit seeming in the eyes of its patrons to outweigh its defects. Now that its mechanical imperfections have almost wholly disappeared and its artistic excellence become more apparent, the ware stands upon a recognized basis of value.

The College cherishes the hope that should this experiment with applied art prove finally successful in its adjustment to supply and demand, it will, as has before been said, widen the opportunities for the art student of New Orleans whose field, after a course of study, is now practically limited to teaching.

This excellence would soon be seen by Dr. Dixon, Mrs. Newcomb, and the Woodward brothers.

The pottery of this period received the first of the many tributes won by Newcomb College and its crafts, when in March of 1900 Newcomb College was solicited by the Ceramic Association of New York to send a small collection of

pottery to the Paris Exposition. When Mrs. Newcomb learned of the request, she insisted that Dr. Dixon and Ellsworth Woodward comply, but there was no pottery on hand on the shelves of the college. Pieces had been sold or taken home by their decorators. After a hasty survey of private collections to locate good work, a small wooden barrel of pottery was assembled and shipped to Paris in the hope that some minute recognition might be afforded the college. To the joy and amazement of everyone at Newcomb, the pottery was awarded a bronze medal in November, 1900. W. S. Ward of the Department of the Interior was in Paris at the time of the award and wrote Newcomb: "Your exhibit, though limited, was one of the most interesting made in that section."

The bronze medal from Paris was to spur the college forward, stimulating the enlargement of the art department. And the invitation to exhibit there made Ellsworth Woodward realize the need for more trained faculty for the crafts program.

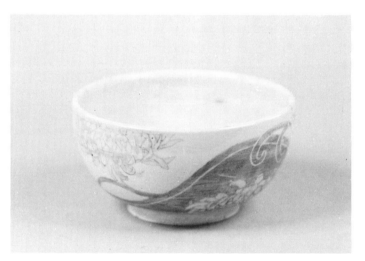

Low bowl with chrysanthemum motif painted on surface in pale blue underglaze, with the early Art Nouveau feeling of Japanese scroll painting. The clay body is cream and has a shiny transparent glaze on entire surface. Decorated by Marie de Hoa LeBlanc, potter unknown. Bears marks of M. H. L., Newcomb College; 1895–1900; 3″ high x 6½″ wide. (Louisiana State Museum Collection)

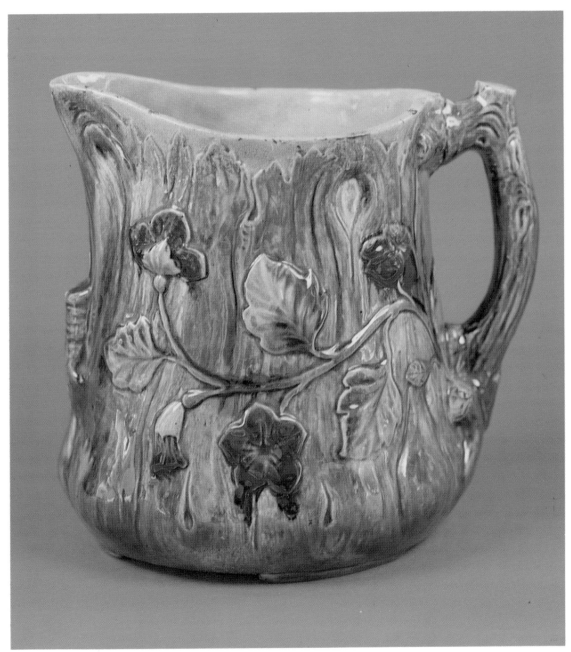

Pitcher made by Joseph Meyer, glazed with transparent colored glazes in tones of green, blue, red, and yellow. Marked on base, JOS. F. MEYER, the Pottery Club, 249 Baronne Street, N.O., La.; 1885–90; 8½″ tall. (Walther Collection)

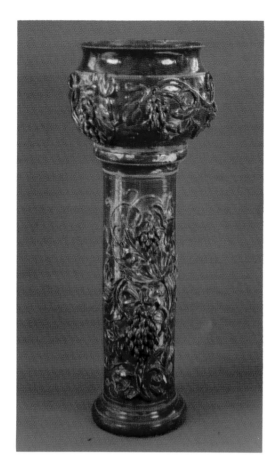

Grape and grape leaf motif on large jardiniere and stand. Motif is applied in high relief on a cream clay body. Burgundy-colored low-fired lead glaze covers entire surface. Marked Katherine Davis of New Orleans Art Pottery Club; 1885–90; jardiniere, 12″ tall; stand pedestal, 32″ tall; overall measurement, 44″ tall. (Louisiana State Museum Collection)

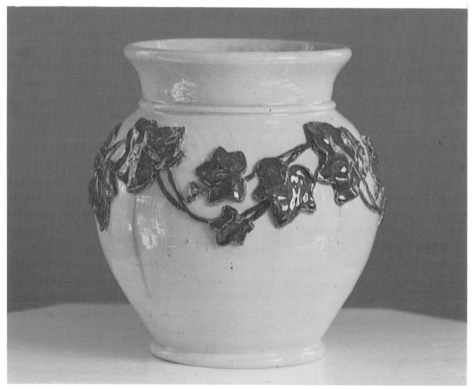

Jardiniere in white clay body with applied motif of English ivy. Leaves are glazed in blue-green-colored low-fired lead glaze, and the entire surface has shiny transparent lead glaze. Made in the New Orleans Art Pottery; bears incised in clay under footrim, NO ART POTTERY CLUB; 1885–90; 11″ tall.

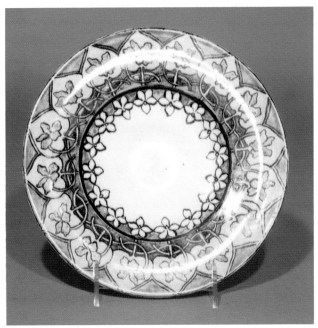

Rare plate in white clay body. The flower motif is violets and leaves in dark blue, light blue, red-purple, green, and black underglaze, with transparent glaze covering the surface. The construction of the plate shows that it was jiggered. Decorated by Katherine Kopman; the potter was Jules Gabry. Bears marks of KK, JG, NC, 20; 1890–95; 8½″ round. (Collection of Newcomb College)

Large jardiniere with Boston fern applied motif in pale pink shiny low-fired lead glaze on entire outside surface. Inside of jardiniere glazed in green-colored low-fired lead glaze. Under footrim is incised, Katherine Davis of New Orleans Art Pottery; 1885–90; 15″ tall. (Louisiana State Museum Collection)

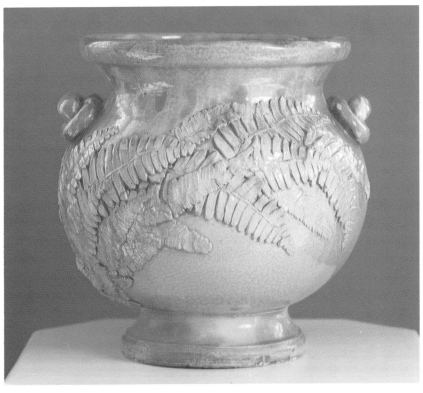

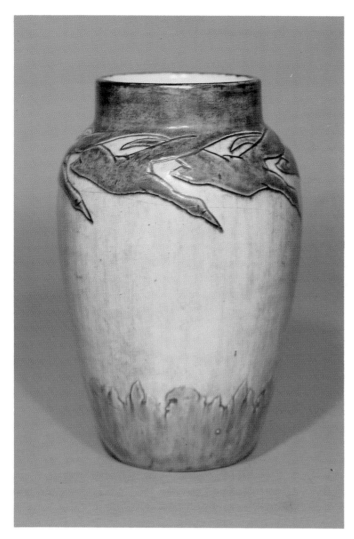

Tall vase with geese in flight motif in white clay with medium blue underglaze and shiny transparent glaze over surface. Decorated by Leona Nicholson, thrown by Joseph Meyer. Bears marks of LN, JM, NC, K 34X; 1895–1900; 9½″ tall. (Collection of Newcomb College)

Upside-down pot in the shape of a mug. Designed with free-form swirls of dark blue, blue-green underglaze on white clay body, with transparent glaze over entire surface. Decorated by Gertrude Roberts Smith, potter unknown. Bears marks of GRS, NC, A182; 1895–1900; 4½″ tall. (Collection of Dr. and Mrs. R. Wynn Irvine)

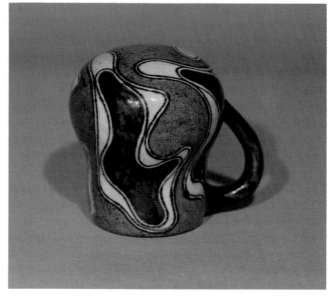

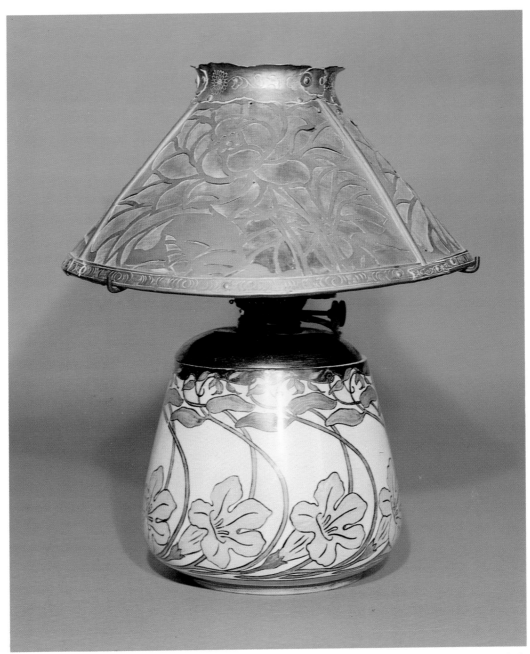

Oil lamp base in white clay body with yellow, blue-green, and black underglaze bignonia motif that has shiny transparent glaze over surface. Decorated by Esther Huger Elliott, potter unknown. Bears marks of EHE, NC, E78; 1895–1900; 8″ tall. Hammered pierced-out brass shade backed with brass mesh screen. The lily flower motif carried out the style. Maker of shade unknown. Shade measures 8″ deep x 13½″ wide. (Collection of Newcomb College)

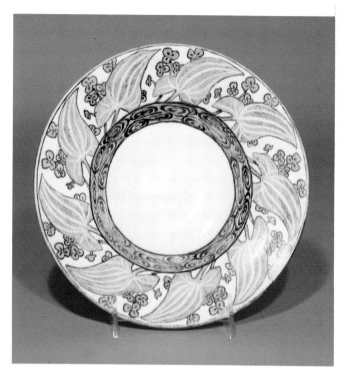

Plate in white clay body with underglaze motif of flowers and leaves in green and yellow; transparent glaze covers entire surface. Decorated by Margaret Shelby, thrown by Joseph Meyer. Bears marks of MHS, JM, NC, D76; 1895–1900; 9″ round. (Collection of Newcomb College)

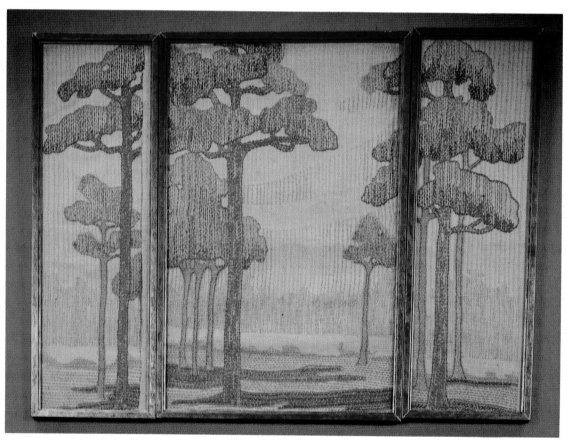

Three-section embroidered fire screen. The panels have southern pine tree motif embroidered in the darning stitch on handspun Russian crash. Needles are tones of green to brown, and trunks of trees are of exact brown color. Designed and executed by Beatrice de Grange about 1904; measures 23½″ x 22″. (Louisiana State Museum Collection)

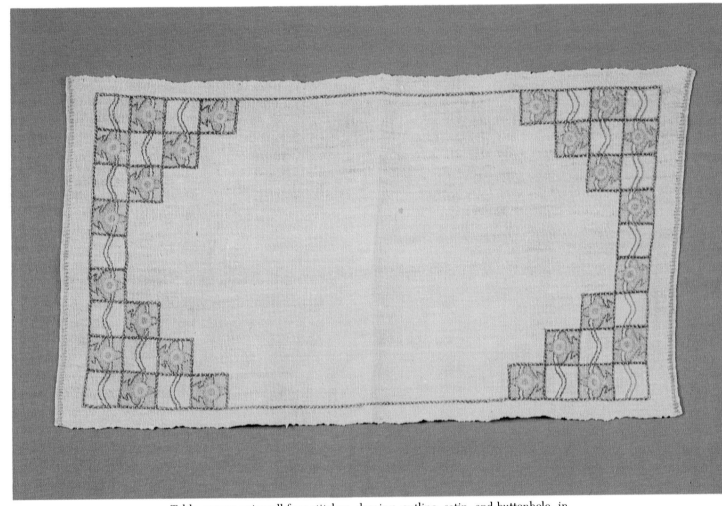

Table runner using all four stitches, darning, outline, satin, and buttonhole, in pastel tones of silk thread on handspun linen. Designed and executed by Gertrude Roberts Smith about 1905; measures 2'2" x 14". (Louisiana State Museum Collection)

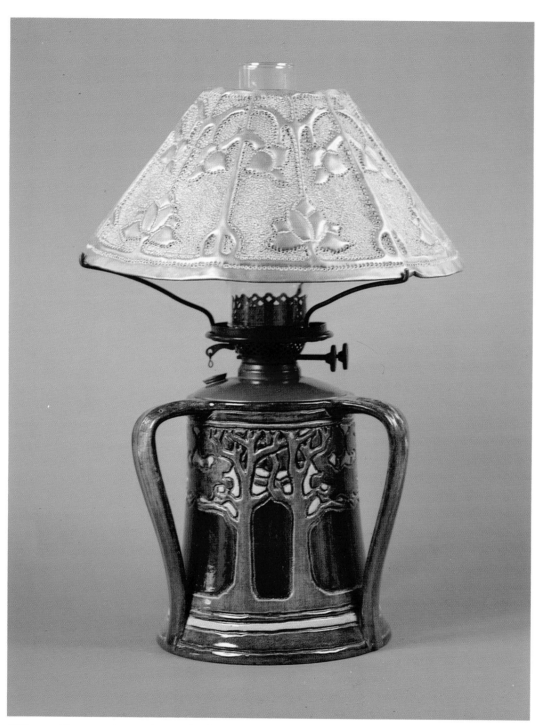

Oil lamp with pottery base and pierced and hammered brass shade. Base is in white clay body with dark blue, medium blue, and blue-green underglaze; has deeply incised lines filled with black underglaze, with transparent glossy glaze over entire surface of stylized tree motif. Shade has a flower motif. Base decorated by Henrietta Bailey, potter unknown, designer and maker of shade unknown. Bears marks of HB, NC, BA2; circa 1905; overall 18″ high x 17″ wide. (Louisiana State Museum Collection)

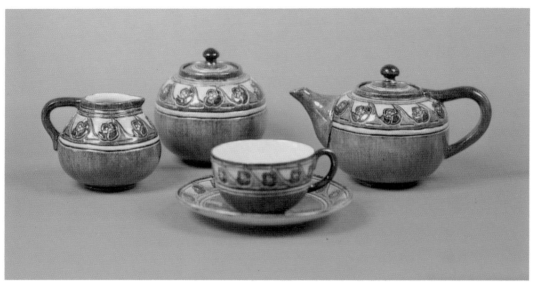

Tea set in blue and pale yellow underglaze with deeply incised design, grooves filled with black underglaze, and transparent glaze over decoration by Henrietta Bailey and Joseph F. Meyer. Bears marks of HB, JM, NC; circa 1904; teapot, 4½″; creamer, 3¼″; sugar, 4½″; teacup, 1¾″; saucer, 5½″. (Louisiana State Museum Collection)

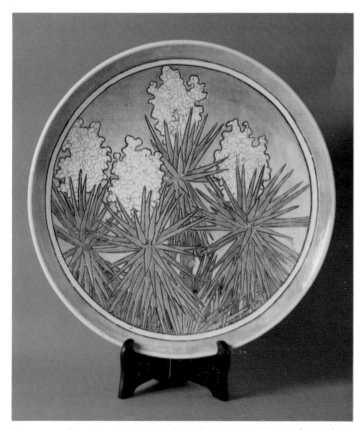

Large round tray in white clay body with yucca motif incised into clay. Blue-green underglazed and incised lines filled with dark blue underglaze. Transparent glaze covers surface. Decorated by Mary Sheerer, thrown by Joseph Meyer. Bears marks of MS, JM, NC, W (white clay), BS92; 1900–1905; 13″ round. (Private collection)

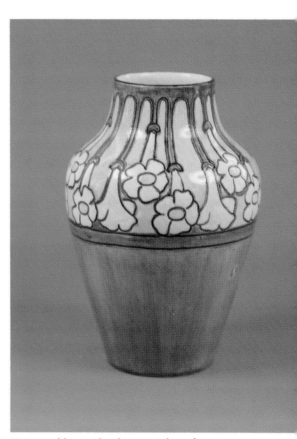

Trumpet lily motif on large jar-shaped vase. Deeply incised lines outline the flowers and stems and are glazed in dark blue underglaze; same color underglaze is repeated in lower portion of pot. Decorated by Medora Ross, wheel-thrown by Joseph Meyer. Bears marks of MRoss, JM, NC, YY22; 1900–1905; 10½″ tall. (Walther Collection)

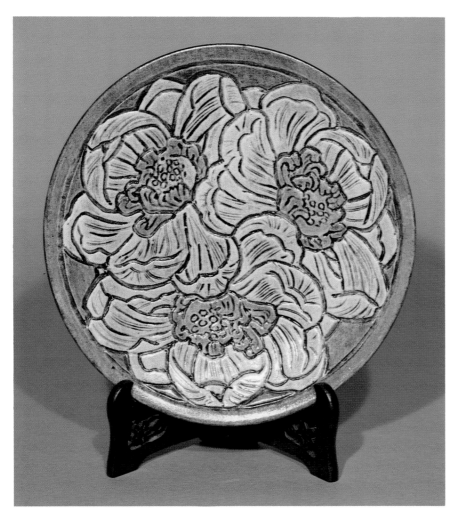

Magnolia motif incised into white clay and medium blue underglaze, with transparent glaze over surface. Decorated by Sabina E. Wells, thrown by Joseph Meyer. Bears marks of SEW, JM, NC, LL74; 1900–1905; 9″ round plate. (Collection of Sonia and Walter Bob)

Low bowl with stylized dragonfly motif on white clay body in blue and green, underglazed and deeply incised lines filled with black underglaze, high-gloss transparent glaze over the entire surface. Decorated by Mary Butler, thrown by Joseph Meyer, bearing marks of MWB, JM, NC, AK97; 1900–1905; 2″ tall x 6″ round. Mug with southern pine tree motif on white clay with blue and green underglaze, deeply incised lines filled with black underglaze, and high-gloss transparent glaze over entire surface. Decorated by Desiree Roman, thrown by Joseph Meyer, bearing marks of DR, JM, NC; 1900–1905; 4½″ tall. (Louisiana State Museum Collection)

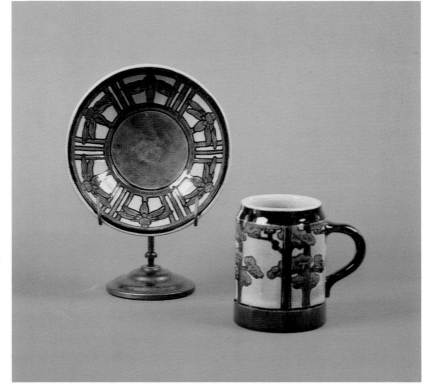

Open-mouth vase with tree motif on cream clay body, in pale blue and dark blue underglaze deeply incised lines filled with dark blue underglaze, and transparent high-gloss glaze over surface. Decorated by Maria L. Benson, thrown by Joseph Meyer, bearing marks of MLB, JM, NC, BT34; circa 1905; 6″ tall. Small covered jar on white clay body with flower motif around bottom of pot in medium blue underglaze, with deeply incised lines filled with dark blue underglaze, and high-gloss transparent glaze over entire surface. Decorated by Gladys Bartlett, thrown by Joseph Meyer, bearing marks of GB, JM, NC, BQ94; 1905–10; 4½″ high. (Louisiana State Museum Collection)

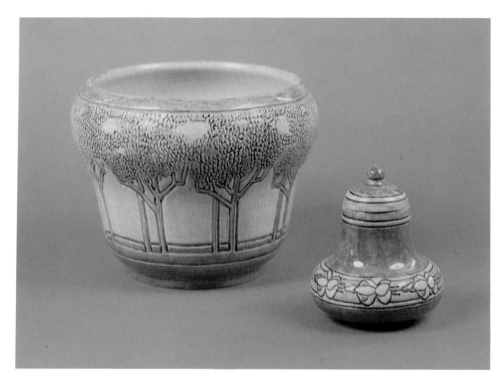

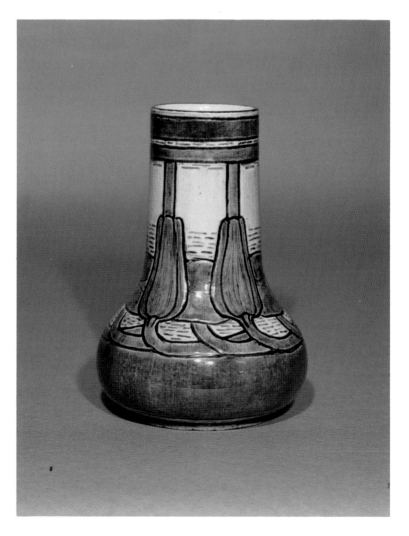

The decorator of this pot has been identified incorrectly since 1902 as N. W. Zulish. Has lotus motif incised in white clay body and is underglazed in blue and green with transparent glaze over surface. Decorated by Sabina E. Wells, potter unknown. Bears marks of SEWELLS, NC, ZZ71; circa 1900; 9½″ tall. (Collection of Newcomb College)

45

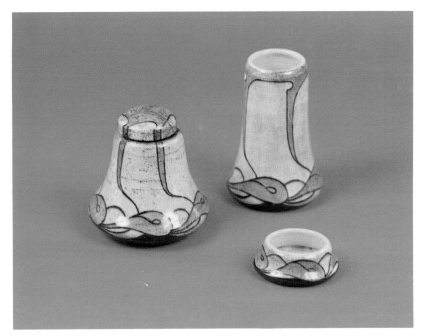

Inkwell set that won prize at the Louisiana Purchase Exposition in 1904. Underglaze motif in blue, green, and light medium blue on cream clay body, with shiny transparent glaze over entire surface. Decorated by Gertrude Roberts Smith, wheel-thrown by Joseph Meyer. Bears marks of GRS, JM, NC; 1903–1904; inkwell, 4½″ tall; quill stand, 4½″ tall; stamp holder, 2½″ tall. (Walther Collection)

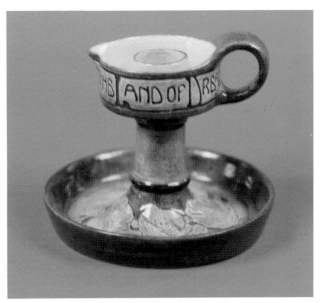

Candle holder decorated by Cynthia Littlejohn in blue, yellow, and black underglaze, with transparent glaze over decoration. Newcomb calligraphy inscription incised on upper rim. Bears marks of CL, JM, NC, CD98; dated Jan. 8, 1908; 4″ x 4⅝″. (Louisiana State Museum Collection)

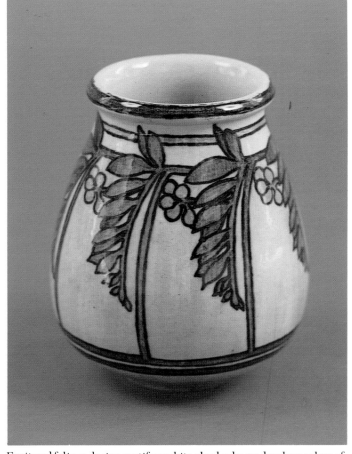

Fruit and foliage design motif on white clay body, underglaze colors of orange, blue-green, and dark blue, with shiny transparent glaze on entire surface. Decorated by Cecile Heller, wheel-thrown by Joseph Meyer. Bears marks of CH, JM, NC, DG6; circa 1909; 5″ tall. (Louisiana State Museum Collection)

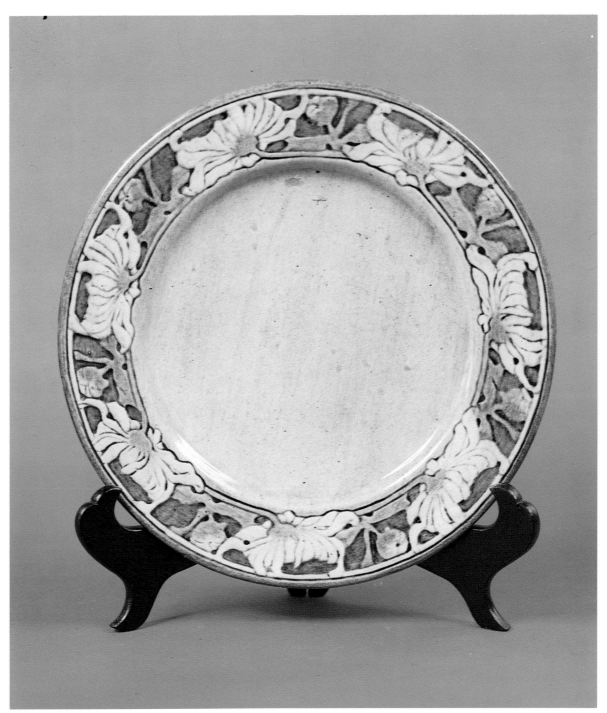

Plate with chrysanthemum motif and leaves in pale blue and medium blue underglaze, on white clay body with transparent glaze over entire piece. Decorated by Sadie Irvine, thrown by Joseph Meyer. Bears marks of SI, JM, NC, CS80; 1905–10; 9¼″ round. (Louisiana State Museum Collection)

The book that contains the Art School Alumnae records from 1890 to 1912. Each class designed and handpainted the pages. Bound and inscribed in hand-tooled letters in the Newcomb style; the corners are made of hammered brass that is pierced out. This book is a reminder of three of the important craft mediums all in one work. The pages shown are of the class of 1911. (Collection of Newcomb College)

Heart-shaped pen wipers in chamois leather; natural and brown leather form the pierced-out design. Designed and executed by Sadie Irvine about 1916; 3″ x 3¾″. Hand-tooled leather embroidery silks case and needle holder, designed and executed by Laura West in brown chamois and tied on fold with leather string. The Louisiana iris is a classic flower motif in all the crafts. Thread showing is original thread used by the embroiderer. Dated 1911; measures 9″ x 6″. (Louisiana State Museum Collection)

Bookbinding designed and executed by Amelie Chalaron in 1931. (Private collection)

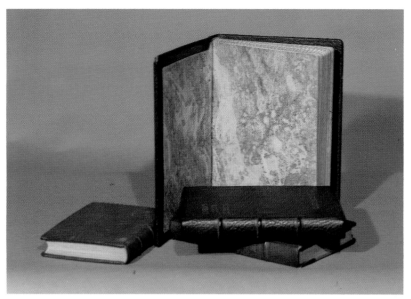

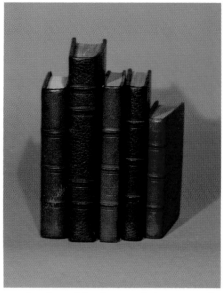

Bookbinding and inside paper showing. Designed and executed by Amelie Chalaron in 1931. (Private collection)

Leather-bound books in red, brown, and black morocco leather. Designed and executed by Mireille LeBreton, 1930–40. (Collection of Mrs. Lloyd J. Cobb)

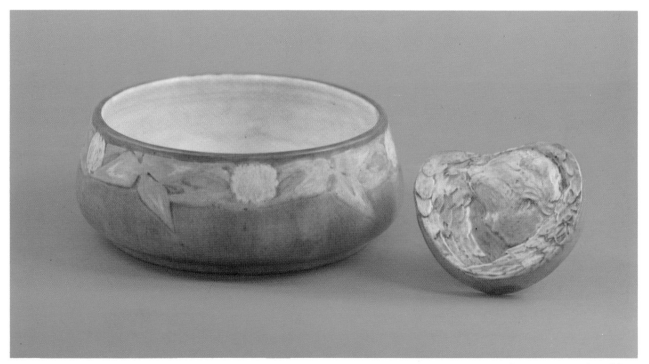

Low bowl in cream clay body and low modeled relief of white double carnation and green foliage around top rim on medium blue background of matt glaze. Decorated by May Morel, wheel-thrown by Joseph Meyer; bears marks of MM, JM, NC, DY7; 1910–18; 3½″ tall x 8″ round. Heart-shaped paperweight with angel and wings, in white clay body and pale to medium blue matt glaze. Handbuilt and decorated in low relief by Sadie Irvine; bears marks of SI, NC, EA6; 1910–18; 3″ x 3¾″. (Louisiana State Museum Collection)

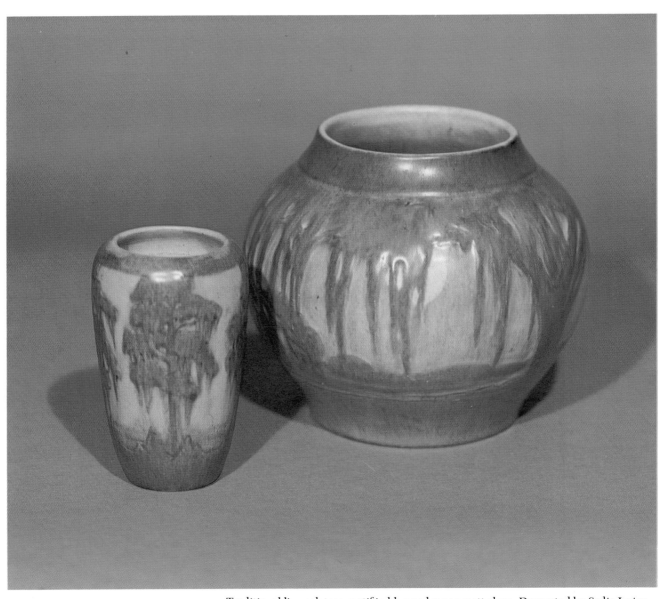

Traditional live oak tree motif in blue and green matt glaze. Decorated by Sadie Irvine, thrown by Jonathan Hunt; bears marks of SI, JH, NC, SX62; 1931; 6″ tall. Small vase with cypress tree motif in blue-green matt glaze. Decorator unknown, thrown by Joseph Meyer; bears marks of JM, NC, HE41; about 1912; 4½″ tall. (Collection of Dr. and Mrs. R. Wynn Irvine)

Handmade tile by Sadie Irvine decorated with calligraphy of Newcomb College and bearing the NC seal in classic blue matt glaze. Bears marks of SI and NC on back of tile; 1910–18; 8¾″ x 5″. (Louisiana State Museum Collection)

Square handbuilt container with oak tree motif in blue and blue-green matt glaze on cream body; inside pot is incised iris motif. Made and decorated by Anna Frances Simpson. Bears marks of AFS, NC, EF45; 1910–18; 5″ tall x 5¼″ square. (Louisiana State Museum Collection)

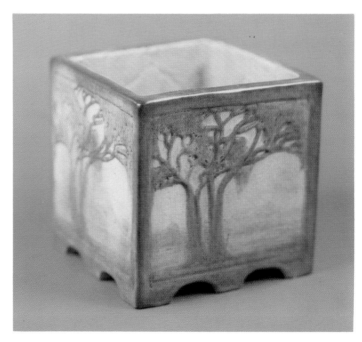

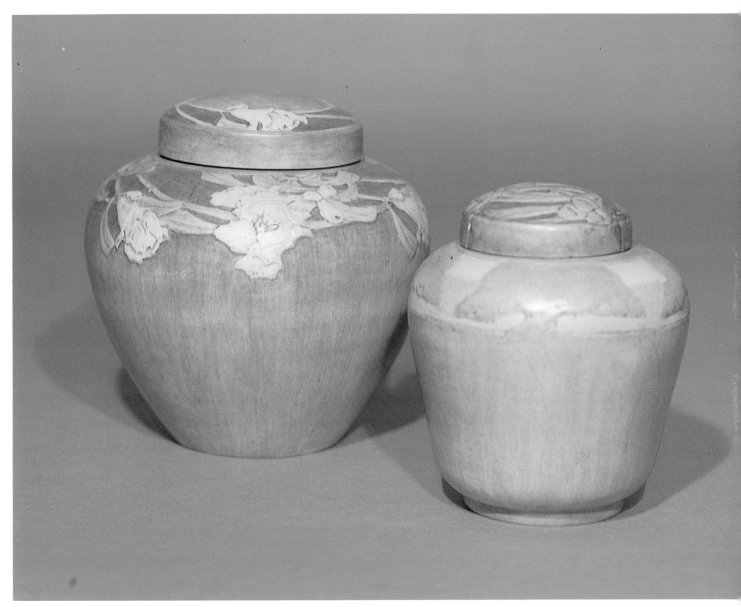

Covered jar with white wild rose motif on top cover and around top of jar in medium blue and green matt glaze. Decorated by Henrietta Bailey, thrown by Joseph Meyer; bears marks of HB, JM, NC, JG91; 1910–18; 7″ tall. Covered jar with oak tree motif in yellow-green and blue matt glaze. Decorated by May Morel, thrown by Joseph Meyer; bears marks of MM, JM, NC, GA54; 1910–18; 5½″ tall. (Collection of Newcomb College)

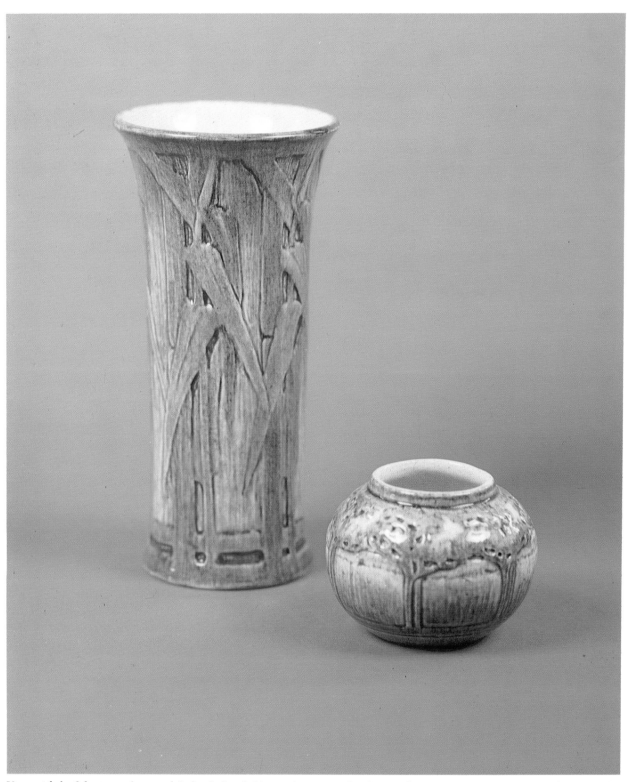

Vase with leaf design in low modeled relief with blue and green underglaze and transparent glaze. Decorated by Maude Robinson, thrown by Joseph Meyer; bears marks of MRobinson, JM, NC, BU69; circa 1910; 8″ tall. Small open-mouthed jar with oak tree low modeled relief motif in blue and green underglaze with transparent glaze over white body. Decorated by Maude Robinson, thrown by Joseph Meyer; bears marks of MRobinson, JM, NC, BT62; circa 1910; 3″ tall. (Louisiana State Museum Collection)

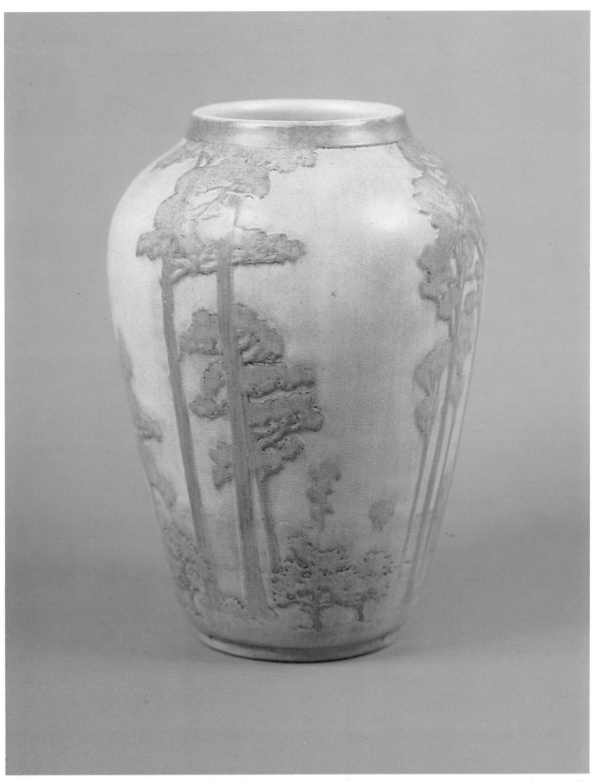

Classic shape vase with southern pine tree motif in blue, white, and blue-green matt glaze on cream body. Decorated by Sadie Irvine, wheel-thrown by Joseph Meyer. Bears marks of SI, JM, NC, IM51; circa 1920; 10″ tall. (Louisiana State Museum Collection)

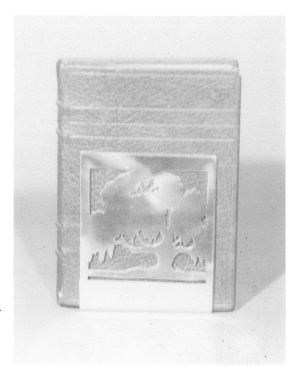

Copper bookends in oak tree motif cut out of metal. Designed and executed by Myrtle Pujol; 1918–22. (Collection of Mrs. Louis A. Dupuy)

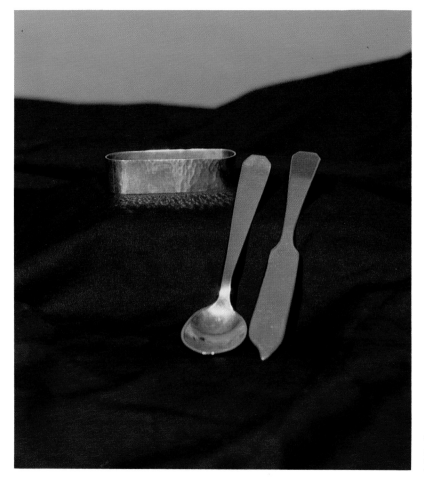

Sterling silver flatware and sterling silver napkin ring designed and executed by Calista Morgan; 1919. (Collection of Mrs. Joseph M. Rault)

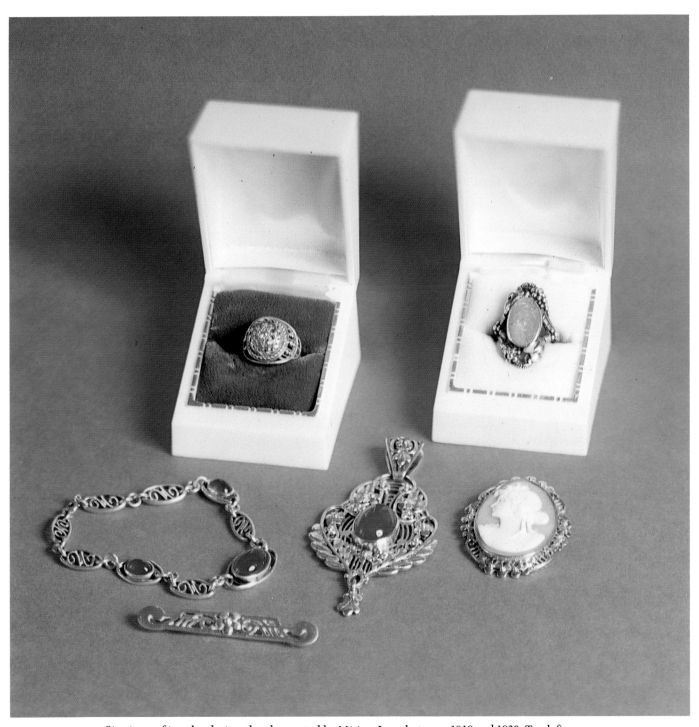

Six pieces of jewelry designed and executed by Miriam Levy between 1919 and 1926. Top left: gold ring with rose diamonds. Top right: silver ring with grape motif surrounding black opal. Bottom, left to right: silver bracelet set with chrysoprase stones; silver brooch in rose motif; pendant in sterling silver set with chalcedony stone; gold setting for cameo brooch. (Private collection)

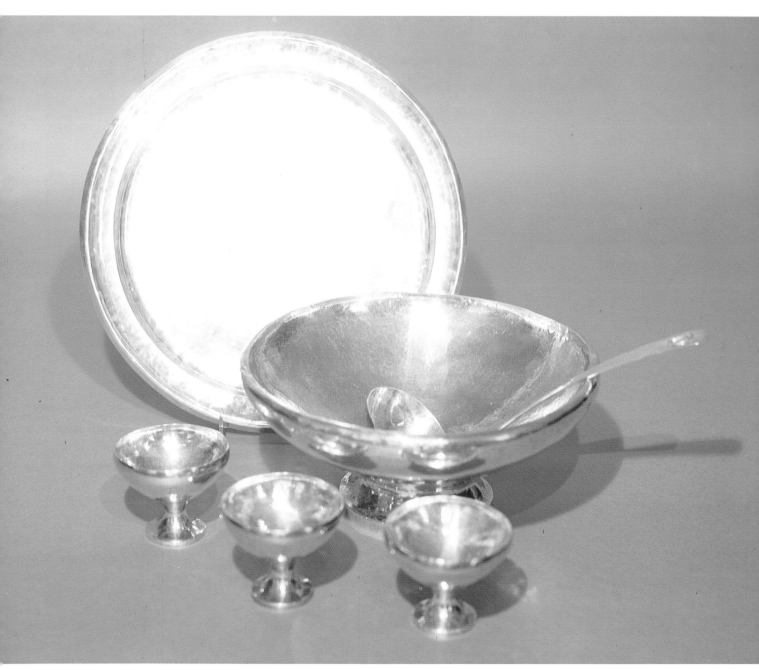

Sterling silver punch set, the silver fabricated by hand and hammered to make a textured surface. Bowl, 5″ tall x 11½″ wide; ladle, 3½″ x 11″ long; tray, 14″ round; 6 cups, 3″ tall. Made in the art school and given to Dr. B. V. B. Dixon, president of Newcomb College. Date believed to be about 1919. (Collection of Newcomb College)

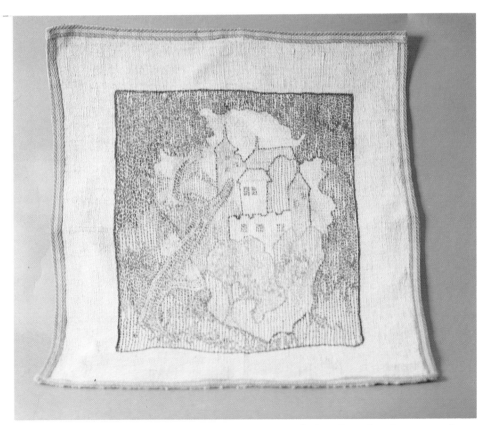

Imaginary castle motif for embroidery on linen crash, silk thread used in darning stitch.
Designed and executed by Maude Parsons while a student of Gertrude Roberts Smith, about
1928. (Private collection)

Linen crash tray sack em-
broidered in darning stitch with
initials BVBD for Dr. Brandt
V. B. Dixon, for silver tray
about 1919. (Collection
of Newcomb College)

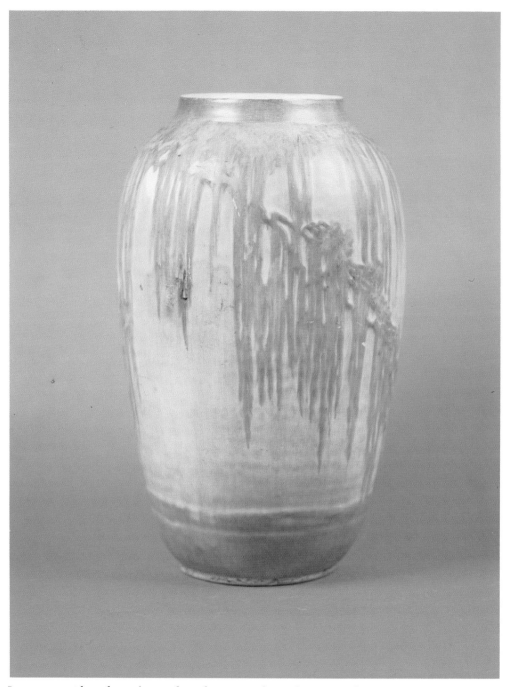

Large vase with traditional moss-draped Louisiana live oak tree motif in blue matt glaze on cream body. Decorated by Sadie Irvine, thrown by Jonathan Hunt. Bears marks of SI, JH, NC, TK63; 1930–34; 14¼″ x 9″. (Louisiana State Museum Collection)

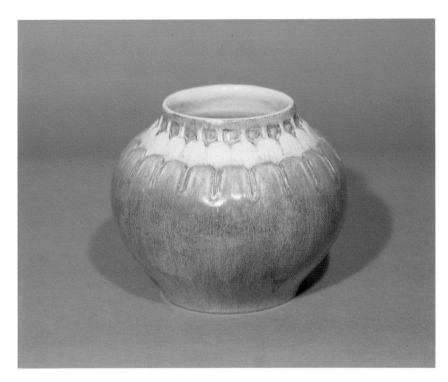

Jar-shaped vase of transitional period, underglazed in light blue and turquoise on white clay body, with transparent shiny glaze. Decorated by Sadie Irvine, thrown by Jonathan Hunt. Bears marks of SI, JH, NC, TB54; 1934; 8½″ x 7″. (Collection of Dr. and Mrs. R. Wynn Irvine)

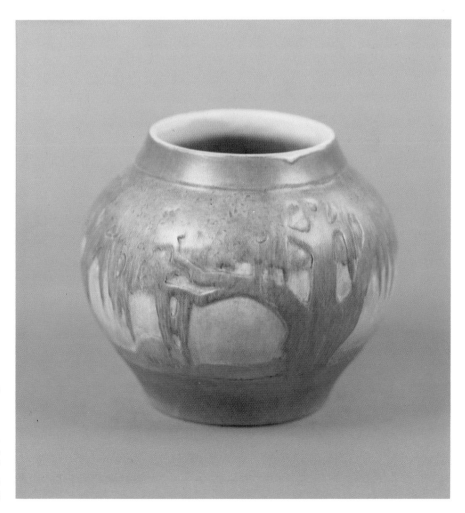

Small jar shape with classic moss-draped live oak tree motif in dark blue and green matt glaze on cream body. Decorated by Sadie Irvine, thrown by Jonathan Hunt. Bears marks of SI, JH, NC, RG35; 1930; 5½″ x 6½″. (Louisiana State Museum Collection)

Christmas card of Saint Louis Cathedral on Jackson Square in New Orleans, designed and executed by Ruth Bultmann (lettering) and Sadie Irvine (art rendering). Beside the finished card is the zinc plate used in the printing. Each card was then handpainted by the two artists; 1930–35. (Louisiana State Museum Collection)

Three Christmas cards designed and executed by Sadie Irvine and Ruth Bultmann. Watercolor detail was added by the artists after cards were printed; 1930–35. (Louisiana State Museum Collection)

Buttons made by Sadie Irvine and Kenneth Smith from a mold. Hand-painted underglaze in white clay body; 1940–44. (Louisiana State Museum Collection)

Lamp base with circles incised around tall hand-thrown cylinder; the glaze is rain. Decorated by Sadie Irvine, thrown by Kenneth Smith. Bears marks of SI, KS, NC; 1935–40; 14″ x 6″. (Collection of Dr. and Mrs. R. Wynn Irvine)

Mugs and pitcher set decorated with goldfish motif in blue, black, and gold underglaze on cream clay body with transparent glaze over clay body and handles glazed in pale green. Decorated by Sadie Irvine, thrown by Kenneth Smith. Bear marks of SI, KS, NC; 1940–44; mugs, 3¼″ x 4½″; pitcher, 9″ x 7″. (Collection of Dr. and Mrs. R. Wynn Irvine)

Two bowls thrown and glazed by Francis Ford in gulf stream glaze. Bear marks of F, NC; Newcomb Guild label still intact; 1944–48. Left piece is 3½″ x 8″; right piece is 3″ x 7½″. (Louisiana State Museum Collection)

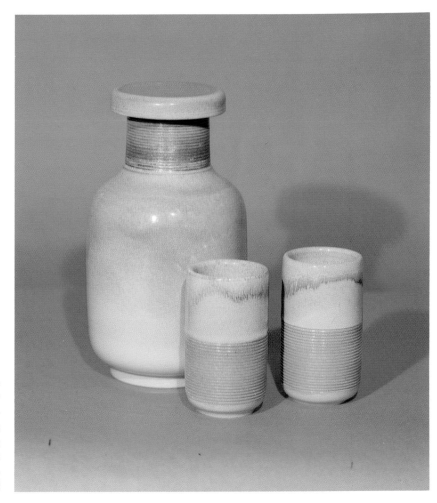

Beverage tumblers and matching jug with cover on red clay body in lichen glaze. Wheelthrown and glazed by Francis Ford. Bear marks of F, NC; 1944–48; tumblers, 4⅞″ x 2¾″; jug, 9″ x 5½″. (Collection of Dr. and Mrs. R. Wynn Irvine)

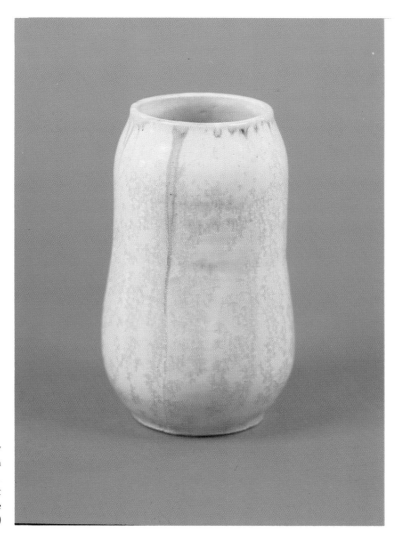

Rare piece of porcelain thrown by Kenneth Smith and glazed in creamy white crystalline glaze. Bears marks of KS, NC; about 1940; 6½″ x 4″. (Louisiana State Museum Collection)

Fountain designed and executed by Sadie Irvine. Snail is made of stoneware and a shiny aqua-color glaze. Water recirculates through horns on top of head. This clay piece was done in the late 1940s. (Collection of Dr. and Mrs. R. Wynn Irvine)

# 4

# THE NEWCOMB GUILD

The last decade of the nineteenth century saw a renaissance in handcrafts about the world, as Art Nouveau became an outcry against the Western World's mechanical industrialization. Craftsmen were experimenting with new materials, thus fashioning completely new art objects. Louis Comfort Tiffany was making his stained glassware, using a medieval art form with a fresh approach. Louis Sullivan was designing new facades for buildings with the aid of a young man named Frank Lloyd Wright. The Newcomb crafts movement was also emerging at this time to parallel the artistic reawakening in other parts of the country.

The people most closely involved, Mrs. Newcomb, Dr. Dixon, and the Woodward brothers, were the catalytic force behind the Newcomb movement. It was natural that the Woodward brothers, both educated at the Rhode Island School of Design, would follow along with the other greats in the arts and crafts movement. Dr. Dixon and Mrs. Newcomb, to their credit, saw the wisdom in what the Woodwards wanted to teach and accomplish. New Orleans women had been primed and dazzled by the suffrage movement and the Cotton Centennial. All these forces were there to merge and blend. The time was right.

But the Newcomb movement was different. Unlike other crafts movements, Newcomb crafts were housed inside the academic walls of a college. Not just another college, but America's first woman's coordinate college; others were to follow—Barnard of Columbia and Radcliffe of Harvard—but Mrs. Newcomb's memorial to her daughter was the first. Rookwood Pottery was a factory for a profit-making company, as was Tiffany Glass Company. Only Newcomb College initiated the concept of producing and marketing its own crafts through the education of its present and future workers and decorators. This concept was both its strength in the beginning and the cause of its demise. The leadership of the movement, unlike that of a profit-making corporation, lay in

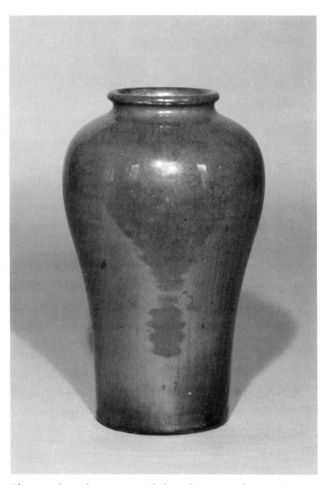

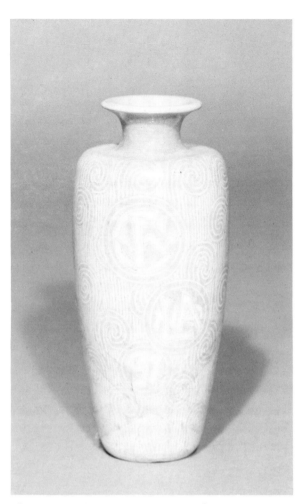

Chinese-shaped vase in sang de boeuf copper reduction glaze on cream body with a low relief design. Decorated by Harriet Joor, thrown by Joseph Meyer. Bears marks of HJ, JM, NC, MHH; 1895–1900; 9½″ tall. (Collection of Newcomb College)

Close-mouthed Chinese-type vase with swirled design motifs carved into a white clay body; the high parts are underglazed in pale celedon green and covered with a transparent glaze. The initials JLN as part of the design are of Josephine L. Newcomb (the founder). Decorator unknown, thrown by Joseph Meyer. Bears marks of JM, NC; about 1895–97; 7″ tall. (Collection of Newcomb College)

the hands of the art faculty and the board of directors of a university. It is doubtful if such an arrangement could persist in today's world of complete individualism in the arts and crafts. Persist it did, though, for almost fifty years at Newcomb College.

There are some misconceptions about the movement. Although the pottery became the most famous, other craft products of equal artistic importance were made. The embroidery received wide attention, along with the brasswork, jewelry, and bookbinding. The only reason these crafts were not as well known is that their quantity was limited. The Newcomb pottery was a production-line item. A potter threw and trimmed the pots, a decorator put the motifs on the ware, and a kiln master fired all the kilns; the marks on the bottom of each piece bear the signatures. However, the embroidery, brasswork, jewelry, and bookbinding were the work of one craftsman from start to finish.

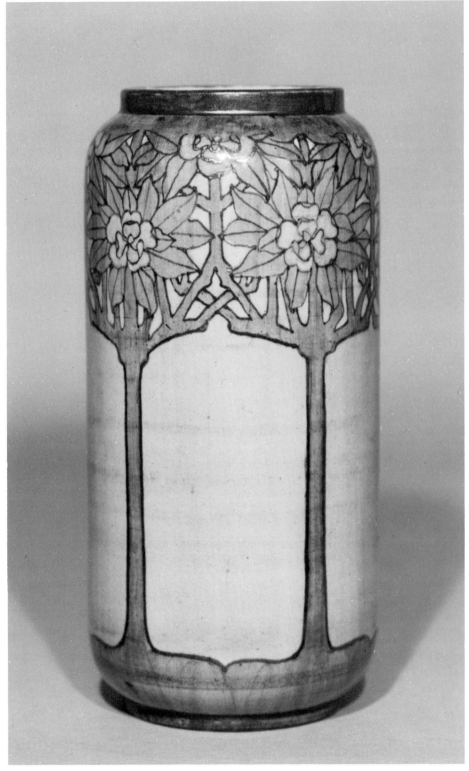

Tall vase decorated in stylized semidouble poinsettia flower motif in shades and tones of blue underglaze on white clay body with entire surface glazed in transparent shiny glaze. Decorated by Mary W. Butler, thrown by Joseph Meyer. Bears marks of MWB, JM, NC, Q, 12; 1895–1900; 12″ tall. (Collection of Newcomb College)

This unique style evolved within the general framework of Art Nouveau, so popular in 1900. The designs were based on southern trees and flowers, each carefully applied in uneven numbers of 1–3–5–7–9, and so on. No matter what the medium, the Newcomb work had a recognizable stamp. The live oak tree, the symbol of Newcomb College, became the most popular motif. The oak tree with the moon rising within its branches, covered with moss, was produced thousands of times on all sizes and shapes of pottery. Other plant material was used also, mostly palms, mock orange, roses, Louisiana iris, lotus, loquat, and pine trees and cones, which grew on the Washington Avenue campus. It was easy to gather a portfolio of designs because there is hardly a time in New

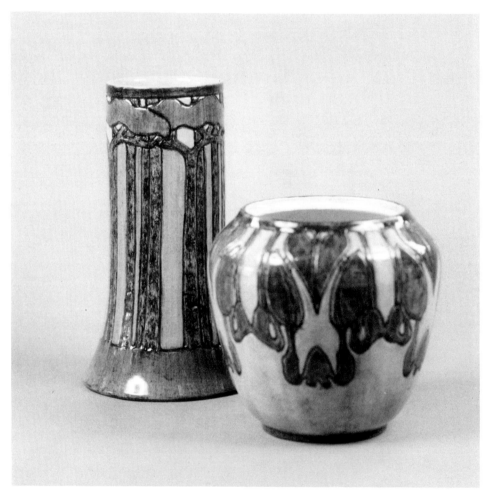

Tall cylindrical vase with pine tree motif done on white clay body with blue and green underglaze, incised with heavy lines filled with black underglaze; transparent gloss glaze over underglaze. Decorated by Roberta B. Kennon and thrown by Joseph Meyer, with marks of RBK, JM, NC, AQ45; 1900–1905; 9½″ tall. Open-mouthed jar with stylized flower motif on cream clay body, blue and black underglaze, with high-gloss transparent glaze over underglaze. Decorated by Roberta B. Kennon, thrown by Joseph Meyer, bearing marks of RBK, JM, NC, PPL; 1895–1900; 6½″ tall. (Louisiana State Museum Collection)

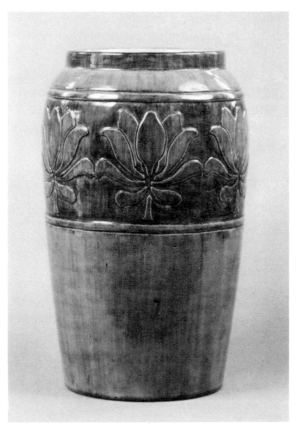

Lotus motif on white clay, large vase has blue-green and dark blue underglaze with deeply incised lines filled with black underglaze. Entire surface is covered with shiny transparent glaze. Decorated by May Dunn, thrown by Joseph Meyer. Bears marks of MD, JM, NC, N84; 1895–1900; 15″ tall. (Louisiana State Museum Collection)

Orleans when something isn't blooming. In the summers, when most of the population of New Orleans fled to the mountains to escape yellow fever, or in later years the heat and rain, the decorators would get designs from the plants viewed while away.

The women who became the famous decorators were of the gentry of New Orleans. They were free to attend college and work at the Newcomb Guild after graduation because their services at home were not needed. Servant help was plentiful in the South, and housework was not considered a ladylike chore. If a woman did not marry and raise children, there was little for her to do at home except read, tea party, or play a musical instrument. The Woodward brothers felt that these women could make an artistic contribution to the community.

## 1900–1906

The winning of the Paris Exposition medal in November, 1900, made Mrs. Newcomb and Dr. Dixon believe that the crafts were indeed a promising area for the college to develop. Plans were made at once to build and equip a building for the crafts and to form a guild to market the wares produced. A structure was needed that could house all the crafts and equipment, plus provide showroom space and offices for faculty. Mrs. Newcomb promised the necessary money, but she was in New York for the winter and did not plan to return to New Orleans until Mardi Gras week in February. Dr. Dixon and Ellsworth Woodward had decided that the vacant lot just across the street from the campus on Camp Street would be a suitable location for the building. Although Mrs. Newcomb had agreed to furnish $35,000 for the project, the Tulane board hadn't agreed to its advisability. Mrs. Newcomb would not live to see the building, as she died on Easter Sunday of 1901 in New York City, but her death did not hinder Dr. Dixon and Ellsworth Woodward. In a letter to the Tulane board dated May 11, 1901, Dr. Dixon wrote: "We have succeeded in making a ware which now commands the interest and attention of the whole country. The Tiffany Glass Company of New York has asked us to place an exhibit in the Pan-American Exposition, in the central court of the Liberal Arts Building, in connection with their own work, and that of the Rookwood and Gruby Potteries. The Arts Club of New York has made the same request, and this we have accepted."

In the same letter, Dr. Dixon asked for funds to build a separate building just to house the crafts projects. He asked for $30,000 for the structure, lot, and equipment, and $5,000 for advance payments to craftsmen. Dr. Dixon had a trust fund of $300,000 that Mrs. Newcomb had entrusted to him secretly, and at her death he had turned over the monies in the fund to the Board of Tulane University. Now he had to appeal to the board to let him go forward with this venture. The Tulane board was not oriented toward culture, and it took a good deal of persuasion on his part to convince its members of the wisdom of this new idea.

Dr. Dixon asked Ellsworth Woodward to design a structure that could house the crafts venture and serve as the headquarters for the newly formed Newcomb Guild, which was organized to market and produce all the crafts of the Newcomb style. Ellsworth and William Woodward had fallen in love with the architecture of the French Quarter, where both men had spent long hours doing paintings and drawings of the entire area. They both liked the proportions of the Cabildo, Presbytere, and Madame John's Legacy. The design for the Newcomb Guild building combined various features of these three landmarks. The still-standing building has a two-story stucco and wood facade with fan-shaped windows of the Spanish colonial, eighteenth-century New Orleans era. On the first floor were a showroom and workspace. The second floor

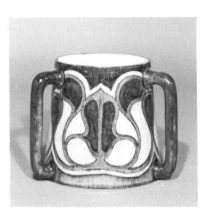

Three-handled mug in white clay body with stylized flower motif of blue-green and royal blue underglaze and transparent shiny glaze on the entire surface. Decorator and potter unknown. Bears marks of NC, LAG, C85; 1895–1900; 6¼″ tall. (Collection of Newcomb College)

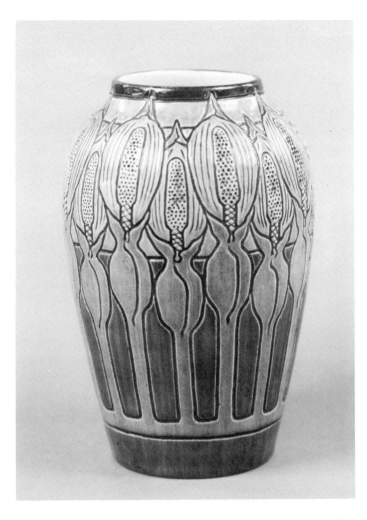

Vase in caladium motif on white clay
body with dark and medium blue un-
derglaze, deeply incised lines filled
with black underglaze, and shiny
transparent overglaze. Decorated by
Esther Huger Elliott, thrown by
Joseph Meyer. Bears marks of EHE,
JM, NC, QQ100; 1895–1900; 9″ tall.
(Louisiana State Museum Collection)

housed classrooms and workspace for whatever craft was being taught and
produced. The pottery operation would require the most space for maximum
production, and Ellsworth Woodward allotted the necessary room for this.
Joseph Meyer and Miss Sheerer were instructed to draw up a set of specifica-
tions taking future needs into account. The lessons learned in the basement–
boiler room of the Burnside building served as guidelines for this expansion.

Two new kilns were designed and built in the rear yard of 2828 Camp Street.
Each kiln had two fireboxes, and the exterior of each was encased in steel plate.
The roof was a flat arch, and the door openings were bricked up for each firing.
One kiln was used for bisque firing only, and the other for glazed ware. Placed
close to the kilns was a thousand-gallon storage tank for oil. The oil was forced
into the kiln burners by pressure from a small blower that injected it into a
central burner. Notes reveal that about eight pounds of pressure had to be
maintained in the burners. The oil was a good firing fuel, and the amount of
reduction in the atmosphere could be easily controlled. Records of 1904 show
that to fire two kilns with about 120 pieces in each kiln (one bisque run and one
gloss run) required about 150 gallons of oil, which cost Newcomb College 6.5 to

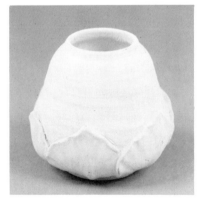

Unglazed wheel-thrown bisque
fired pot by Joseph Meyer. Bears his
mark of JM only; 4″ tall. (Walther Col-
lection)

7.5 cents per gallon. Notes on these firings reveal about fourteen hours' average time to reach Cone 4 (1,200 degrees C.) for the gloss firings.

These two kilns were used by the Newcomb Guild from 1902 to 1918. Both kilns were dismantled when the college moved to the present campus on Broadway. Some of the most beautiful and creative pottery came from these kilns—the pottery that won the major medals at the expositions held both in the United States and abroad. Both kilns were simple in design and construction but were excellent for firing ware. Ellsworth Woodward's notes tell of the

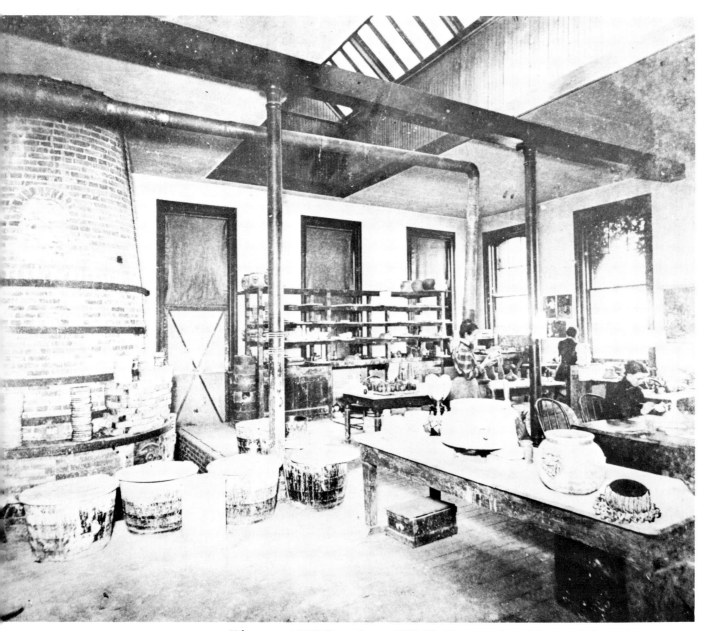

Kiln room at 2828 Camp Street, 1902–18. (Louisiana State Museum Collection)

74

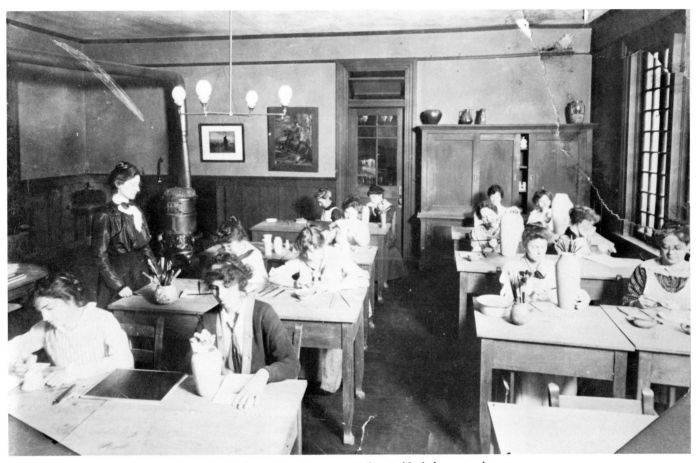

Pottery class held at 2828 Camp Street about 1914. Henrietta Bailey, in black dress standing at left; Sadie Irvine, third table from front left row; Gertrude Roberts Smith, extreme right front table. (R. J. Vial Collection)

excitement from the faculty, workers, and students when glazed ware was drawn from the kiln. He expressed it as being like Christmas morning for those involved in the craft. The pottery pieces produced in these kilns speak for themselves in excellence.

About this time George Ohr left Newcomb College, because Dr. Dixon and Ellsworth Woodward thought that his attitude toward the young women was not wholesome. Dr. Dixon felt that he wasn't the person to have with young unmarried women under close working conditions. He returned to Biloxi, Mississippi, where he opened his own pottery business.

The building was finished in the fall of 1902. Once in the new quarters, the art department became the Newcomb Art School, and the Newcomb Guild was organized to provide a sales outlet for the women of Newcomb College. In order to maintain strict quality control, Ellsworth Woodward and Miss Sheerer remained the sole judges of what might be displayed and sold. A staff was hired

and a salesroom was equipped on the first floor of the new building. The guild hired a full-time manager for the showroom, and the crafts were displayed for the first time to their best advantage. The craftsmen received 50 percent of the sale price of each item they produced, and the remaining 50 percent was returned to the Newcomb Art School.

Regular showings of new work were held, and buyers for fine stores around the United States and other countries visited the art school for the purpose of acquiring Newcomb crafts for resale. The popularity of the crafts was growing, and the Newcomb Guild exhibited at all major expositions and major museums. The awards came thick and fast. Soon Newcomb Guild crafts were represented in the collections of museums in Boston, New York, and Philadelphia.

Mr. Meyer and Miss Sheerer were the main faculty members of the pottery, and the craftsmen were all trained at the college's art school, completing a course of study and receiving either a diploma or a degree in design before entering the guild. This requirement was strictly adhered to by Miss Sheerer for full-time decorators. The misconception that most of the work was done by students still lingers today. The fact is that most of the best work was done by graduates who stayed on to become full-time professional decorators, receiving a small salary and commission from the guild. This was the dream of Dr. Dixon, Mrs. Newcomb, and Ellsworth Woodward inspired by Julia Ward Howe at the Cotton Centennial of 1884–85.

If this noble experiment was to succeed in New Orleans in those first years of the twentieth century, fees for a course of study had to be reasonable. Parents of a would-be student had to be sold on the value of spending money on an art education for their daughter. This was a time in New Orleans when people worked for a dollar a day, and many felt they were being adequately compensated. It was apparent to both Dr. Dixon and Ellsworth Woodward that they must keep the tuition as low as possible, and the catalog for the 1904–5 session lists the tuition as

$15.00 per term (12 weeks)
$45.00 per session year (36 weeks)
$ 5.00 registration fee
$ 2.00 studio fee
$  .50 locker fee

This tuition seems small when an article written in 1901 in *Harlequin* stated that over two thousand dollars in monies was turned over to the craftsmen from the profits of the guild. The article stated that a clever craftsman could earn forty or fifty dollars a month. At this wage, the women in the guild were doing better financially than other people in the community.

The decisions made during this period provided a sound foundation for the crafts produced at the Newcomb Art School, which would later become the

Crafts of the Newcomb Style. By employing native flowers and trees as the design motif and showing sound judgment in the criteria of good crafts, Miss Sheerer and Ellsworth Woodward created a workable crafts industry. If a work did not meet their standards of quality, it was either destroyed or the *Ⓝ* removed, or, in the case of pottery, the seal was ground out. Many of these inferior pots remain in collectors' hands, but they are not as valuable as those that bear the famous *Ⓝ* . The *Ⓝ* assures that the craft was subjected to a rigid judgment. The smallest flaw would render the piece not worthy of the seal, which many a craftsman found a heartbreaking rejection. It is felt that the critical eye of Miss Sheerer may have insured the quality that enabled Newcomb to win so many prizes and medals.

It was in this period that most of the famous decorators and craftsmen entered Newcomb. Women like Henrietta Bailey, Anna Frances Simpson, Sadie A. E. Irvine, Cynthia Littlejohn, Amelie Roman, and Marie de Hoa LeBlanc were trained in the art school in this era.

Of these, Sadie A. E. Irvine became the most famous. She arrived at Newcomb Art School for the 1903–4 session, and remained at Newcomb College until her retirement in 1952. This frail and talented girl, sixteen when she entered Newcomb, produced the finest pottery in the Newcomb style. Although she did not win as many medals as her fellow decorators, she originated most of the famous motifs seen on the pottery. No one knows how many pots Sadie Irvine decorated in her tenure at the art school, but a good guess would place the number well above five thousand. This number is arrived at by multiplying forty-nine years of work by a hundred pots a year in output. She worked beautifully and quickly and could divide a piece of ware into five sections with the naked eye. People who watched her work say that when the measurements were taken by a divider, her sections were within a hairline of being perfect. Sadie Irvine was credited with the famous motif of moss-draped live oak trees with the moon peeking through. This design became a standard for the pottery. She herself said in a letter that she grew weary of producing this motif over and over again. The popularity of this design made advance orders to the guild almost impossible to supply. Many people, when they think of Newcomb pottery, think at once of the live oak done in watery blue matt glaze as the only true art style. Nothing could be further from the truth, for many other motifs are of equal, if not better, form. But Miss Irvine's oak tree motifs have become the classic Newcomb style.

The art school must have been a wonderful place to work. Sources reveal that the members of the group considered themselves one big happy family and enjoyed themselves to the point where work indeed became pleasure. This happiness, in addition to the leadership of Ellsworth Woodward, was an important factor in the financial success of the guild. One writer said that the hours would slip away and the day would end all too soon. Mr. and Mrs.

Ellsworth Woodward had no children, and many of the young women were treated like their adopted daughters. They exchanged letters while on vacation, and during the school year they took tea and meals with them at their home down Camp Street, one block from the guild building. Ellsworth Woodward's kindness was repaid by the complete loyalty of his faculty, students, and craftsmen. There has never been a person at Newcomb College who was more revered.

The textile class started in the fall of 1902 in the new building at 2828 Camp Street. The addition of this craft to the curriculum had long been considered by

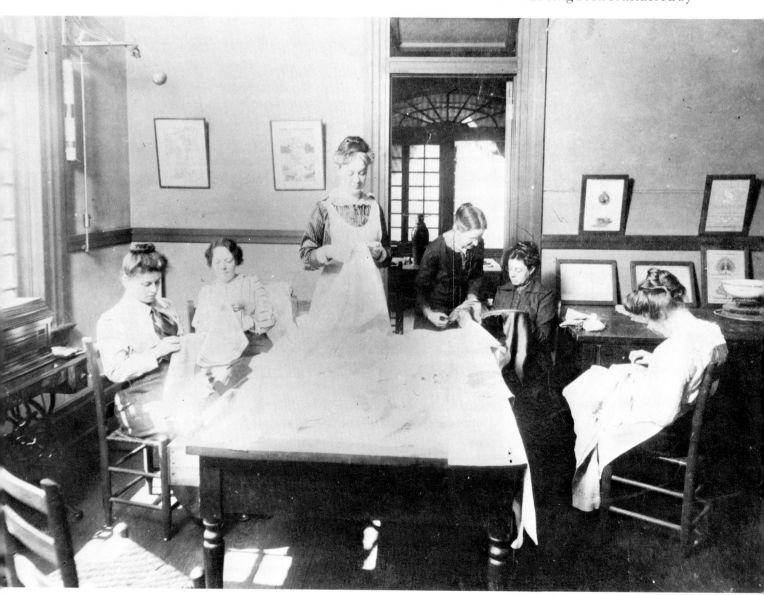

Embroidery class at 2828 Camp Street. Gertrude Roberts Smith, standing with apron, was instructor of embroidery. In right foreground, seated, is Anna Frances Simpson. (R. J. Vial Collection)

Table runner in handspun and woven linen crash made by the weavers and spinners of the guild. Embroidery in black and blue silk thread. The design motif of flowers and leaves is in the buttonhole stitch. The craftsman is unknown, but this type of work was done between 1902 and 1910; 3′ x 16″. (Louisiana State Museum Collection)

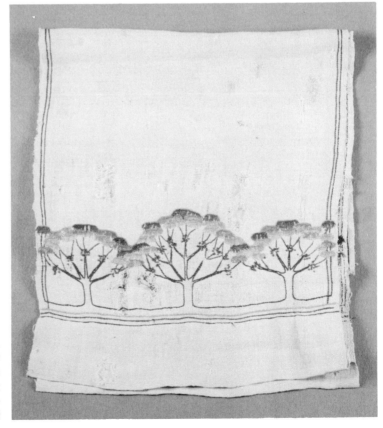

Dora Janfroid Miller designed and executed the embroidered table runner. Tree motif in silk thread of rust and yellow, worked on handspun and woven linen crash. The stitches used are darning and outline. Piece has initials of DJ in lower corner; 5′ x 16″. (Louisiana State Museum Collection)

Ellsworth Woodward and Mrs. Gertrude Roberts Smith. Mrs. Smith had been on the faculty since the beginning of the college but had always taught drawing and painting. Both believed that needlecraft was peculiarly a woman's craft and should be included. (It might be noted here that today a great many men do creative needlecraft.) The pottery had great competition from male decorators everywhere, but in needlecraft women reigned supreme. Since most women already possessed the basic skills, Ellsworth Woodward felt that artistic training and a grounding in design fundamentals were all that was needed to turn a skill into a true art form, incorporating the established design motifs in the embroidery.

From a practical standpoint, an art industry in textile work had one advantage over an industry in pottery. Upon leaving Newcomb College, a graduate could pursue a career in needlecraft without the expensive equipment that pottery demands. From the very beginning it was determined that the materials used would be the simplest and most permanent to be found. The finished work would depend on the freshness and loveliness of the design, on color, and on good needle technique.

So with a small group of students on an early fall day in 1902, Mrs. Smith started what later became the famous Newcomb embroidery. A tiny classroom

Weaving in cotton by Mary Ballard, in bands of dark blue, yellow, red, green, black, white, and light blue. This unusual piece shows the influence of Middle America that came when Tulane University started digging in Central America; 1916; measures 25″ x 14½″. (Louisiana State Museum Collection)

Bird of paradise motif in center of weaving in tones of yellow, black, aqua, blue, and rust. Designed and executed by Mary Ballard; weaving measures 47″ x 22″. (Louisiana State Museum Collection)

behind the pottery studio on the first floor became the embroidery room. Russian crash and soft-toned cotton crepe were chosen, along with oriental silk thread that would not fade. Mrs. Smith had decided to use only four basic stitches, familiar to all the young women—darning, buttonhole, satin, and outline.

From this small beginning the embroidery department became, next to the pottery, the single most lucrative craft. Students loved the embroidery program, and many were to use this training all their lives. Among the popular items produced were table covers, napkins, dress accessories, infant apparel, smocking, decorative screens, panels, and church vestments. The demands for this craft spread far and wide. When pottery was shipped for exhibition at expositions, embroidery always was sent along. Many prizes were awarded to the embroidery, which was a complement to the pottery because of the same motif design.

In the days of changing from winter to summer furnishings in the South, Newcomb pottery and embroidery became the casual furnishings for summer use. The silks, brocades, oriental rugs, and heavy velvet furniture would be put up for the summer. In their place wicker furniture, straw rugs, and cotton covers were used. The crafts adapted themselves to the open windows with shutters closed and small electric fans of the era. Summer flowers looked lovely in pottery on a table covered with an embroidered runner.

In 1904 weaving was started in the top room of the guild building at 2828 Camp Street. Spinning was taught as part of the weaving course, and beautiful handspun and handwoven fabrics were made. Many of these handwoven fabrics were later embroidered by the craftsmen. Pillows made from fabric of the looms of the guild and embroidered by the craftsmen are still in use after sixty-five years. As in the case of the pottery, a jury of faculty was the sole judge of the quality of needlecraft placed on sale. The seal of Newcomb was placed on each piece of needlecraft.

Brasswork started in the art school quite by accident, developing out of a need to produce lampshades for the oil-lamp bases made in the pottery. The handpainted glass Victorian shades of that era screamed at the glazed pottery bases made in the guild. Every once in a while a shade could be bought in a local store, but for the most part nothing was available that enhanced the base. In desperation, a few lamp bases were sent to the Tiffany Glass Company to be fitted with shades, but transportation problems rendered this unfeasible. Then an experiment with textiles over wire frames was tried, but it too was unsatisfactory. Finally, Miss Elizabeth Rogers, in order to complete an oil-lamp base, hit upon the idea of doing her shade in brass. The brass was stretched over a wooden form and then hammered and punched out so that light penetrated the small openings to make an excellent pattern. Proficiency in metalwork developed immediately.

Miss Mary Butler then undertook to teach classes, and enrollment in this course began to soar. Although the pierced brass shades were successful, they suited only the deeply incised decoration on the pottery. Miss Sheerer started to experiment with leaded glass. Sheets of stained glass were obtained from the Tiffany Glass Company, and with the aid of a wooden form the exact area of the shade was marked on tracing paper upon which the design was then drawn. Lead cames were cut to fit the lines of the design, and then cardboard shapes were cut to fit the lead cames perfectly. Then the cardboard shapes were placed on the glass and the glass carefully cut with a diamond glazer's knife. The glass shapes were placed between the lead cames on the wooden form, and the joints were sealed with solder. When the shade was lifted from the wooden form, the inside too was soldered, and then the whole frame was galvanized with copper.

The Newcomb beaded lampshades were the invention of Miss Sheerer. She strung small glass beads on copper wire and fashioned the beads into flower motifs that were then sewn to a fabric shade on a wire frame. The beaded shades were a good complement for the matt glazed pottery bases.

By 1905 the yellow fever epidemics that had plagued New Orleans since its founding in 1718 came to an end. With the fear of this deadly disease over, women from all over the nation began seeking admission to Newcomb College, whose fame had spread through its crafts. Newcomb College had come a long way in eighteen years. This rapid growth made Ellsworth Woodward and Dr. Dixon reevaluate their future needs. There was no room to expand on the Washington Avenue campus, for the area was built up with homes of the rich of New Orleans, and the popularity of the Garden District made it impossible to purchase more space on which to build additional classroom buildings. In April, 1905, Dr. Dixon purchased for Newcomb College a thirty-acre site on Napoleon Avenue near South Broad Street, but this site was never used, because there was little or no city transit in the area and not likely to be any for some time.

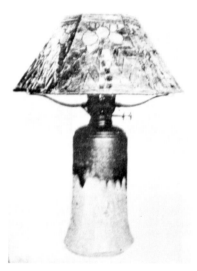

Leaded glass shade and pottery base, the shade probably done by Mary Sheerer. (*The Year Book of Tulane University, Tulane Architectural Society* [1916], page 43. (Louisiana State Museum Library)

### 1906–11

Every year at the beginning of the Christmas season, the college, through the guild, had a large showing of all the work done in the previous year, an event eagerly awaited by the residents of New Orleans. The showroom on the first floor of 2828 Camp Street would be filled with the labors of the year, proudly displayed by the students, workers, and graduates. The Art Alumnae had formed their own association and would create for this event, plus have showings at regular intervals. Their association maintained a permanent exhibition room and hired a salesperson just to sell the crafts produced by the group. Records reveal that the Art Alumnae salesperson was paid a salary of fifteen dollars monthly to handle the sales. From the profits of the Art Alumnae shows, money prizes and scholarships were given to promising students, to

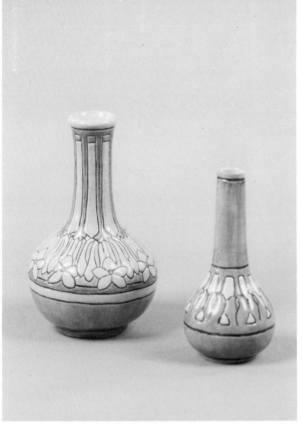

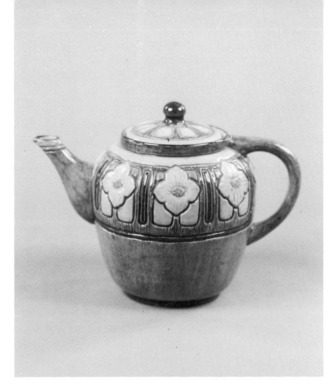

Teapot with dogwood motif on white clay body with blue-green, dark blue, and yellow underglaze, deeply incised lines filled with black underglaze and high-gloss transparent glaze covering surface. Decorated by Leona Nicholson, wheel-thrown by Joseph Meyer. Bears marks of LN, JM, NC, AQ30; 1900–1905; 6″ tall. (Louisiana State Museum Collection)

Tall bottle-shaped vase with lily motif on white clay body in blue and yellow underglaze, incised lines filled with black underglaze, and high-gloss transparent glaze over entire surface. Decorated by Henrietta Bailey, thrown by Joseph Meyer; bears marks of HB, JM, NC, AG52; 1900–1905; 7″ tall. Bottle-shaped bud vase in white clay body with stylized flower motif in blue-green and yellow underglaze, deeply incised with lines filled with black underglaze, and transparent shiny glaze over surface. Decorated by Marie de Hoa LeBlanc, thrown by Joseph Meyer; bears marks of MHLeB, JM, NC, 9277; 1900–1905; 6″ tall. (Louisiana State Museum Collection)

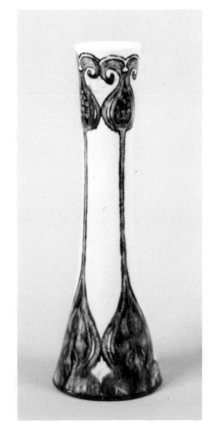

Tall narrow vase with blue-green and dark blue underglaze stylized flower pod motif on white clay body and transparent shiny glaze over entire surface. Decorated by Mary W. Butler, wheel-thrown by Joseph Meyer. Bears marks of MWB, JM, NC, A57; 1897–1900; 13″ tall. (Louisiana State Museum Collection)

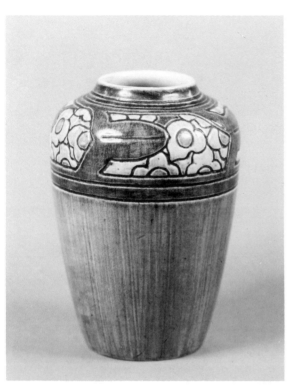

Open-mouthed decorated vase in blue underglaze, with incised trillium flower design, incised lines filled with black underglaze, and transparent glaze over decoration by Roberta Kennon and Joseph F. Meyer. Bears marks of RK, JM, NC, 2260; 1900–1905; 7½″ tall. (Louisiana State Museum Collection)

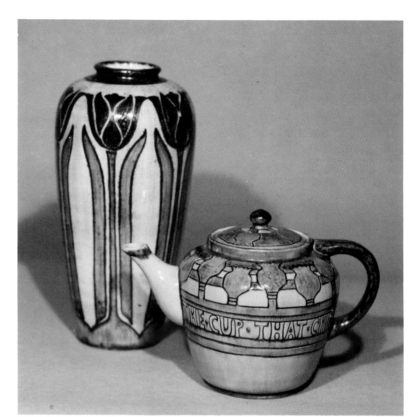

Teapot in white clay body with deeply incised tulip motif and lettered legend around girth of pot, blue-green and dark blue underglaze, and transparent glaze on the entire surface. Decorated by Alice Rosalie Urquhart, potter unknown; bears marks of RU, NC, AQ100; 1900–1905; 4¾″ tall. Closed-mouth tall vase decorated with tulip motif on white clay and dark and medium blue underglaze, covered with transparent shiny glaze. Decorated by Alice Rosalie Urquhart, thrown by Joseph Meyer; bears marks of RU, JM, NC, J86; 1895–1900; 9½″ tall. (Collection of Kenneth Urquhart)

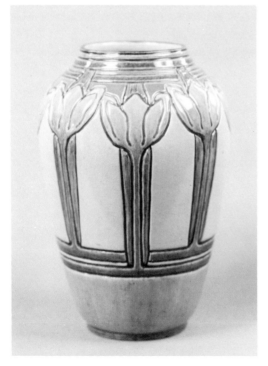

Large open-mouthed vase with lily motif deeply incised in blue, yellow, and green underglaze, outline in black underglaze, with transparent glaze over entire surface. Decorated by Leona Nicholson. Bears marks of LN, JM, NC, AJ71; 1900–1905; 11″ tall. (Louisiana State Museum Collection)

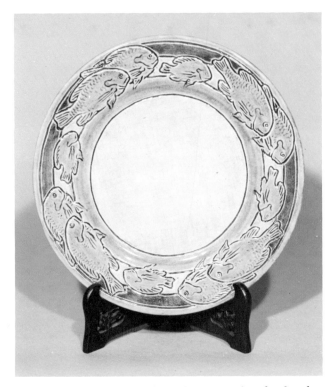

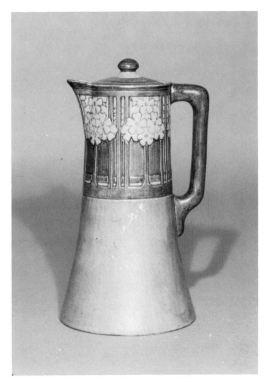

Plate in white clay body with fish design motif, underglazed in medium blue, with black underglaze-filled deeply incised lines, and entire surface covered with transparent shiny glaze. Decorated by Mary Frances Baker, thrown by Joseph Meyer. Bears marks of MFB, JM, NC, A147; 1900–1905; 9½" round. (Collection of Sonia and Walter Bob)

Chocolate pitcher in white clay body with phlox flower motif of blue underglaze; the incised lines are filled with black underglaze, and the entire piece is glazed in a transparent shiny glaze. Decorator unknown, thrown by Joseph Meyer. Bears marks of JM, NC; 1900–1905; 9½" tall. (Collection of Newcomb College)

encourage more enrollment in the art school. Ellsworth Woodward wrote in *Vocational Education*, November, 1913, "The thing that makes us happy is that a girl can face this community and make a living without teaching and without staying with us."

As the interest grew for more pottery, it was necessary to add another potter to help Joseph Meyer. Robert Miller joined the guild in the fall of 1909, but he left in the late summer of 1910. In the fall of 1910, Paul E. Cox came to the art department at Newcomb College. Cox had been trained at Alfred University's New York College of Ceramics under the well-known Professor Charles F. Binns. He was trained in ceramic chemistry and had done extensive work in kiln building. The arrival of Paul Cox led to the perfection of the glazes and clay bodies that gave the ware its later reliability. He began at once to reevaluate the clay being used. Although the pottery was using the best local clays, Cox was not convinced that better clays could not be found. The low-fire white clay body from Back Bay, Biloxi, had severe drawbacks. It was porous; glazes tended to crawl on the surface, and crazing was common. To make matters worse, it leaked when filled with water, making many of the vase shapes unusable as

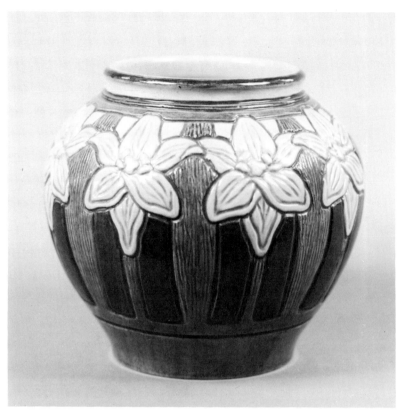

Plate with underglazed motif of narcissus on white clay body and glazed over with a transparent glaze. Decorated by Cynthia Littlejohn, thrown by Joseph F. Meyer. Bears marks of CL, JM, NC, BY15; 1900–1905; 5½″ round. (Louisiana State Museum Collection)

Large open-mouthed jar with daffodil motif deeply incised with blue and green underglaze, outlined with black underglaze on white clay body, and high-gloss transparent glaze. Decorated by Leona Nicholson, thrown by Joseph Meyer. Bears marks of LN, JM, AC15; 1900–1905; 7″ tall x 10″ wide. (Louisiana State Museum Collection)

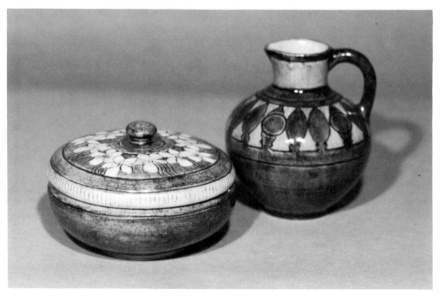

Candy dish with deeply incised flower motif in medium blue and green underglaze, covered by transparent shiny glaze. Decorated by Alice Rosalie Urquhart, thrown by Joseph Meyer; bears marks of RU, JM, NC; 1900–1905; 2¼″ tall x 5″ wide. Milk pitcher in white clay body with incised motif of flowers, underglazed in medium and light blue, with transparent glaze over surface. Decorated by Alice Rosalie Urquhart, thrown by Joseph Meyer; bears marks of RU, JM, NC, UU40; 1900; 5″ tall. (Collection of Kenneth Urquhart)

Hanging vase in white clay body with yellow, pale blue, and deeply incised lines filled with dark blue underglaze with a stylized flower motif circling top rim, the entire surface in shiny transparent glaze. Decorated by Amelie Roman, wheel-thrown by Joseph Meyer. Bears marks of AR, JM, NC, N28; circa 1900; 10″ tall. (Louisiana State Museum Collection)

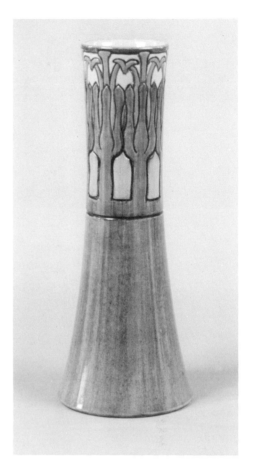

Narrow tall vase in white clay body with century plant stylized motif on upper rim. Dark yellow, medium blue, and blue-green underglaze with deeply incised lines filled with dark blue underglaze, the entire piece glazed with a transparent shiny glaze. Decorated by Marie de Hoa LeBlanc, potter unknown. Bears marks of M.H.L., NC, MM69; circa 1900; 9½″ tall. (Louisiana State Museum Collection)

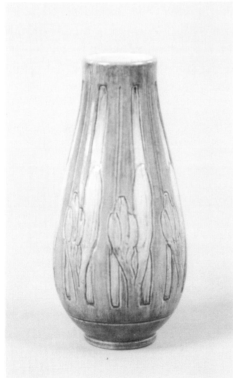

Tall closed-mouth vase with lily motif on white clay body deeply incised with blue and green underglaze, outlined with black underglaze, and high-gloss transparent glaze over entire pot. Decorated by Marie de Hoa LeBlanc, wheel-thrown by Joseph Meyer. Bears marks of MHLeB, JM, NC, BS43; 1900–1905; 8″ tall. (Louisiana State Museum Collection)

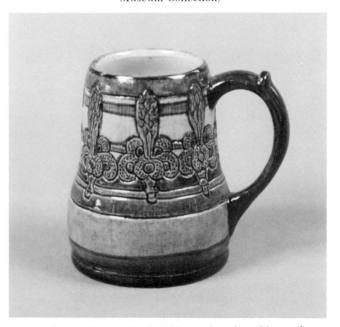

Mug with tiger lily motif in dark blue and medium blue underglaze, deeply incised lines filled with dark blue underglaze on clay body of cream color, and shiny transparent glaze over surface. Decorated by Mary W. Butler, wheel-thrown by Joseph Meyer. Bears marks of MWB, JM, NC, BI22; 1900–1905; 4⅝″ tall. (Louisiana State Museum Collection)

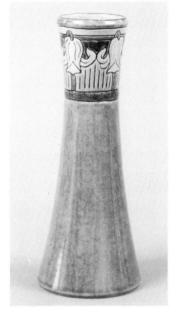

Tall narrow vase with orchid flower motif in white clay body with medium and dark blue underglaze, deeply incised lines outlining motif and filled with dark blue underglaze, and transparent shiny glaze covering the entire piece. Decorated by Leona Nicholson, potter unknown. Bears marks of LN, NC, XX, 51; circa 1900; 9″ tall. (Louisiana State Museum Collection)

flower containers. Paul Cox set about finding other suitable clays locally, and after some investigation a good clay was located in Saint Tammany Parish (counties are parishes in Louisiana) just north of New Orleans, bordering on Lake Pontchartrain. He located a clay bank on the Bogue Falaya River near the town of Covington, and to the Covington clay he added Kentucky ball clay and feldspar to even out and open the body. This clay blend could be fired to a higher temperature in the medium range of 1,100 to 1,200 degrees C. It had unusually good throwing qualities and a clean, grit-free surface that made it easy to create low-relief modeling design motifs.

The fame of the art school had now spread into the community and the nation, the workers were receiving commissions for special order work, and the Newcomb calligraphy had been developed and was in general use. Sadie Irvine created interesting bookplates in this period. As New Orleanians became more educated, they started establishing libraries in their own homes. There was no large, developed public library system in the city at that time. The craftsmen began to receive commissions to do illustrations for books and newspaper articles. Blockprinting and the Newcomb calligraphy were employed on lovely calendars that were sold each Christmas in the showroom.

Leather crafts were introduced in this period. Leather of soft suede was used to fashion book covers and desk sets of blotters, inkwells, and covers for cloth penwipers, each of which was hand tooled with the design of the Newcomb style. The telephone was in common use, and a standard wedding gift of that day was a leather hand-tooled cover for the telephone directory. Traveling cases for stationery were a popular gift to those departing for the mountains or

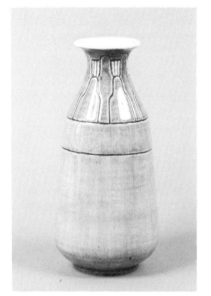

Closed-mouth vase in pale and medium blue underglaze with deeply incised design outlined with black underglaze. The entire pot has transparent glaze over decoration by Sabina E. Wells and Joseph Meyer. Bears marks of SEW, JM, NC, S94; 1900; 8″. (Louisiana State Museum Collection)

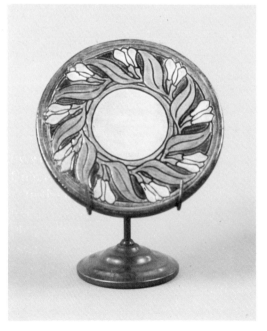

Trivet in stylized lily motif in green and dark blue underglaze, deeply incised lines filled with black underglaze, on white clay body with shiny transparent glaze on entire surface. Decorated by Ada Wilt Lonnegan, thrown by Joseph Meyer. Bears marks of LONNEGAN, JM, NC, BF37; 1902–6; 6″ round. (Louisiana State Museum Collection)

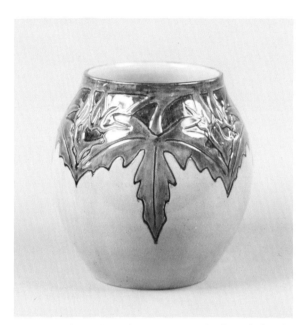

Open-mouth jar-shaped vase on cream body with deeply incised leaf motif, dark blue-green and dark blue underglaze, with black underglaze filling the incised lines. Transparent high-gloss glaze covers entire piece. Decorated by Roberta B. Kennon, potter unknown. Bears marks of RBK, NC, Z77; about 1900; 8½″ tall. (Louisiana State Museum Collection)

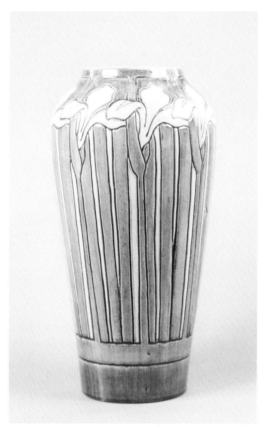

Large vase-shaped jar. Louisiana iris motif in white clay body, medium blue and green underglaze, with deeply incised lines filled with dark blue underglaze. Transparent shiny glaze covers the entire piece. Decorated by Roberta B. Kennon, thrown by Joseph Meyer. Bears marks of RBK, NC, JM, AI13; 1900–1905; 15″ tall. (Louisiana State Museum Collection)

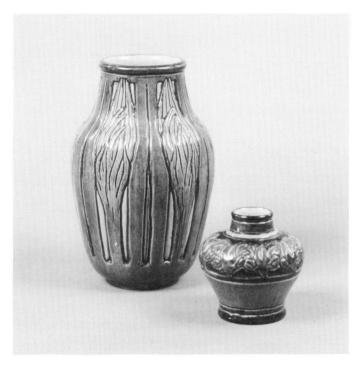

Tall jar-shaped vase in white clay with stylized flower, dark blue and medium blue underglaze, deeply incised lines filled with dark blue underglaze, covered by transparent shiny glaze. Decorated by Marie de Hoa LeBlanc, potter unknown; bears marks of MHLeB, NC, AL81, Q; 1900–1905; 7″ tall. Small closed-mouth vase in flower motif with blue-green, medium and dark blue underglaze, deeply incised lines filled with dark blue underglaze, and shiny transparent glaze on entire surface. Decorated by Henrietta Bailey, potter unknown; bears marks of HB, NC, BD5; circa 1903; 4″ tall. (Louisiana State Museum Collection)

89

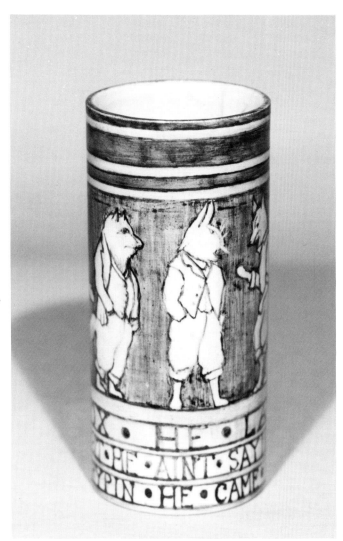

Tall mug in white clay body with underglazed rabbits and legend
in dark blue; shiny transparent glaze covers entire surface.
Decorated by Alice Rosalie Urquhart, thrown by Joseph Meyer.
Bears marks of RU, JM, NC, AE34, WFU (standing for Wilkins
Fish Urquhart); circa 1900; 7¾″ tall. (Collection of Kenneth
Urquhart)

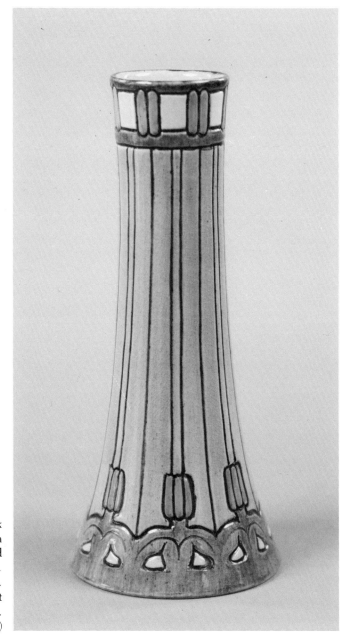

Tall vase with stylized flower pod motif in dark
yellow, pale green, dark and light blue underglaze, with
deeply incised lines filled with dark blue underglaze, and
shiny transparent glaze covering entire surface.
Decorated by Marie de Hoa LeBlanc, potter unknown.
Bears marks of M.H.L., NC, original paper label intact
covering inventory number; circa 1900; 10″ tall.
(Louisiana State Museum Collection)

90

Europe for the summer. Many of the leather pieces had silver or gold leaf worked into the hand tooling, and sometimes color was painted into the grooves. Leather was incorporated with silver jewelry in objects such as men's watchfobs.

The jewelry became more sophisticated in this period, encompassing the use of stones and pearls. Many of the stones were of native, semiprecious gem material picked up on rock hunts in the Smoky Mountains on vacations. The popular stones used were moonstone, sapphire, chalcedony, and agate from the hills in North Carolina and Georgia. When pearls were used, they were generally baroque, freshwater American pearls. Every kind of jewelry was made including brooches, bracelets, earrings, and necklaces, with the stones attached in a simple bezel setting. Cloisonné on silver and gold metal was in use, and beautiful pieces of ornament were made in this period. So skillful did the workers become that demands for the jewelry could not be met. Many worked long hours to keep up with orders that flowed into the guild.

By 1908 enrollment was increasing by leaps and bounds. Students came from all over the United States to gain their art training from the college, and Dr. Dixon and Ellsworth Woodward were looking into the future needs of the college. In November of 1908, Dr. Dixon, with the approval of the Tulane University board, purchased a large plot of ground in the general area of the Tulane University campus, which lay just across the street from the site of the World's Industrial and Cotton Centennial, now Audubon Park, in uptown New Orleans on Saint Charles Avenue—the crafts of the Newcomb style were to

Plate with stylized butterfly motif incised into cream clay body and underglazed in blue-green, dark blue, and yellow, covered with transparent shiny glaze. Decorated by Alice Rosalie Urquhart, thrown by Joseph Meyer. Bears marks of RU, JM, NC, AT42; 1900–1905; 6½″ round. (Collection of Kenneth Urquhart)

91

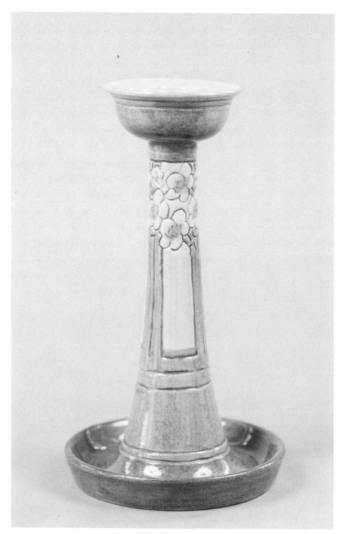

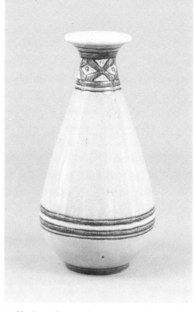

Tall closed-mouth vase in white clay body; circles band the middle and top part of the piece. Medium blue and dark yellow underglaze covers the circles, and the entire pot is glazed in transparent shiny glaze. Decorated by Roberta B. Kennon, thrown by Joseph Meyer. Bears marks of RBK, JM, NC, AN27; 1900–1905; 8½″ tall. (Louisiana State Museum Collection)

Candlestick with mock orange motif in yellow and green underglaze, outlined with incised lines filled with black underglaze, on white clay body showing through area that is not underglazed. Transparent glaze covers the entire body. Decorated by Henrietta Bailey, thrown by Joseph Meyer. Bears marks of HB, JM, NC, BU75; 1900–1905; 9¼″ tall. (Louisiana State Museum Collection)

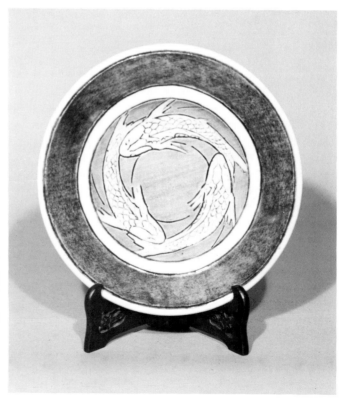

Plate in fish design motif incised in white clay, underglazed in royal blue and light blue, with shiny transparent glaze on surface. Decorated by Sabina E. Wells, thrown by Joseph Meyer. Bears marks of SEW, JM, NC, TT73; 1900–1905; 9″ round. (Collection of Sonia and Walter Bob)

92

Small narrow vase with incised flower motif in blue underglaze, outlined with black underglaze, on white clay body with high-gloss transparent glaze. Decorated by Leona Nicholson, thrown by Joseph Meyer, bearing marks of LN, JM, NC, AN99; 1900–1905; 4½″ tall. Tall closed-mouth vase with persimmon motif in pale blue and medium blue underglaze on white body, incised lines filled with dark blue underglaze, with transparent glossy glaze. Decorated by Henrietta Bailey, thrown by Joseph Meyer, bearing marks of HB, JM, NC, AL77; 1905–10; 7½″ tall. (Louisiana State Museum Collection)

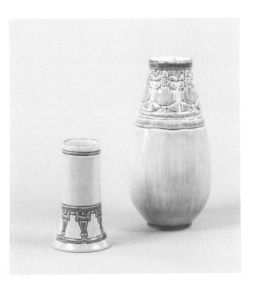

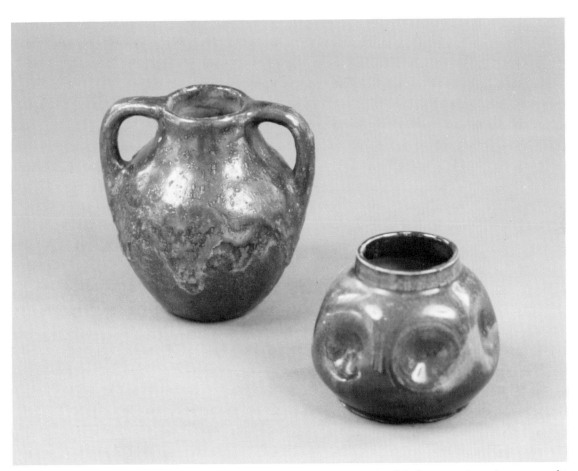

Two wheel-thrown pots by Joseph Meyer. Handle jug has luster glaze of red and dark green color and was entered in Louisiana Purchase Exposition; bears marks of JM, NC; 1904; 4″ tall. Thumbprint wheel-thrown jar in red and dark green luster glaze; bears marks of JM, NC; entered in Louisiana Purchase Exposition of 1904; 3″ tall. (Walther Collection)

Silver medal for pottery won at the Louisiana Purchase Exposition by Joseph F. Meyer in 1904, Saint Louis, Missouri. (Walther Collection)

Work done by Joseph Meyer. The collection of pottery, sent to the Louisiana Purchase Exposition held in Saint Louis in 1904, won a medal for Joseph Meyer (see photograph of medal). (Walther Collection)

Invitation in postcard size designed by Sadie Irvine for the annual art show of the Newcomb Art Alumnae Association for the benefit of scholarships. Dated 1906. (Walther Collection)

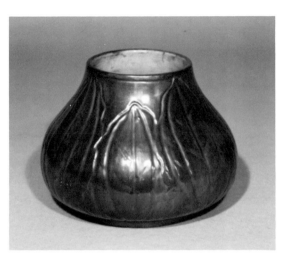

Jar-shaped vase with incised leaf motif on cream body in red reduction matt glaze. Decorated by Harriet Joor, thrown by Joseph Meyer. Bears marks of HJ, JM, NC, CC35; 1905–10; 7″ tall. (Collection of Newcomb College)

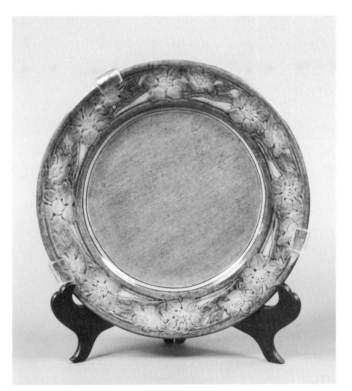

Plate with single cornflower motif in blue and yellow underglaze, with incised lines filled with black underglaze. Decorated by Anna Frances Simpson, wheel-thrown by Joseph Meyer. Bears marks of AFS, JM, NC, CL34; 1905–10; 9″ round. (Louisiana State Museum Collection)

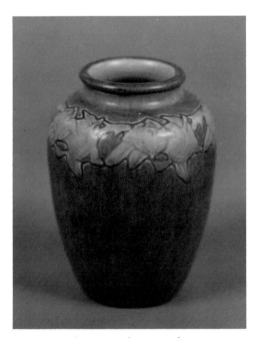

Small vase of transition between shiny transparent glaze and the matt glaze. Flower design has light incised lines that are filled with glaze, the motif in very low relief. Decorated by Sadie Irvine, wheel-thrown by Joseph Meyer. Bears marks of SI, JM, NC, DM86; 1908–10; 4½″ tall. (Louisiana State Museum Collection)

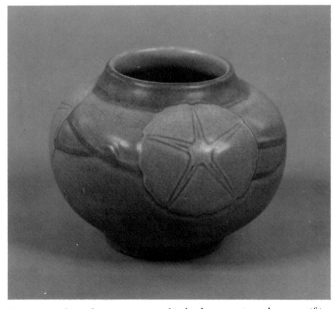

Low vase-shaped pot in cream clay body, morning glory motif in tones of pink, background of medium blue, entire pot in matt glaze. Decorated by Corinne Chalaron, wheel-thrown by Joseph Meyer. Bears marks of CC, JM, NC, KD46; 1910–18; 4″ tall. (Louisiana State Museum Collection)

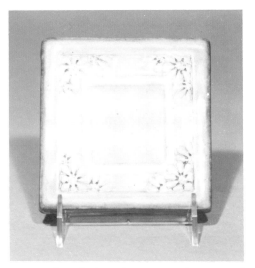

Square-shaped tile with poinsettia flower motif in low modeled relief and blue and green matt glaze. Decorated and executed by May Dunn. Bears marks of MD, NC, FB15; circa 1910; 4½". (Collection of Newcomb College)

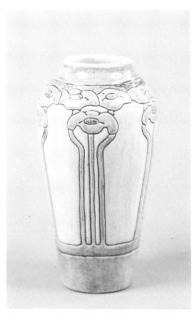

Vase in stylized floral design in blue, green, and white underglaze, incised lines in black underglaze, with transparent overglaze. Decorated by Lynn Watkins. Bears marks of LW, JM; NC has been scratched out, meaning reject; circa 1909; 8½" tall. (Louisiana State Museum Collection)

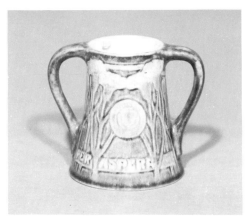

Three-handle mug with carnation flower motif in low relief incised, underglazed in medium blue and green with white clay body showing through, and glazed with a shiny transparent glaze over surface. Decorated by Katherine Kopman, thrown by Joseph Meyer. Bears marks of KK, JM, NC, CC38; 1905–10; 3¼" tall. (Collection of Newcomb College)

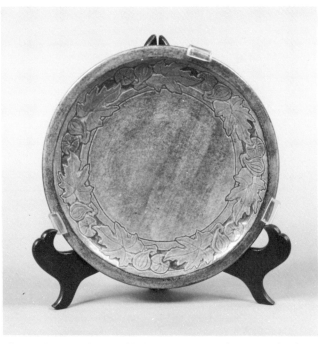

Plate with motif of figs and fig leaves in blue and green underglaze, with incised lines filled with black underglaze. Decorated by Cynthia Littlejohn, thrown by Joseph Meyer. Bears marks of CL, JM, DC35, NC; 1905–10; 8¼" round. (Louisiana State Museum Collection)

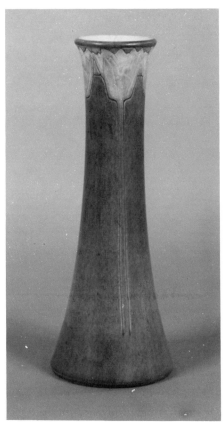

Tall narrow vase of transitional period done with tulip motif in medium blue underglaze, lightly incised lines filled with dark blue underglaze. Piece has semi-matt glaze over entire body of light cream-colored clay. Decorated by Sadie Irvine, wheel-thrown by Joseph Meyer. Bears marks of SI, JM, NC, DM29; circa 1908; 12" tall. (Louisiana State Museum Collection)

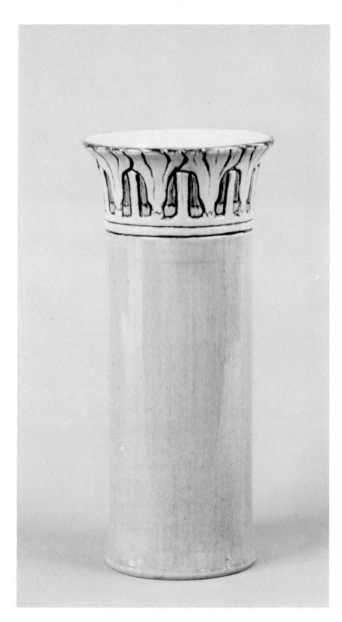

Tall cylindrical vase in white clay body with lily motif on top rim area, pale blue-green and dark blue underglaze, deeply incised lines filled with dark blue underglaze, and entire surface covered with transparent shiny glaze. Decorated by Marie de Hoa LeBlanc, thrown by Joseph Meyer. Bears marks of MHLeB, JM, NC, AM56; 1900–10; 10½″ tall. (Louisiana State Museum Collection)

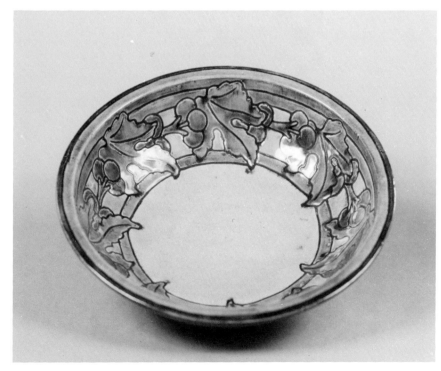

Low bowl with only inside decorated, in grape and grape leaf motif on white clay with green and dark blue underglaze, deeply incised lines filled with black underglaze, and shiny transparent glaze covering surface. Decorated by Sarah Bloom Levy, thrown by Joseph Meyer. Bears marks of SBL, JM, NC, BF55; 1905–10; 2¼″ tall x 10″ round. (Lent to Louisiana State Museum)

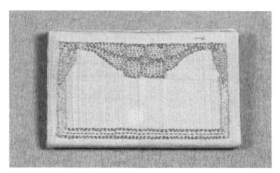

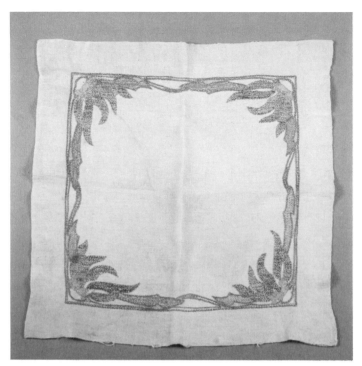

Lady's visiting-card case. Designed and executed by Mary Taylor Payne on silk material, embroidered in red and green silk thread. The design motif of flowers and leaves is in the tradition of the Newcomb style employed in all the crafts; 1909–11; 2⅜″ x 4½″. (Louisiana State Museum Collection)

Stylized flower motif in tones of red with green leaves around border, in darning stitch on handspun linen crash. Designed and executed by Lois Janvier about 1909. Square measures 2′. (Louisiana State Museum Collection)

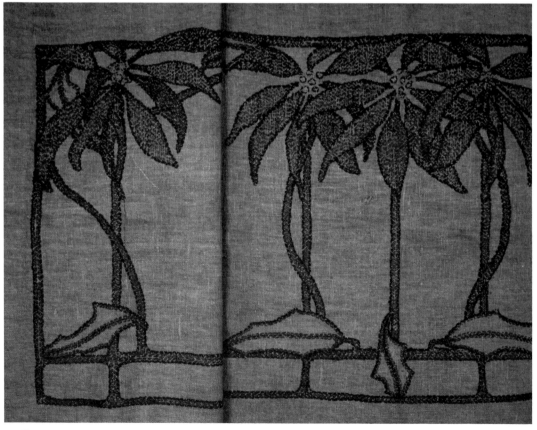

Wall panel in poinsettia design, embroidered in darning stitch using tones of red, rouge, and yellow in flower motifs and leaves in two shades of green; silk thread on handspun Russian crash. Designed and executed by Gladys Molton, 1910–11. Measures 3′6″ x 19″; bears NC in corner, for the guild. (Louisiana State Museum Collection)

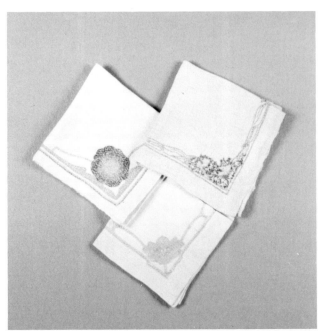

Dress insert designed and executed by Alix Bettison Colby, embroidered on chiffon using outline, buttonhole, and darning stitches. Colors in stylized flower motif are rouge, red, green, violet, and burgundy on pale green background material. As in all embroidery, imported silk thread was used. Insert was made about 1911; measures 5″ x 7″. (Louisiana State Museum Collection)

Table napkins each with a different flower motif on cotton-flax handwoven fabric, embroidery done in silk thread using the darning stitch in yellow, green, and red colors. Motifs are of the same feeling as those used in other crafts. Craftsman unknown; about 1910; napkin measures 13″ x 13″. (Louisiana State Museum Collection)

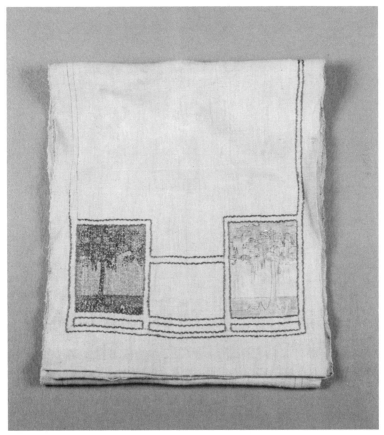

Long table-runner embroidered in darning and outline stitches. Pine trees are rendered in darning stitch, and blocks are fashioned in outline stitch. The embroidery is on Newcomb handspun linen crash woven by the guild. Silk thread was used for embroidering. Designed and executed by Mary Taylor Payne; 5′7″ x 15″, and unfinished; 1909–11. (Louisiana State Museum Collection)

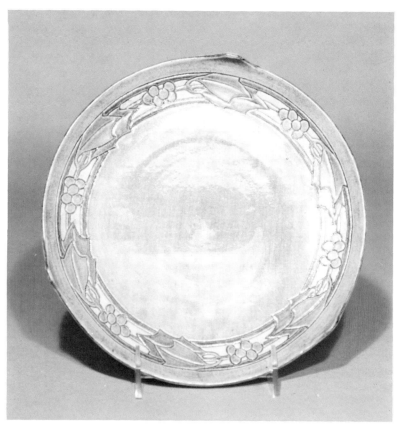

Plate with incised motif of holly leaves and berries on cream clay body, matt glazed in blue and blue-green. Decorated by Mary Given Sheerer, thrown by Joseph Meyer. Bears marks of MGS, JM, NEWCOMB ART ALUMNAE (1910), DH5; 9″ round. (Collection of Newcomb College)

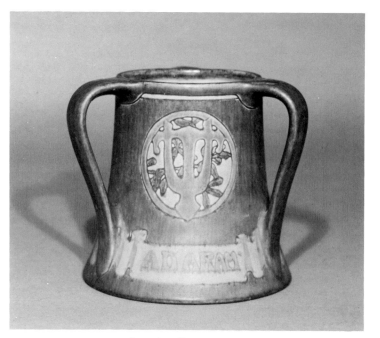

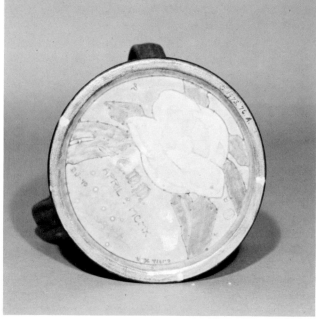

Three-handle mug with initials TU (for Tulane University) on side incised in white clay, underglazed in olive green and blue, with transparent glaze over surface. Decorated by Sadie Irvine, potter unknown. Bears marks and magnolia flower incised of SI, NC, DJ40, April 9, MCMX (1910); 7½″ tall. (Collection of Newcomb College)

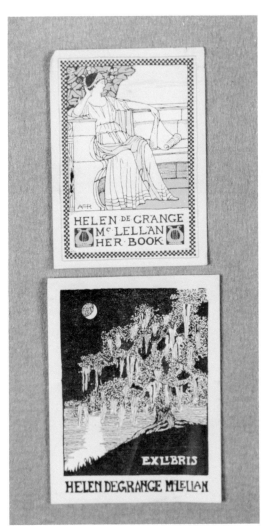

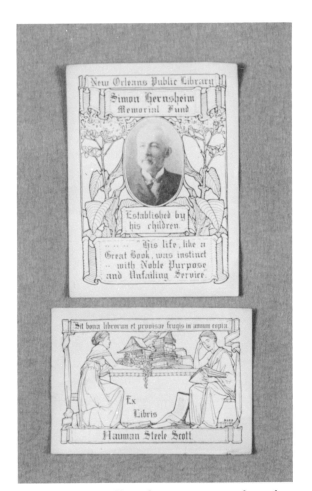

Bookplates designed by Sadie Irvine using southern plant material as part of the design style. (Louisiana State Museum Collection)

Bookplates employing the southern plant material of the Newcomb style. Top plate was designed by Amelie Roman for Helen de Grange McLellan. Bottom plate is traditional moss-draped oak from a linoleum cut designed and executed by Helen de Grange McLellan. (Louisiana State Museum Collection)

Bookplate detailing the traditional moss-draped oak tree motif. Katherine Severance Wraight was the designer and craftsman. (Louisiana State Museum Collection.

Bookplate designed by Sadie Irvine with classic oak in background. (Louisiana State Museum Collection)

make a perfect circle geographically. The acreage was bounded by Freret, Audubon, and Plum streets, Audubon Place, and Broadway. Ten years later, this land became the third and present campus of Newcomb College.

All the classes of Newcomb College and Newcomb High School, spearheaded by the graduating class of 1909, were to make a positive link to the new campus from the old. In the fall of 1908 the student body gathered acorns from the Louisiana live oak trees on the Washington Avenue campus. In carefully arranged and labeled garden beds, the acorns were planted. When about a foot tall they were transplanted to the new campus on Broadway. This living link between the campuses has provided the symbol of Newcomb College. The oak tree became a popular motif used in all the crafts. The huge oaks of the Washington Avenue campus remain today, carefully preserved by the builders of today's handsome homes, and stand like sentinels guarding the spot so loved by Mrs. Newcomb and Dr. Dixon.

With the purchasing of the land for the new campus on Broadway, Dr. Dixon, Woodward, Cox, Meyer, and Miss Sheerer could plan a new building, spacious enough for greatly increased production.

The famous matt glazes of the Newcomb style were introduced and came into common usage in this period. Many collectors feel that this is the most beautiful Newcomb pottery ever produced. It was in 1913 that the gold medal

Design for silver head of riding crop. (Photograph reprint appears in *The Year Book of Tulane University* [1916], page 41. Louisiana State Museum Library)

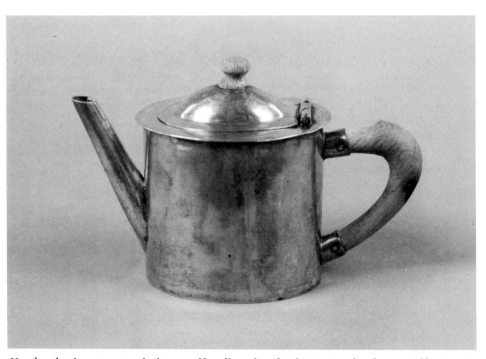

Handmade silver teapot with olivewood handle and top knob. Designed and executed by Juanita Mauras; 1905–10; 3½″ high x 7″ wide. (Louisiana State Museum Collection)

102

at Knoxville was won, and the great honor of the silver medal at the San Francisco Exposition came in 1915. These tributes prompted Dr. Dixon and Ellsworth Woodward to ask that a large building just for the art school be designed and constructed on the new Broadway campus. Working with the architect selected to design the new campus, the faculty of the art school made known their needs. Finally a design for a four-story building was completed. The pottery was to have the entire ground floor of the building, the main floor was to have offices, a gallery, and classrooms, and the remaining two top floors

Grand Prize Certificate awarded to Newcomb College at the Panama-Pacific International Exposition in San Francisco, California, 1915.

Waxed-paper stencil used to make textile inked design. Date unknown. (Walther Collection)

would have studios and class/work rooms. The entire faculty of the art school helped with the blueprints, to insure that this new building would meet all the present and future space requirements for teaching and for the various guild functions.

In this period the first of the bookbinding crafts was introduced. Leather crafts had been practiced for some time and had become very popular, among those in both the guild and the Art Alumnae Association. This new use of the craft aroused great interest in the community. Book covers previously had been made of fabric, embroidered or stenciled, and had served as removable protection to keep the book's binding clean. Now whole sets of volumes were stripped of their original binding and reworked with new binding made by the guild. So popular did this craft become that even today there are Newcomb graduates still engaged in the art of bookbinding. From a folder printed by the Newcomb Art School at this time comes this quote: "BOOKBINDING. Books bound as good books should be dressed, with beauty and strength and due regard for their character. You may leave an order to have a favorite bound with confidence that it will give lasting satisfaction." A treasured gift was a book of poems or the family Bible bound by the guild with the owner's name tooled into the leather.

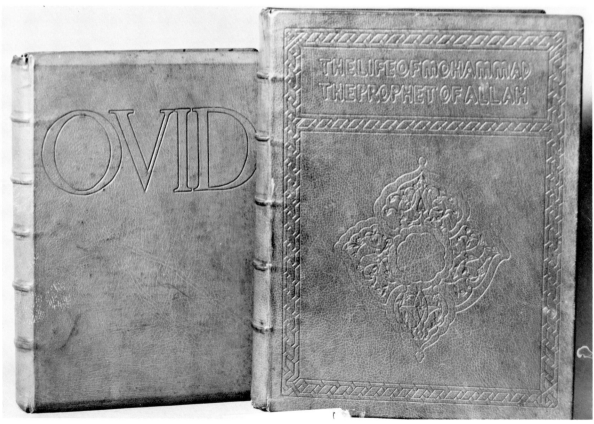

Two large books in morocco leather of orange color. Designed and executed by Maude Parsons. Hand-tooled lettering and motifs on covers; 1925–30. (Private collection)

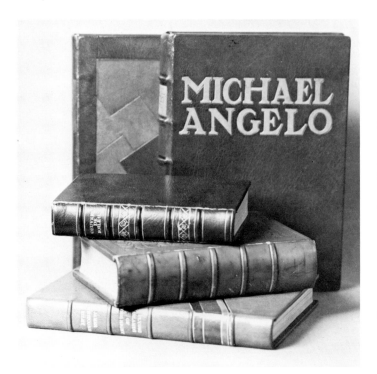

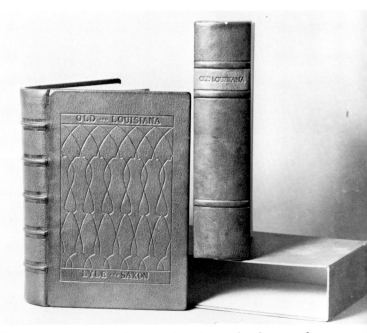

Five books with unusual bookbinding, hand-tooled motifs, and lettering are excellent examples of the quality produced by the Newcomb Guild. Designed and executed by Eunice Baccich about 1918. (Private collection)

Unusual bookbinding and hand-tooling designed and executed by Eunice Baccich. The two-piece slipcase was made to fit the book bound to match outer case; about 1929. (Private collection)

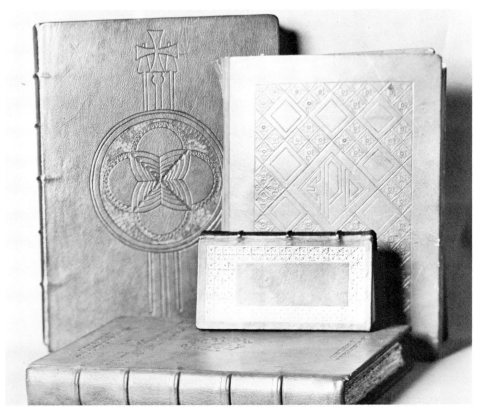

Bookbinding designed and executed by Maude Parsons. Three large books are in green morocco leather with hand-tooled motifs on covers; small book is in red morocco leather; 1925–30. (Private collection)

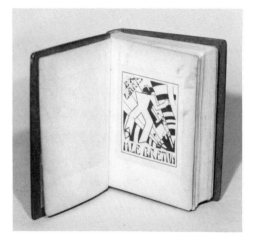

Leather-bound book with bookplate. Designed and executed by Mireille LeBreton in 1931. (Collection of Mrs. Lloyd J. Cobb)

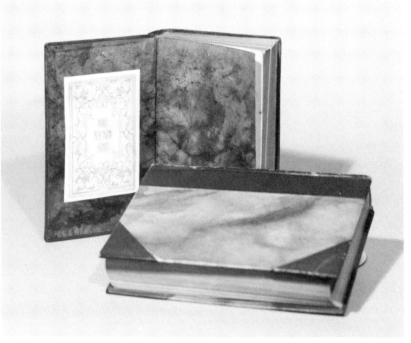

Bookbinding and bookplate showing on inside cover of standing book. Designed and executed by Mary Hall Tupper about 1929. (Private collection)

Three books bound in morocco leather of red color. Designed and executed by Lilian Walther in 1936. (Private collection)

Paul Cox and Mary Sheerer continued to experiment, and discovered a New Orleans clay that they could incorporate into their clay bodies. This New Orleans clay came from the excavations for the water purification plant of the New Orleans Sewerage and Water Board. In the dug state it was pale grayish blue, and it fired to a strong white body. A problem with this clay was that in it were deposits of oyster and clam shells, and many screenings were necessary to remove these lime-content foreign particles. Such particles, if not removed, caused "poppers" to occur, which fractured the fired clay body. But the introduction of a completely native material gave the craft a unique distinction.

With Newcomb College about to join its brother, Tulane University, in uptown New Orleans, a closer relationship developed between the two institutions. The campus life of the students began to be oriented toward the new location and its proximity to the male students of Tulane. In 1916 the campuses drew closer emotionally. Tulane was in need of a new grandstand for its ball field, and Herman Seiferth, a local newspaper editor, conceived the idea of setting aside a whole day for fund raising to build a new stadium. The Newcomb students thought the idea a great one in which to participate. March 31, 1916, was designated as Realization Day. The guild building became a beehive of activity as the students and faculty set about to create work that would be sold in every store on Canal Street. The newspapers gave it wide publicity and

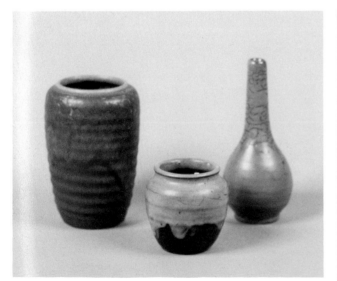

Undecorated matt glazed wheel-thrown pots of Joseph F. Meyer. Green and blue jar bears marks of JM, NC; 1910–18; 5½″ tall. Small jar-vase in green and black matt glaze bears marks of JM, NC; 1910–18; 3″ tall. Long-neck bottle-vase in green crackle matt glaze bears marks of JM, NC; 1910–18; 6″ tall. (Louisiana State Museum Collection)

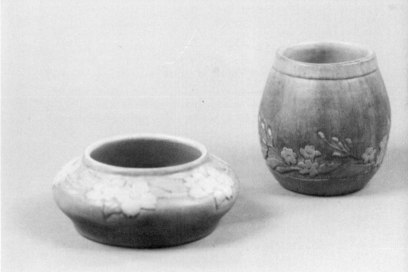

Low bowl with low relief modeled of dogwood motif in yellow, medium blue, and green matt glaze on cream body. Decorated by Alma Mason, potter unknown; bears marks of AM, NC, B, FX37; circa 1910; 2″ x 5¼″. Jar-vase with wild rose motif modeled in low relief on cream clay body in blue and green matt glaze. Decorated by Hermione Weil, potter unknown; bears marks of H. WEIL, Q NH; circa 1916; 4″ tall. (Louisiana State Museum Collection)

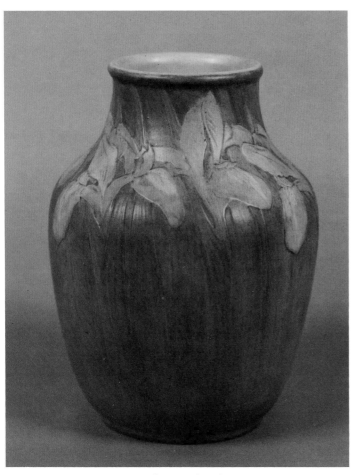

Periwinkle flower motif in center of low bowl in cream clay body. Flower motif in low relief in tones of pink, pale blue, and green in matt glaze. Decorated by Henrietta Bailey, thrown by Joseph Meyer. Bears marks of HB, JM, NC, JG9; 1910–18; 2″ x 9″. (Louisiana State Museum Collection)

Large jar decorated with Louisiana iris motif on cream clay body and matt glazed in medium blue and blue-green. Decorated by Henrietta Bailey, thrown by Joseph Meyer. Bears marks of HB, JM, NC, IL4; circa 1913; 9½″ x 7″. (Louisiana State Museum Collection)

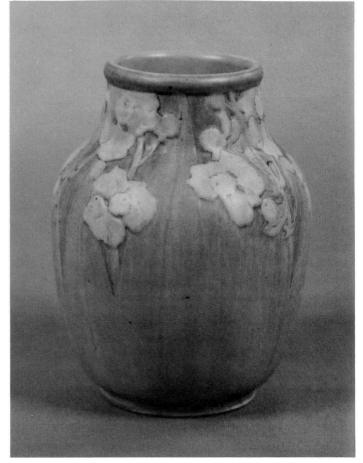

Open-mouthed jar with bearded iris motif, in low relief of medium blue, yellow, and green matt glaze. Decorated by Henrietta Bailey, thrown by Joseph Meyer. Bears marks of HB, JM, NC, JD67; 1910–18; 8″ x 6½″. (Louisiana State Museum Collection)

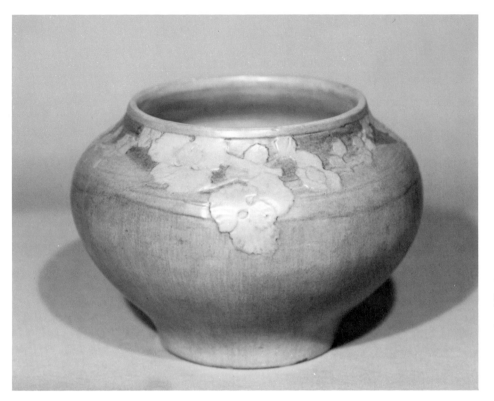

Bowl-shaped container done in white narcissus with yellow cup motif around upper rim, medium and dark blue and yellow matt glaze on cream clay body. Decorated by Henrietta Bailey, thrown by Joseph Meyer. Bears marks of HB, JM, NC, JG99; 1910–18; 7″ tall. (Collection of Dr. and Mrs. R. Wynn Irvine)

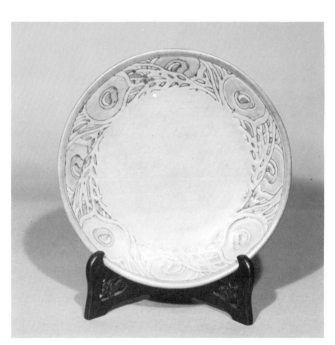

Plate in lightly incised flower motif on cream clay in tones of pale blue and green matt glaze. Decorator unknown, thrown by Joseph Meyer. Bears marks of JM, NC, HE38; 1910–18; 8¼″ round. (Collection of Dr. and Mrs. R. Wynn Irvine)

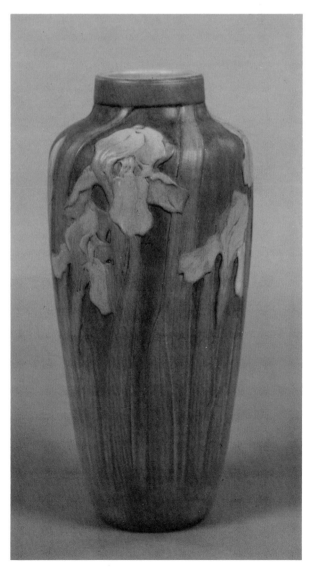

Tall vase with Louisiana flag lily motif in low modeled relief, medium green leaves on medium blue background in matt glaze. Decorated by Anna Frances Simpson, wheel-thrown by Joseph Meyer. Bears marks of AFS, JM, NC, 151; 1910–18; 12″ tall. (Louisiana State Museum Collection)

helped persuade the merchants to turn their premises over to the students for the sale of their crafts, candy, handmade flowers, and handkerchiefs. Everyone on the Newcomb campus worked on the project, including the high school students, and every student, regardless of age, became a salesperson for that day. When the day was over, a total of more than five thousand dollars had been earned through their efforts. Other Realization Days would occur, but none as much fun for the Newcomb student body.

The new campus was not yet started. Although much of the design for the new building had been completed, the Tulane board had not authorized spending the funds from the endowment that Mrs. Newcomb left to the

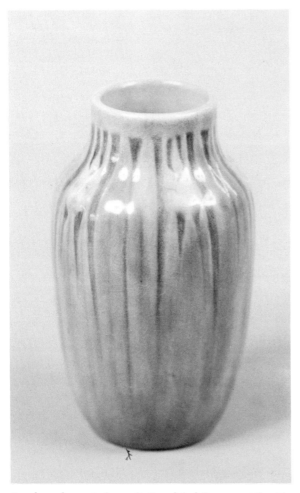

Jar-shaped vase in low relief modeled flower motif, with blue and green underglaze on cream body and shiny transparent glaze on surface. This is a transition piece of work. Decorated by Henrietta Bailey, potter unknown. Bears marks of HB, NC, 38; circa 1910; 7″ tall. (Louisiana State Museum Collection)

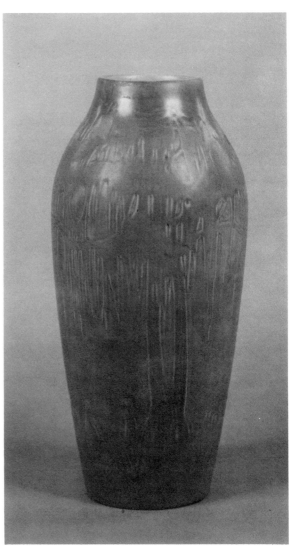

Tall vase with low modeled relief encircling the pot of moss-draped cypress trees. Entire surface is glazed in mauve and pink matt glaze. Decorated by Sadie Irvine, wheel-thrown by Joseph Meyer. Bears marks of SI, JM, NC, FY57; 1910–18; 14″ tall. (Louisiana State Museum Collection)

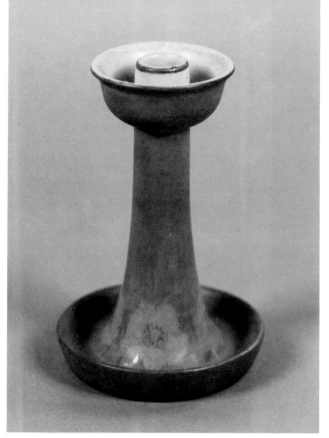

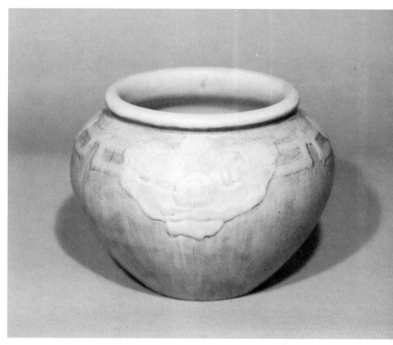

Poppy motif at base of candle holder in medium blue matt glaze on cream clay body. Decorated by Anna Frances Simpson, thrown by Joseph Meyer. Bears marks of AFS, JM, NC, FG58; 1910–18; 6½″ tall. (Louisiana State Museum Collection)

Open-mouth low vase shape in matt glaze, with large Cherokee rose design in tones of white on background of blue-green on cream clay body. Decorated by Hannah Seymour Graham, thrown by Joseph Meyer. Bears marks of HSG, JM, NC, FS85; 1910; 6″ x 7″. (Private collection)

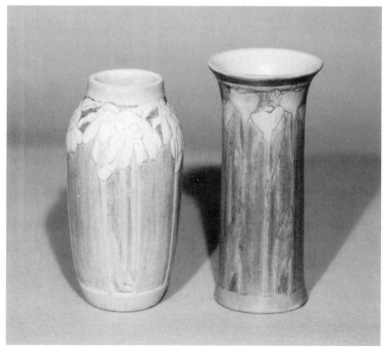

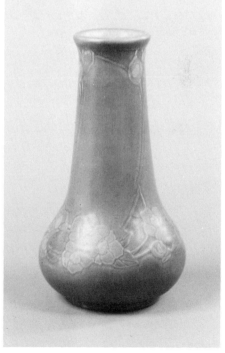

Black-eyed Susan motif on narrow vase; green and blue matt glaze on the low modeled relief. Decorated by Hannah Graham, thrown by Joseph Meyer; bears marks of HSG, JM, NC, GH48; 1911; 5½″ x 3″. Cylinder-shaped vase with stylized flower motif in low modeled relief in tones of blue-green matt glaze. Decorated by Hannah Seymour Graham, thrown by Joseph Meyer; bears marks of HSG, JM, NC, FN6; 1910; 6″ x 2¾″. (Private collection)

Tall closed-mouth vase in cream clay body with flower cluster motif in mauve, yellow, and pink matt glaze on low modeled relief. Decorated by Cynthia Littlejohn, thrown by Joseph Meyer. Bears marks of CL, JM, NC, 179; 1910–18; 9″ x 5″. (Louisiana State Museum Collection)

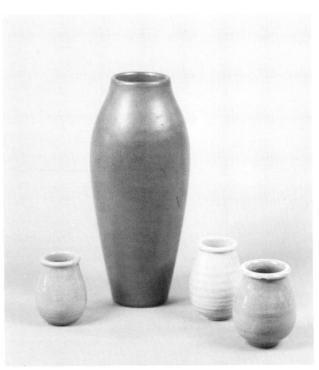

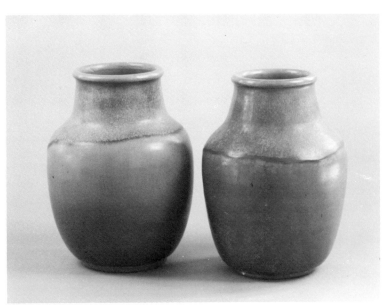

Pair of large jars glazed in blue-green vellum. No decoration on surface, thrown by Joseph Meyer. Bears marks of JM, NC; 1910–18; 9″ x 6″. (Louisiana State Museum Collection)

Three small Forty Thieves jars and large closed-mouth vase in undecorated glazed ware thrown by Joseph Meyer. Small jars in pale blue, yellow, and pink matt glaze, bearing JM and NC marks; each 2½″ high. Tall vase in mauve matt glaze bears marks of JM and NC; 8½″; 1910–18 period. (Louisiana State Museum Collection)

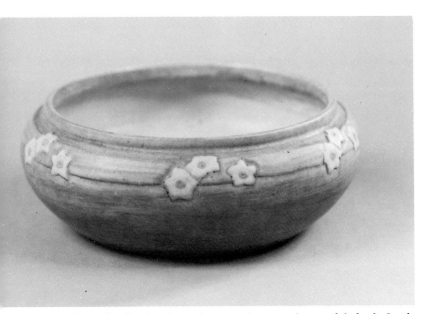

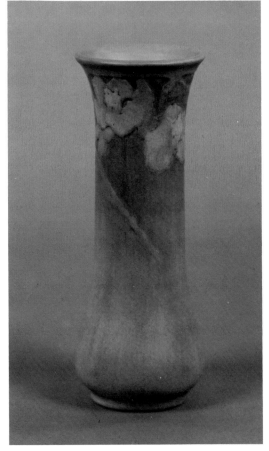

Large low bowl with mock orange flowers in low modeled relief with blue background in matt overglaze. Decorated by Hermione Weil, thrown by Joseph Meyer. Bears marks of HWEIL, JM, NC, B6; 1910–18; 3½″ x 8½″. (Louisiana State Museum Collection)

Tall narrow-neck vase with lily motif around top rim in pale blue and green on background of medium blue matt glaze in cream clay body. Decorated by Sadie Irvine, thrown by Joseph Meyer. Bears marks of SI, JM, NC, JT96; 1910–18; 9″ x 3″. (Louisiana State Museum Collection)

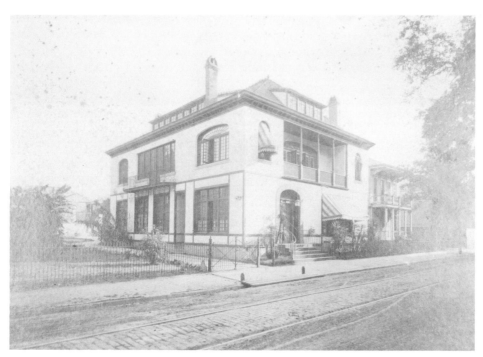

The Newcomb Guild Building at 2828 Camp Street, designed by Ellsworth Woodward and built in 1901–1902. Photo shows the streetcar tracks for the now defunct Camp Street car. (Louisiana State Museum Collection)

college. In 1916 the Newcomb Alumnae and the Art Alumnae associations served notice on the Tulane board that they would not tolerate any further delays. The art school had outgrown 2828 Camp Street. The quarters were too small for expanding the pottery or increasing the work area in the jewelry, embroidery, bookbinding, and metal crafts. Orders for Newcomb crafts had been pouring in so rapidly that the craftsmen were falling over each other trying to meet the demand. Newcomb had educated and trained a large number of craftsmen by this time, and they were anxious to use their training to earn a living. The Tulane board sold the Washington Avenue campus to the New Orleans Baptist Theological Seminary for $100,000. Dr. Dixon and Ellsworth Woodward urged the Tulane board to proceed at once with construction. On January 9, 1917, the board finally authorized the beginning of construction.

Great excitement reigned at Newcomb, and a formal ceremony was planned, with a parade and speeches to accompany the pile-driving event. The morning of February 24, 1917, was chosen for this ceremony. A letter written by an alumna can best describe the day:

. . . I cannot say what predominated: Balloons, flags, Newcomb pennants or noise. There was an abundance of all these and packed into one hundred or more automobiles, it made a very, very creditable parade. . . . As it wound its way out

113

Washington and up St. Charles Avenue, it looked like a long wavery line. . . . To me Newcomb isn't just a group of old buildings. A part of me is still there, a precious joyous part of me. . . . This new Newcomb can never mean what the old does. We can be proud of it, we can rejoice that our little sisters are to be given such wonderful opportunities there. . . . But in our minds and hearts Newcomb will never move from the old oak-shadowed square down on Washington Avenue.

Although the campus was to be modern and very up-to-date in equipment, the crafts produced would lose some of their past quality. The reasons for this will be explained later. However, that is hindsight, and at this time in the history of the Newcomb Art School, the move and the new building seemed wise.

## 1918–30

In the fall of 1918 the college moved into its new and present campus on Broadway. The complex, which includes many buildings today, had then only three large buildings for the college's use. In the center of the frontage facing Broadway was Newcomb Hall, the administration building; to the left of Newcomb Hall was a large dormitory named for Mrs. Newcomb, called Josephine Louise House; and to the rear of Josephine Louise House on the

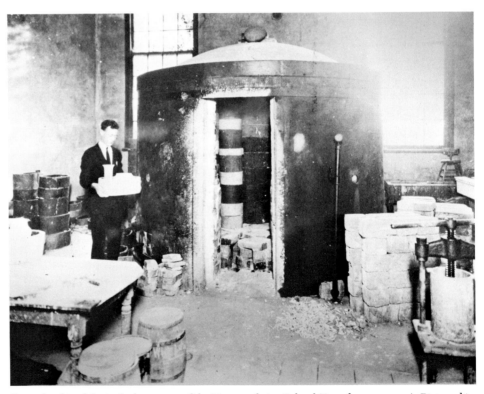

Large beehive kiln in the basement of the Newcomb Art School (Broadway campus). Pictured is Kenneth E. Smith, about 1935. The kiln was destroyed in 1957 to make way for a metal foundry for the art school. (Louisiana State Museum Library)

114

inner quadrangle was the art school building. The other buildings in the complex were to be added in later years as monies became available. These included the music school, the gymnasium, and other domitories and supportive buildings.

Newcomb's beloved chapel was left behind. At first it was thought that it could be dismantled and moved piece by piece to the campus, but this proved unfeasible. Instead, the windows made by the Tiffany Glass Company were removed and, along with the brass tablet, crated and stored in the attic of Newcomb Hall. The use of the chapel on Washington Avenue was retained. The chapel stood on the Washington Avenue campus until it was destroyed with the other buildings in the 1950s. At this writing, a chapel is under construction on the lawn to the right of Newcomb Hall. The Tiffany windows are to be installed in this new structure. After almost sixty years, Mrs. Newcomb's memorial to her daughter will again be a reality. For many alumnae this is a long-awaited event. This link with the old campus is as strong in feeling as the sturdy oak trees that line the present campus.

The new Newcomb Art School building had one of the finest facilities in the nation for teaching arts and crafts. The first or ground-level floor contained the

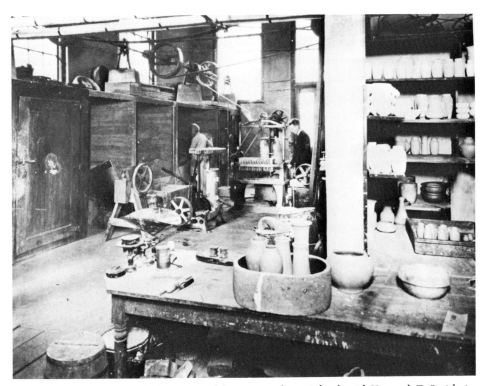

The large pottery room in the basement of the Newcomb Art School, with Kenneth E. Smith, in dark suit, in center rear of photograph, taken about 1935. The equipment was dismantled in 1957. (Louisiana State Museum Library)

pottery operation. In the rear of the building stood a huge beehive downdraft kiln. Along the walls were overhead belt-driven potters' wheels and numerous shelves and storage for clay. For the first time, the decorators had enough worktable space. Two large damp cellars were provided, a big drying room, spraying booths for glazing, and an entire room for glaze materials and preparation. On the upper three floors were studios, classrooms, galleries, offices, lounges, and an auditorium.

Paul Cox left Newcomb College in this period to go to Iowa State University. He was followed by a series of potters and ceramic chemists: Frederick Walrath, 1918–22, died while on the faculty; Vincent Axford, 1922–27, became an instructor in chemistry in 1925; Harry Rogers, 1927–30, became an instructor in ceramic chemistry in 1929; Jonathan Bowne Hunt, 1928–34; Kenneth E. Smith, 1929–44; Francis Ford, 1944–48 (part-time until February 1, 1945). Each of these potters put his stamp on the ware, and each added his special touch to the types produced. It is interesting to note that the beauty of the pottery stems from the variances in shape and technique that each individual potter added. Although Joseph Meyer was the most famous, others did excellent wheel work, and their various efforts speak well for themselves.

The guild continued to do the low modeled relief with the soft-toned matt glaze that was developed by Paul Cox. Now, with the expanded facilities, more work could be turned out. Ten full-time decorators worked six days a week to meet the demand for the pottery. The large beehive kiln was filled and fired regularly, and three small kilns were added to augment the firings of the big kiln. Sales increased spectacularly, reaching about thirty thousand dollars a year in pottery alone. In an article about the guild, Kenneth Smith wrote: "The standard ware (that still decorated by graduate students) has become more or less stereotyped in color, decorative treatment, and design. This style is so entrenched on the buying public that it has become a 'hallmark' of Newcomb Pottery to the extent that when the decorators make a piece even in the same technique but using another color than the traditional soft blues and greens, it will stay on the shelves unnoticed or unrecognized as real Newcomb Pottery."

The real pottery in the public's mind was that with the moss-draped live oak, southern pine, Louisiana cypress, magnolia grandiflora, Louisiana iris, marsh maple, Cherokee rose, day lilies, and water hyacinth always done in odd-number motifs. Ellsworth Woodward, a true nature-lover, would take large groups of students in the spring and fall on field trips to sketch from nature the future designs for the crafts. Many times the workers stopped their tasks to go on these all-day picnic excursions. Woodward felt that nature and beauty were everywhere and could be found in one's own back yard. In one of his writings he said that the sunsets in Louisiana were the most beautiful in the world. He imparted a love of nature in Louisiana to both students and workers, and they never forgot his teachings.

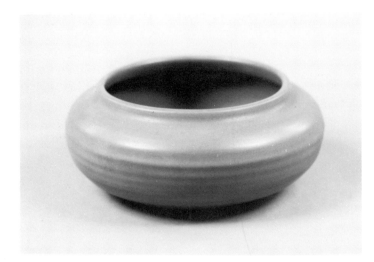

Undecorated wheel-thrown low bowl
by Joseph F. Meyer bearing marks of
JM and NC, in pale pink matt glaze;
inventory number NP104 0; 1920–28;
4″ x 9″. (Louisiana State Museum Col-
lection)

Tall vase with low relief
motif of pine cones and nee-
dles, pine cones in pink,
needles in green, on back-
ground of dark blue on
cream body with matt glaze.
Decorated by Henrietta
Bailey, thrown by Joseph
Meyer; bears marks of HB,
JM, NC, PM80; 1920–28;
14″ x 7″. Small jar in tones of
pink, mauve, and purple
matt glaze on cream body
with low modeled relief
flower motif. Decorated by
Henrietta Bailey, thrown by
Joseph Meyer; bears marks
of HB, JM, NC, IT80; circa
1920; 5″ x 4″. (Louisiana
State Museum Collection)

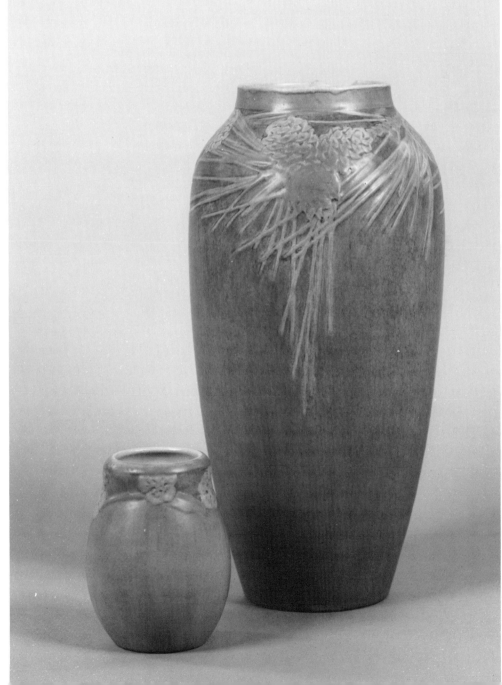
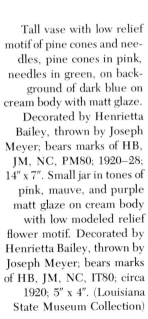

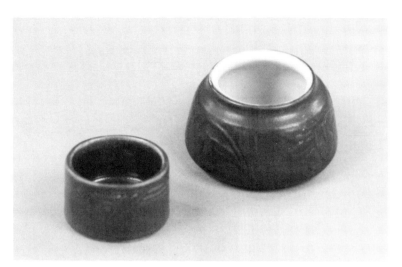

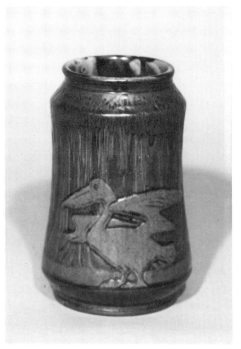

Small jar decorated with low relief flower design and glazed in black vellum matt glaze. Decorated and thrown by Fred E. Walrath, bearing his mark; circa 1921; 2″. Paperclip holder in cherry red matt vellum glaze with a small incised decoration. Wheel-thrown and decorated by Fred E. Walrath, bearing his mark; circa 1921; 1½″ x 2″. (Walther Collection)

Vase with unusual pelican motif in tones of dark blue and lighter blue matt glaze on cream clay body. Decorated by Anna Frances Simpson, thrown by Jonathan Hunt. Bears marks of AFS, JH, NC, SG11; 1928–30; 7¾″ x 5″. (Vial Collection)

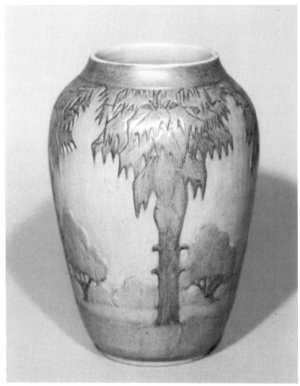

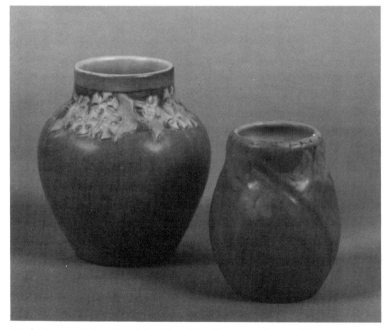

Vase with low modeled palm trees and small trees in background on cream clay body, matt glazed in tones of blue and blue-green. Decorated by Anna Frances Simpson, thrown by Jonathan Hunt. Bears marks of AFS, JH, NC, RU83; 1928–30; 10″ x 8″. (Vial Collection)

Dark blue matt glaze jar with white phlox flowers and green foliage motif. Modeled in low relief by Anna Frances Simpson, wheel-thrown by Jonathan Hunt; bears marks of AFS, JH, NC, SN56; 1928–30; 6½″ x 5″. Jar-shaped vase with stylized flowers of white and green on dark blue matt glaze background. Decorated by Henrietta Bailey, wheel-thrown by Joseph Meyer; bears marks of HB, JM, NC; 1920–28; 5″ x 3½″. (Louisiana State Museum Collection)

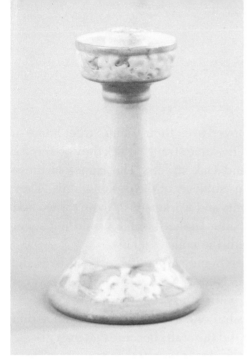

Candle holder with mock orange motif in low modeled relief on cream body, pale blue and green matt glaze. Decorated by Anna Frances Simpson, potter unknown. Bears mark of AFS only; circa 1920; 7″ x 4″. (Louisiana State Museum Collection)

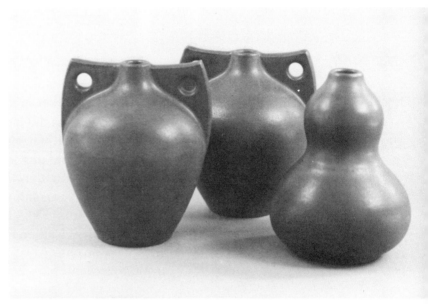

Pair of bottles and double-gourd vase in dark blue vellum matt glaze. Potter and craftsman unknown. Bottles bear marks of NC, 9039 and 9039A; 6″ x 5″. Double gourd is marked NC, 9039C; 7″ x 4½″. Circa 1925. (Louisiana State Museum Collection)

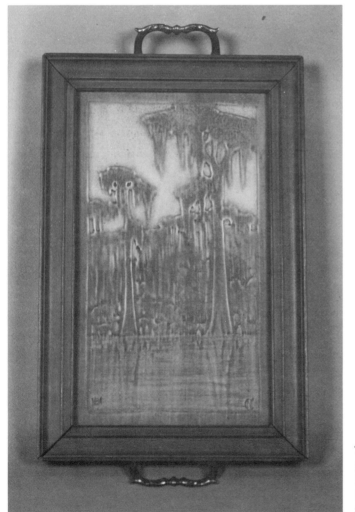

Two glazed wheel-thrown undecorated pots by Joseph F. Meyer. The double-gourd vase is in gray and mauve matt glaze; bears marks of JM, NC, NP119–0; 7½″ x 4½″. Open-mouth jar in gray and mauve matt glaze bears marks of JM, NC, NP139–R; 5″ x 3″. Both 1920–28. (Louisiana State Museum Collection)

Tile tray in blue, blue-green, and green matt glaze with Louisiana cypress tree motif. Decorated and made by Henrietta Bailey; 1918–30; 10½″ x 5½″. (Louisiana State Museum Collection)

Mr. and Mrs. Ellsworth Woodward moved from their Camp Street home to another one near the Broadway campus. By some strange quirk they selected a house on Pine Street between Plum and Oak streets. The names of these streets were the same as the most famous subjects of the design motifs. They continued their practice of having students and workers visit them for tea and meals. Woodward wrote in a letter to Sadie Irvine that life would not seem pleasant without sharing their home with the college family.

The crafts of the Newcomb style were being shipped weekly all over the United States. Fine stores like Tiffany's in New York City had large displays of the pottery, jewelry, leathercraft, and embroidery and were constantly replenishing their inventory. Tiffany's was but one of many stores in the nation that carried Newcomb crafts. So popular did the crafts become that every bride in New Orleans would receive at least half a dozen assorted Newcomb crafts as gifts.

In October of 1919 Dr. Brandt V. B. Dixon retired as president of Newcomb College, a position he had held for thirty-two years. He turned over his duties to Dr. Pierce Butler, who was dean of Newcomb College. It is interesting to note that the college has had only one president, that being Dr. Dixon. After

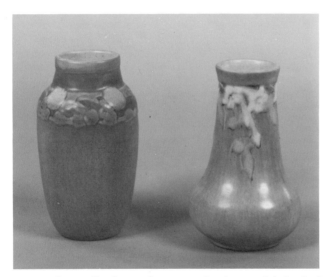

Vase with camellia flower design motif in low modeled relief, pink flowers, green leaves, and top rim of brighter green on medium blue background of matt glaze. Decorated by Sadie Irvine, wheel-thrown by Joseph Meyer; bears marks of SI, JM, NC, NL68; about 1925; 6½″ x 3½″. Closed-mouth vase with Confederate jasmine motif, flowers in white, leaves in bright green on background of medium blue matt glaze. Decorated by Anna Frances Simpson, wheel-thrown by Joseph Meyer; bears marks of AFS, JM, NC, OT75; about 1927; 6″ x 3½″. (Louisiana State Museum Collection)

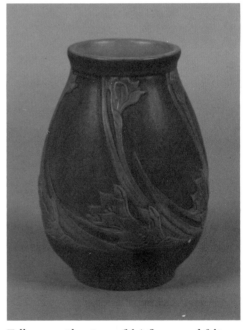

Tall vase with crinum (lily) flower and foliage design in low modeled relief. Flowers are rose, leaves are green, and background is dark blue-purple matt glaze. Decorated by Anna Frances Simpson, wheel-thrown by Jonathan Hunt. Bears marks of AFS, JH, NC, RQ31; 1929; 7½″ x 5″. (Louisiana State Museum Collection)

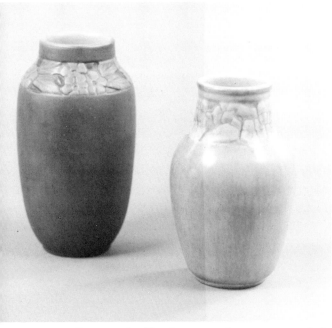

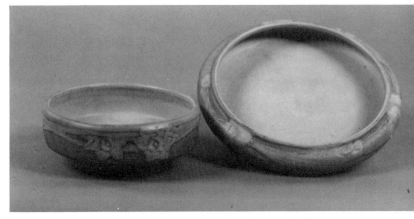

Tall vase with phlox flower motif on top rim in dark blue, pink, and green matt glaze on cream body in low modeled relief. Decorated by Anna Frances Simpson, thrown by Joseph Meyer; bears marks of AFS, JM, NC, PX77; 1918–28; 7″ x 4½″. Closed-mouth vase with low modeled stylized flower motif in blue, pink, and green matt glaze. Decorated by Anna Frances Simpson, thrown by Jonathan Hunt; bears marks of AFS, JH, NC, SB53; 1928–30; 6½″ x 4″. (Louisiana State Museum Collection)

Two low bowls in matt glaze on cream body with low relief flower motifs, green, pale blue, and medium blue tones. Both decorated by Sadie Irvine and thrown by Joseph Meyer. Left bears marks of SI, JM, NC, LP33; circa 1920; 2½″ tall x 5½″ round. Right bears marks SI, JM, NC, LG59; circa 1920; 2″ tall x 8″ round. (Louisiana State Museum Collection)

his retirement, the title of president was never used again. The college is presided over by a dean. Under Dr. Dixon's leadership the college had grown from fewer than a hundred students in all categories to over seven hundred students in 1919. Dr. Dixon and Mrs. Newcomb had given the community an institution of great value. In the thirty-two years under his direction, the college had moved three times, each time into larger quarters. With the college's growth came the fame of the Newcomb crafts. The college had survived yellow fever, two wars, business depressions, and influenza. The faculty of seven in 1887 had grown by Dr. Dixon's retirement into a faculty of sixty-three: twenty-nine professors and instructors in regular academic studies and six teaching fellows; eight professors and instructors in the art school, one potter, and one ceramic chemist; fourteen in the music school; and four in the household arts department. Others would retire in this period.

The nation after World War I had new wealth, and education became a must for every young woman of means. The dream of a college education for one's children swept the nation. Women were about to have the right to vote, and career opportunities were opening for women everywhere. With this new awareness came a feeling of self-worth and freedom. In 1921 Newcomb's high

school was disbanded, because the need to educate girls for Newcomb College entrance was being served by private and public schools, many with Newcomb graduates as the teachers. Newcomb College had passed another milestone.

New Orleans experienced a building boom of new housing. Until now, in the South, it was not uncommon for three generations to live together, but the Roaring Twenties changed this custom. The bungalow, with its lower ceilings, became an architectural style for the newly built-up section around the Tulane and Newcomb campuses. The crafts of the Newcomb style adapted themselves easily to this new mode, and to a new American lifestyle brought about by electricity and the automobile. In fact, while the crafts had been avant-garde in the early part of the century, they now represented the accepted decorative style.

Production was stepped up in the crafts to fill this demand. In this period, 1918–30, forty to fifty thousand individually wheel-thrown, hand-decorated, and glazed pieces of ware were made. This number boggles the modern potter's mind.

Coupled with this large output of pottery, of course, was the output of jewelry, metalwork, bookbinding, and needlecraft. Cloisonné became increasingly popular in this period, and the college perfected this technique to its

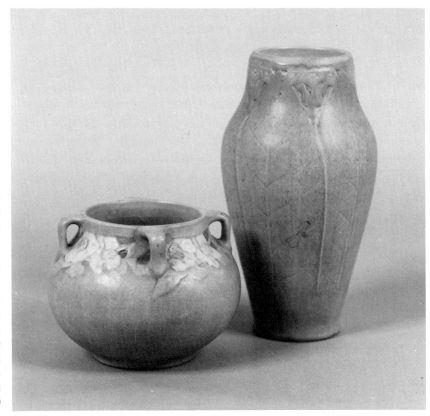

Small vase with handles in flower motif of single camellia japonica in white matt glaze, leaves in medium green matt glaze, with blue-green matt background on cream clay body. Decorated by Anna Frances Simpson, thrown by Joseph Meyer; bears marks of AFS, JM, NC, OT92; 1926; 4½" x 6". Tall vase in verbenna flower motif, flowers in pink matt glaze on background of blue-gray matt glaze, on cream clay body. Decorated by Sadie Irvine, thrown by Joseph Meyer; bears marks of SI, JM, NC, OM73; 1925; 9" x 5". (Louisiana State Museum Collection)

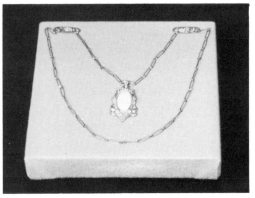

Sterling silver necklace chain and pendant of abalone. Pendant has grape motif that is repeated on chain. Designed and executed by Georgia Seago in 1925. (Collection of Mrs. G. S. Fischer)

Sterling silver jewelry designed and made by Mary Rosenblatt. Belt buckle is pierced-out monograms of letters MLR; 1924–28; 1″ x 1½″. Hand-hammered bracelet has pierced-out monogram applied to it; 1924–28; 2½″ overall. (Louisiana State Museum Collection)

Sterling silver bracelet with dark blue cloisonné in pierced-out motif. Designed and executed by Carmen Favrot; 1918–29. (Collection of Carmen Favrot)

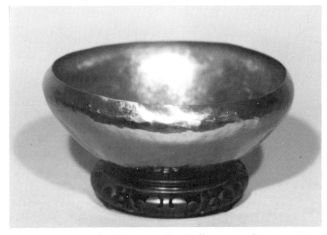

Handmade copper bowl of hammered texture. Designed and executed by Myrtle Pujol; 1918–22; 3″ tall x 8¾″ round. (Collection of Mrs. Louis A. Dupuy)

Sterling silver trivet designed and executed by Alice Moise in 1935. The pierced-out motif is incorporated with initials of EMP, and the metal is of satin brush finish; 8″ x 9″. (Private collection)

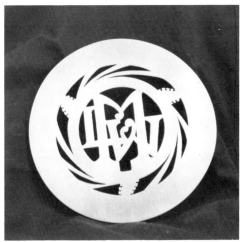

Sterling silver trivet in pierced-out design of pine cones and needles and circle motif with LWM monogram. Designed and executed by Alice Moise in 1940. (Louisiana State Museum Collection)

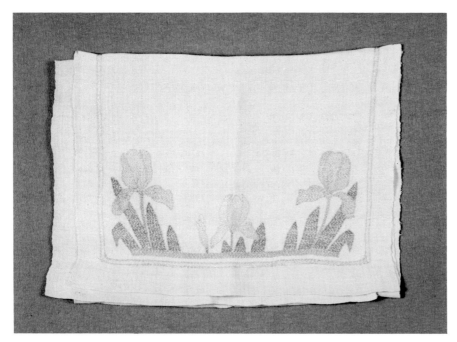

Table runner in handspun-woven Russian crash fabric, bearded iris motif in satin and darning stitch. Designed and executed by an unknown craftsman; 3′8″ x 15″. (Louisiana State Museum Collection)

Embroidered lady's handbag in silk fabric, with wood handles for mounting of work, designed and executed by Marcelle M. Peret. Flower motif in outline, darning, satin, and buttonhole stitches in pastel colors of red, blue, yellow, and green on natural silk background. About 1922; 9½″ x 10″. (Louisiana State Museum Collection)

Unfinished dogwood motif in darning stitch on handspun linen crash, with green silk thread. Designed and executed by Marcelle M. Peret about 1922; 21″ x 15″. (Louisiana State Museum Collection)

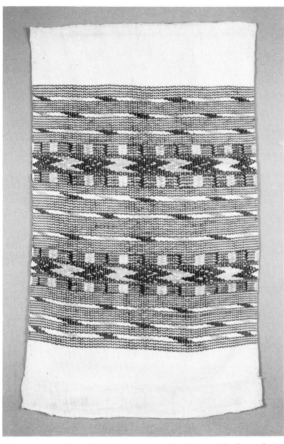

Darning stitch in black, rose, and yellow silk thread on handspun linen crash. Embroiderer unknown; 2′5″ x 18″. (Louisiana State Museum Collection)

Linen bridge cloth embroidered in satin and outline stitches, flower motifs in pastel tones at each corner in silk thread. Designed and executed by Marcelle M. Peret about 1922; 2½′ square. (Louisiana State Museum Collection)

Chinese straw holder containing silk threads used in Newcomb embroidery. (Louisiana State Museum Collection)

Unknown craftsman executed this unfinished table runner, with needle and silk thread still in place. Date unknown; 3′6″ x 17″. (Louisiana State Museum Collection)

Pelican in glazed clay, designed and executed by Ruth Maddox in 1929; overall measurement, 9″. (Private collection)

In classic motif of live oak tree with Spanish moss, this bookplate was designed and executed by Myrtle A. Pujol in 1922. (Collection of Mrs. Louis A. Dupuy)

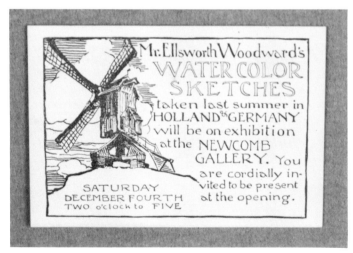

Invitation done by Ellsworth Woodward for his own show in 1920. (Louisiana State Museum Collection)

highest. Some of the most beautiful handcrafted jewelry was produced at this time. Kenneth Smith wrote a long article on the technique that the art school employed. Using 22-gauge silver with the design soldered on the piece as a foundation, the piece was first pickled in a dilute solution of hydrochloric acid. The enamel was passed through a 20-mesh screen, then melted to Cone 010 (950 degrees C.) and poured into water, then washed and ground. The metal was completely burnished. Newcomb used two methods of firing on the enamel—blowtorches were used for small pieces, and large pieces were placed in a small muffle kiln. The kiln temperature was raised to Cone 012 (910 degrees C.). Then the piece was placed in the hot kiln for about two minutes, withdrawn from the kiln and air cooled, and the next color placed on the piece, and this repeated until all colors were in place. These were the formulas used:

Soft base %
White lead    68.8
Sodium bicarbonate    11.2
Flint / Silica    20.0

Hard base %
White lead    70.0
Sodium bicarbonate    10.0
Flint / Silica    20.0

To the base formula, metal oxides for color were added in percentage of the total weight of the base: blue, 1 percent cobalt oxide; dark green, 8 percent chrome oxide; black, 2 percent manganese oxide and .5 percent cobalt oxide; white, .5 percent tin oxide. Bracelets, brooches, earrings, and necklaces were the favorites, but very popular second choices were letter openers and bookmarks.

In September, 1929, Kenneth E. Smith came to the art school, having just graduated from Alfred University's New York State College of Ceramics. Single and very young, he took up some of the duties of Joseph Meyer, whose eyesight was failing. Meyer, now in his eighties, had served the college long and faithfully. It was he who had thrown the major portion of all the pottery produced in the guild. Kenneth Smith remained at Newcomb until 1945, when the guild was disbanded. But along with Kenneth Smith came a new era in the development of the ware.

Miss Anna Frances Simpson, the first of the decorators who had labored so long and hard to make the beautiful motifs, died in the early summer of 1930. Retirement and death would soon reduce the ranks of those who had shaped the movement, but it was still a few years before the last of the crafts would be discontinued. The guild was well into its thirty-fifth year, and those who had begun the movement were reaching the age when they could no longer physically do the work.

Ellsworth Woodward wanted to end the guild when his retirement ap-

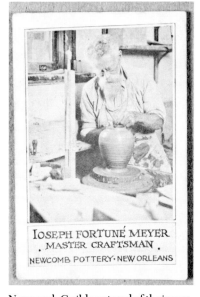

Newcomb Guild postcard of their master potter. Photographed in the basement of the art school of Newcomb College on Broadway. (Louisiana State Museum Collection)

127

proached, but the Tulane board decided that it must be maintained. One reason was the amount of money that the guild produced annually for the art school. The country was in a severe financial depression, student enrollment was down, and the guild was an extra source of income. One can only speculate what the outcome might have been if the Newcomb Guild had been disbanded in 1930. It continued until 1945, however, and this period from 1931 to 1945 was the final phase of the movement.

Bookplate done from a linoleum block. Designed and executed by Mary Rosenblatt. (Louisiana State Museum Collection)

Poster announcing exhibition about 1915, in Newcomb-style lettering. (Appears in *The Year Book of Tulane University* [1916], page 43. Louisiana State Museum Library)

The ALUMNAE of the
NEWCOMB
SCHOOL of ART
take pleasure in
announcing an exhibition
of Water colors by
SIDNEY
RICHMOND
BURLEIGH
You are cordially invited
to attend the informal
reception in the
Newcomb Art Gallery
February 9th.
from 3:30 p.m to 6 p.m.
The exhibition will
continue until March 1st.
R.BULTMANN

You are
cordially invited to at-
tend the eighteenth
annual Exhibition and
Sale of Art work con-
ducted by the Alumnae
of the NEWCOMB SCHOOL
of ART. Opening
DECEMBER · 2 · 1925 at 8 p.m. and
continuing DECEMBER 3 and 4
from 10 a.m. to 5 p.m.

The Alumnae have the
honor of including in the Ex-
hibition a collection of paintings
by Ellsworth Woodward

NEWCOMB SCHOOL of ART
AUDUBON ~ PLACE
RUTH · E · BULTMANN

THE ALVMNAE OF
THE NEWCOMB
SCHOOL of ART
INVITE YOV TO AN EX-
HIBITION OF ILLUMIN-
ATED AND ENGROSSED
TEXTS BY ◦◦◦◦◦◦◦
RVTH·BVLTMANN

BEGINNING FEBRVARY THE
ELEVENTH·NINETEEN HVN-
DRED TWENTY SIX
NEWCOMB SCHOOL OF ART
AVDVBON · PLACE

THE ASSOCIATION
HAS PECULIAR PLEASVRE
IN PRESENTING THIS
WORK BECAVSE OF ITS
BEAVTY AND PRACTICAL
VALVE. ◦◦◦◦◦◦ AB

Collection of handsome lettering for
invitations issued by the Newcomb
Art School. Designed and executed by
Ruth E. Bultmann between 1925 and
1930. (Private collection)

The spring of 1931 saw some of the original group retire or die. There were changes in the concept of the movement as new directors took the places of those early leaders who had made the guild a national and international artistic success. Although the guild and its crafts were a financial success, that was never the primary concern of Dr. Dixon, Ellsworth Woodward, and Mary Sheerer. Their concern was good quality and artistic merit. The Woodward saying of "Art is work well done" was always their paramount guiding principle.

Joseph Meyer died on March 16, 1931, at the age of eighty-three. He had retired in 1928 because of age and the loss of his eyesight, and Kenneth Smith assumed all of his duties as master potter. The death of Meyer was a personal blow to people like Ellsworth Woodward, Mary Sheerer, Dr. Dixon, and Sadie Irvine. They had all been closely bound together, not only in work but also in their private lives. They each considered the others close personal friends.

Both Ellsworth Woodward and Mary Given Sheerer retired at the end of the school session in June of 1931. Ellsworth was succeeded by Miss Lota Lee Troy, who had taught design and bookbinding for years at the art school. She had come to the art school at 2828 Camp Street, having been hired by Dr. Dixon in 1909, and was prominent in the promotion of bookbinding as a highly specialized art form. Many of the present-day bookbinders had their training under Miss Troy. She carried out the traditions of the Woodward brothers, and little changed in the philosophy of the art school under her direction. The changes were to take place later in this period. Kenneth Smith assumed all the duties of Mary Sheerer. It was at this time that the mechanical equipment was

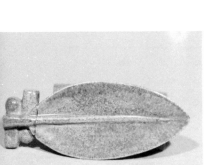

Ceramic construction in white clay with a speckled yellow-toned glaze. Designed, executed, and marked by Juanita Gonzalez; 1930–35; 5″ x 2″. (Louisiana State Museum Collection)

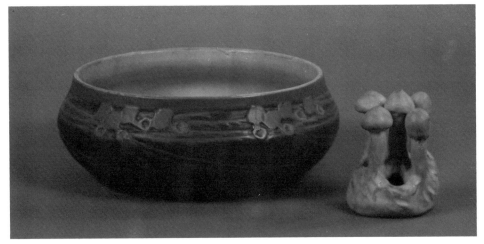

Low bowl with low relief Dutchman pipe motif in cream clay body; lavendar flowers on blue-purple matt glaze. Decorated by Sadie Irvine, thrown by Jonathan Hunt; bears marks of SI, JH, NC; 1928–34; 3½″ tall x 8″ round. Handbuilt flower frog in mushroom form in cream clay body and off-white matt glaze. Designed and built by Sadie Irvine; bears marks of SI, NC, HB; circa 1920; 3½″ x 2½″. (Louisiana State Museum Collection)

expanded in the pottery department, Sadie Irvine became the chief decorator for the guild and a part-time instructor, and Ellsworth Woodward's classes in painting were assumed by Will H. Stevens and Xavier Gonzales, both of whom became well known in the art world.

Miss Juanita Gonzales became the full-time pottery instructor for the pottery department the same year. She had a short but brilliant career. Having graduated from Newcomb in 1925, she went to New York City and became a student of the great Archipenko and other noted artists of the day, then returned to New Orleans and opened her own studio on Governor Nicholls Street. Although most of her best work was clay sculpture, her tiles and pottery were quite original for that period. Both in technique and glazing, her work was far ahead of its time. Death took her away from the art scene much too early. She died while on the faculty of the art school in July, 1935, after a lengthy illness, at the age of thirty-two. The guild was robbed of someone who may have helped shape a new direction in design. This direction was to come later, but the beginnings of a newer type of shape, form, and texture were first created by Juanita Gonzales. The results brought by her creative attempts were seen in the period 1940–45, five years after her death.

Juanita Gonzalez shortly before her death, about 1934. (Keith Temple Collection)

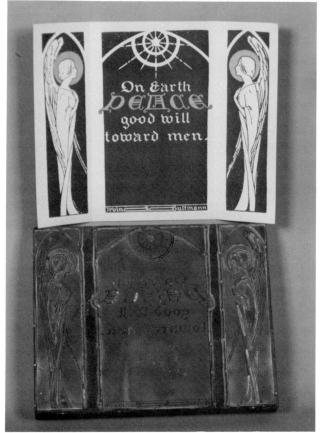

Christmas card designed by Sadie Irvine and lettered by Ruth Bultmann; 1930–35. Linoleum block is shown with finished handpainted card. (Louisiana State Museum Collection)

Handkerchief case designed and executed by Henrietta Bailey. It was not unusual to make a linoleum block for a paper printing and then use the same block on a textile. Many of the blocks were used in several mediums; i.e., block prints, bookplates, textiles, and Christmas cards. Henrietta Bailey used southern pine cones as the motif on aqua-colored cotton printed in black ink; around the edges is whipped-on black silk cording; about 1925. (Private collection)

131

Sculptured animals made by Sadie Irvine. Duck is black and orange underglaze on cream clay with shiny transparent glaze; bears her mark SI; 1935–45; 3″ x 5″. Cat in cream clay with blue-gray glaze; bears her mark SI; 1935–45; 2½″ x 5″. (Collection of Dr. and Mrs. R. Wynn Irvine)

Lamp base in red clay body with deeply incised leaf motif, glazed in semi-matt turquoise glaze. Decorated by Sadie Irvine, thrown by Kenneth Smith. Bears marks of SI, KS, NC; 1935–40; 7½″ tall. Shade in natural-color yarn by Sadie Irvine. (Collection of Dr. and Mrs. R. Wynn Irvine)

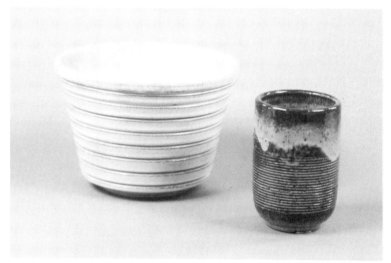

Jardiniere wheel-thrown by Francis Ford in cumulus glaze, a semitransparent white glaze, the pink tone of the clay body showing through the glaze; bears marks of F, NC; 1944–48; 4¾″ x 6¾″. Drinking glass in gulf stream glaze, tones of aqua color over dark red stone clay body. Thrown by Francis Ford; bears marks of F, NC; 1944–48; 4½″ x 2¾″. (Louisiana State Museum Collection)

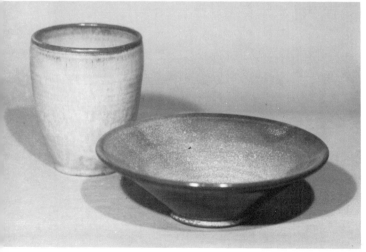

Bowl on red clay body in copper red reduction glaze. Potter unknown; bears mark of NC; 1944–48; 2½″ tall x 8¼″ round. Open-mouth vase in gulf stream glaze on red clay body. Potter unknown; bears mark of NC; about 1940; 5½″ x 4¼″. (Collection of Dr. and Mrs. R. Wynn Irvine)

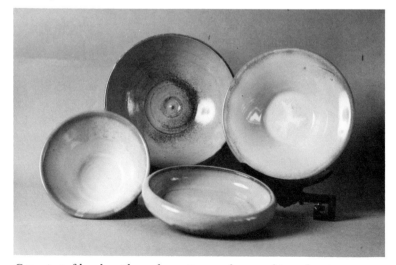

Grouping of bowls with no decorations and no marking, showing a wide range of late-period glazes. Left to right: spindrift, a blue glaze falling away to show red stone clay body at ridges, 7″ round; monks ware, a tan glaze made of nickel oxide, 7″ round; warbler, a yellow glaze made from uranium oxide, 6″ round; spindrift glaze with no markings, 6″ round. All 1940–50. (Collection of Dr. and Mrs. R. Wynn Irvine)

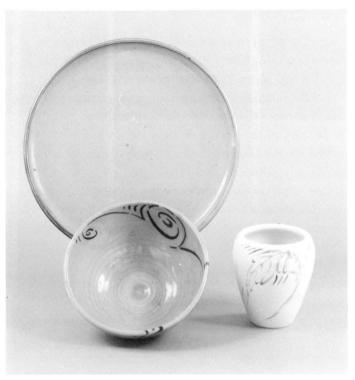

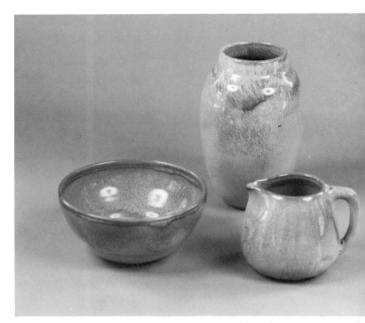

Wheel-thrown undecorated pieces in lichen glaze by Francis Ford. Cream pitcher, 3½" x 4"; vase, 7" x 4½"; bowl, 3" x 6" round. Bear marks of F, NC; about 1945. (Louisiana State Museum Collection)

Large plate with gray glaze on redstone body by Kenneth Smith, bearing marks of KS, NC; circa 1940; 10" round. Cream-colored clay body bowl, underglaze black decoration, with transparent glaze; decorated by Sadie Irvine, thrown by Francis Ford; bears marks of SI, F, NC; about 1945; 3" x 6". Vase decorated by Sadie Irvine in underglaze leaf motif with transparent shiny glaze; potter unknown; bears marks of SI, NC; about 1945; 4¼" x 3¾". (Louisiana State Museum Collection)

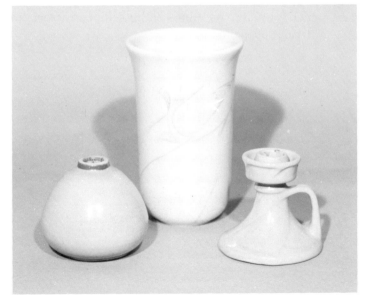

Tall vase in cream clay body with pale black underglazed motif of fighting fish and shiny transparent glaze over entire surface; decorated by Sadie Irvine, thrown by Francis Ford; bears marks of SI, F, NC; 1944–48; 7" x 4½". Bottle in lichen glaze on red clay body by Francis Ford; bears marks of F, NC; 1944–48; 4" x 4". Candle holder in shiny turquoise glaze on white clay body, with low modeled relief of swirls; decorated by Sadie Irvine, thrown by Jonathan Hunt; bears marks of SI, JH, NC, TU57; 1934; 4" x 4". (Collection of Dr. and Mrs. R. Wynn Irvine)

133

The nation was going through the worst financial depression in its history in the early 1930s. The crafts, like everything else, fell on hard times. Sales began to drop, and for a while the guild had serious financial problems. For a short period it ran at a deficit. Many of the decorators and artists drifted off to work in WPA projects, as WPA was paying more than they could earn with the guild.

Jonathan B. Hunt left the pottery in the spring of 1934 for the Century of Progress in Chicago and worked for the Haeger Pottery Company at the fair. This left Kenneth Smith as the only potter in the department.

Henrietta Bailey, Sadie Irvine, and Aurelia Arbo were the decorators in the middle thirties. They continued to decorate in the same manner as during the twenties. However, in the late thirties Kenneth Smith started experimenting with new glazes and clay bodies. He began the work that would be the final period of work produced by the guild.

In this period Sadie Irvine and Henrietta Bailey did their finest blockprint work. They developed a technique using linoleum backed by wood and cut away the portion that would not be printed. In some cases two to three blocks would be cut to complete the composition. The prints had the same flowers used on the pottery, but portraits, cityscapes, animals, and birds were introduced in some of the newer prints. These lovely examples of graphic work gave a new dimension to their talents.

The college tried at this point to revive interest in the crafts, but in the end its effort was wasted. One thing attempted was a reorganization of the Art Alumnae Association. In the New Orleans *Morning Tribune* the following report appeared on December 11, 1935: "The Newcomb Alumnae Association's new pottery class will hold its first meeting a 7 P.M. today in the Newcomb Art School it was announced yesterday by Miss Florence Ruth Fowler, chairman of the alumnae art group. Miss Emilia [*sic*] Arbo is in charge of the pottery class, which is open to members of the Alumnae association and will meet Monday and Wednesday evening."

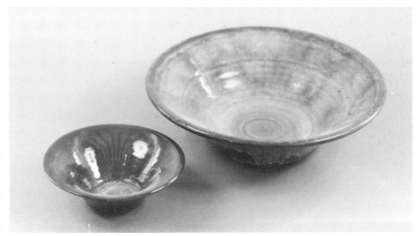

Two bowls in copper red reduction glaze in tones of red to violet on red-stone body. Potter unknown; bear the NC seal only; 1940–45. Left bowl is 3″ x 12″; bowl on right is 2″ x 6½″. (Louisiana State Museum Collection)

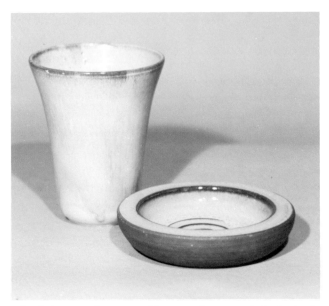 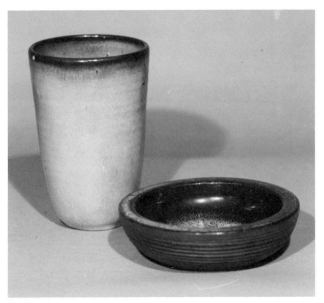

Wheel-thrown ashtray in gulf stream glaze on red clay body, by Francis Ford; bears marks of F, NC; 1944–48; 2″ x 6″. Vase in lichen glaze on red clay body, thrown by Francis Ford; bears marks of F, NC; 1944–48; 6¼″ tall. (Collection of Dr. and Mrs. R. Wynn Irvine)

Wheel-thrown ashtray on red clay body in gulf stream glaze, by Francis Ford; bears marks of F, NC; 1944–48; 2″ x 6½″ round. Vase in gulf stream glaze on red clay body, wheel-thrown by Francis Ford; bears marks of F, NC; 1944–48; 7″ x 4½″. (Collection of Dr. and Mrs. R. Wynn Irvine)

The pottery was being criticized as "Victorian." The art world was becoming interested in newer shapes and glazes, and the old Newcomb matt blues and greens did not blend well with the Scandinavian look that furniture, silver, carpeting, and fabrics assumed. The vogue of the so-called modern house was sweeping the nation, with the Frank Lloyd Wright ranch house the newest thing in living.

At this time in the late thirties, Kenneth Smith redesigned the shapes and produced new glazes that had a shiny quality. An article titled "One of Mankind's Oldest Arts Gets Its Face Lifted," by Georgette McGregor, reported:

The Newcomb art school is in the process of having its face lifted by incorporating in its teaching techniques a sense of responsibility towards our present-day age. . . . Kenneth Smith serves as professor in charge of the ceramic department.

The pottery tradition is the oldest in the Newcomb art school. This pottery, which is known the country over, measures up to the highest standards of our contemporary times. . . .

The Newcomb ceramic plant gives all the processes and practice in pottery making on a small scale. The mixtures and textures are made from clays taken from Kentucky, Florida and Georgia mines in various blends. The wheels on which the pottery are molded are worked by foot. . . . There is one small kiln in the Newcomb setup for baking the glaze and one large kiln which can bake 500 pieces of pottery at one time. . . .

The Newcomb Guild, which includes graduate students and faculty members,

makes pottery for commercial purposes which is on display and sold at a school gallery. It is an exclusive line with shops in New Orleans, Oklahoma City and New York as other outlets for production. Approximately 1000 pieces of pottery are completed each year with plans for expansion in the future.

The Guild concept maintains professional productivity along with teaching making ware of high caliber for selling purposes. Besides ceramic art pieces, painting and photographs done by Guild members are on sale.

The 1944 ceramic patterns and glazes include Gulf Stream, Lichen, Monks, Cumulus and Spindrift. These pottery lines have similar tonal relationship within the individual groupings.

Added to the pottery making was a button-making industry, when the department undertook the manufacture of ceramic dress buttons. These buttons, turned out of molds by the thousands, saw the Newcomb Guild through World War II. The lovely buttons were generally in the shape of flowers incorporated either in mold or handpainted underglaze.

In a letter dated July 30, 1975, Kenneth Smith wrote:

The traditional Newcomb Style was concluded about 1940 and a new line was developed which was not decorated except with rather unusual glazes. All this was mainly at the insistence of the new chairman of the Art Department, Mr. Robert Feild. We used the same clay body although now, colored glazes with interesting colors and textures. These new glazes were developed and made at the pottery and mostly fired in a fairly large Denver Muffle Tyle Kiln with gas. The production was not as large in this type of ware and there was little or no added decoration and frankly was not as widely accepted as the traditional Newcomb Ware made by the Guild. While there were display cases of the new ware and it was offered for sale by the Guild, there was no longer a large gallery and sales room after the traditional type of ware was no longer produced.

It was part of my duty to prepare all the clay body, glaze the ware and fire the kilns. This was done from 1929 to 1934 . . . when . . . Mr. Hunt left our employ. At that time it was my added duty to make the pottery on the wheel as well as offer a course in Ceramic Chemistry to the art students. We were able to obtain the services of Mr. Francis Ford to throw on the wheel a few years before I left Newcomb. . . .

Another duty after 1931 was to manage the commercial business of the Guild. The Decorators were paid by the type and size of the piece decorated and the sales were turned over to the college as all cost for materials, equipment and labor was borne by the college. After leaving Newcomb College in 1945, Mr. Francis Ford and Miss Sadie Irvine carried on for a few more years in the above duties although the Guild as such was pretty much closed several years before this time.

In the spring of 1944 Kenneth Smith left the college, and Francis Ford became the master potter. Miss Sadie Irvine continued to make and decorate ware, but the old forces that had formed the guild were gone. Miss Troy had retired as director of the art school in 1940, and in her place Robert Durant Feild became director.

Mr. Feild had no link with the past such as Miss Troy had had with the Woodwards. He had new ideas about what an art school should be, and he

136

implemented them. The Newcomb Guild was now out of touch with the educational edicts of the day, and slowly the guild was to wind down, but the Newcomb Art School would continue as a viable part of the educational and cultural life of the city of New Orleans. Miss Sadie Irvine stayed on until her retirement in 1952. Francis Ford left Newcomb in August, 1948.

Upon the departure of Ford, the famous Ⓝ was laid to rest, and all pottery produced after his time bore the maker's mark alone.

Honors awarded to the crafts of the Newcomb style at international expositions and fairs were these:

International Exposition, Paris, France, 1900, bronze medal.
Pan-American Exposition, Buffalo, New York, 1901, silver medal.
Charleston, South Carolina, 1902, silver medal.
Louisiana Purchase Exposition, Saint Louis, Missouri, 1904, silver medal.
Lewis and Clark Centennial Exposition, Portland, Oregon, 1905, bronze medal.
Tercentenary Exposition, Jamestown, Virginia, 1907, gold medal.
Knoxville, Tennessee, 1913, gold medal.
Panama-Pacific International Exposition, San Francisco, California, 1915, silver medal.

For years the crafts of the Newcomb style either were in the safekeeping of the owners and makers or were relegated to junk shops and secondhand stores around the country. It was not uncommon to pick up a handsome Sadie Irvine pot circa 1920 for a few dollars, but slowly its worth began to be recognized again. Collectors began to appreciate Art Nouveau for its value in artistic terms, and their activity brought about a new interest in the crafts. Many of the alumnae of Newcomb and their friends who had owned the crafts and had appreciated the effort that went into them saw the wisdom of preserving them for future generations.

In May, 1970, the Louisiana Crafts Council, whose main purpose is the education in and sale of contemporary crafts, conceived the idea of a foundation to preserve crafts of the past in Louisiana. It was their foresight in starting the Foundation for the Crafts of the Newcomb Style that led to the assembly of the large and valuable collection housed in the Louisiana State Museum on Jackson Square in New Orleans. The collection has received wide attention nationally and internationally. The art world and the collectors who heretofore had to glean small bits were able for the first time to see all the periods in the order of their development. They were able to see all the crafts assembled together and understand how each influenced the other.

This collection displays an art form as native as jazz to the state of Louisiana. Those years between 1895 and 1945 have blended into the historical fabric of the state, and this eloquent record of them is an achievement of major significance.

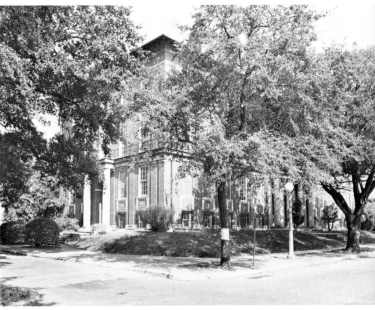

The Newcomb College Art School on Broadway, built in 1918.

Woodward Way, a covered passageway between the Newcomb Art School and the gymnasium building. Dedicated in 1933, it is named for Ellsworth Woodward.

Dixon Hall on the Newcomb College campus houses an auditorium and the music department. It was built with funds from the second Realization Day in 1924.

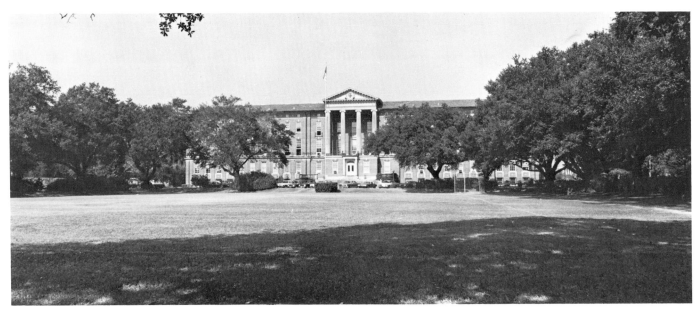

View of Newcomb Hall from the quadrangle, showing oak trees planted in 1909.

# 5

# THE DIRECTORS

**Dr. Brandt Van Blarcom Dixon** (1850–1941)
President of H. Sophie Newcomb College (1887–1919)

Dr. Dixon was born on February 27, 1850, in Paterson, New Jersey. His father was a harness maker, and his grandfather was the first mayor of Paterson. In 1857, when he was eight years old, the family moved to Saint Louis, where he received his education in private and public schools. He entered Amherst College in 1866, but after two years there he transferred to Cornell University, where he received a Bachelor of Arts degree in 1870 and a Master of Arts in 1873. He taught at the Bellevue Academy in Caledonia, Missouri, beginning in 1870, and was a member of Alpha Delta Phi fraternity. He returned to Saint Louis with the hope of entering the firm of Captain James B. Eads, builder of the jetties on the Mississippi River below the city of New Orleans. Eads, however, was in Europe, so Dr. Dixon turned to teaching in the public schools of Saint Louis, where he remained until 1887. In 1873 he married the former Eliza R. Carson of Caledonia. Mrs. Dixon died on July 17, 1930.

Dr. Dixon received two honorary LL.D. degrees, one from Southwestern University in 1891, and the other from Tulane University in 1930. Hired by the Board of Tulane University in 1887 as the first president of Newcomb College, he remained in that position until his retirement in 1919.

The three locations of the college were established by Dr. Dixon. He was a personal friend of Mrs. Newcomb and served as the coexecutor of her estate. Dr. Dixon conceived the idea of planting the oak trees that stand today on the present campus, using acorns from the trees on the Washington Avenue campus. He helped select the seal of the college, helped ordain the colors, brown and blue, and wrote the music for Newcomb College's alma mater.

On June 6, 1929, the college dedicated Dixon Hall, built partly with funds obtained by the alumnae on the second Realization Day. Dixon Hall now

139

houses the music department and an auditorium. A book of Dr. Dixon's personal reminiscences about the college was published in 1928.

Dr. and Mrs. Dixon had two children, both sons, and it was his son William A. with whom he resided after Mrs. Dixon's death. He died at 11:10 P.M. on Saturday, September 6, 1941, at 1732 Palmer Avenue, New Orleans. He is buried in the Belfontaine Cemetery in Saint Louis.

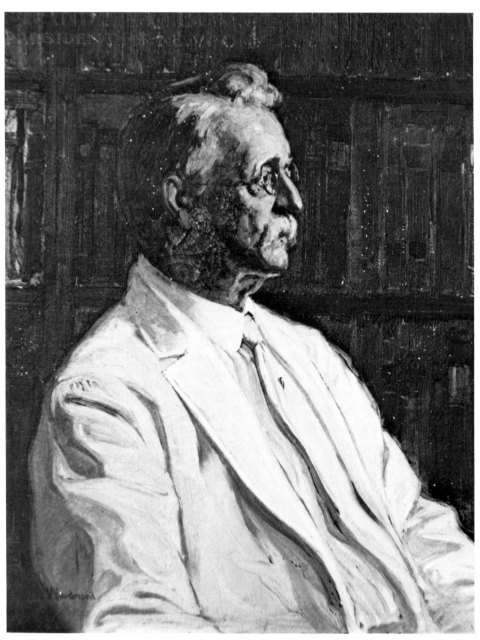

Oil portrait by William Woodward of Dr. Brandt Van Blarcom Dixon, first president of Newcomb College, 1887–1919. (Collection of Newcomb College)

**Ellsworth Woodward** (1861–1939), Newcomb College (1887–1931)
Ellsworth Woodward was born July 14, 1861, in Seekonk, Bristol County, Massachusetts. He was the younger brother of William Woodward. After graduating from the Rhode Island School of Design in Providence, he went abroad to study with Carl Marr and Samuel Richards in Munich. In January, 1885, he married Mary Belle Johnson of East Providence, Rhode Island, and came south to New Orleans to join his brother, William, who was a professor of drawing at Tulane University. He taught classes in the World's Industrial and Cotton Centennial, 1884–85, held in New Orleans. He was a founder and one of the directors of the Ladies' Decorative Art League and the New Orleans Art Pottery on Saint Joseph and Baronne streets, from 1885 to 1890.

With the founding of Newcomb College in the fall of 1887, he became the professor of art. In 1890 he became the director of the art school. This post he held until his retirement in 1931, when he became director emeritus, a position he retained until his death. On June 7, 1933, Tulane University conferred on him the degree of Doctor of Learned Letters, and the Newcomb Alumnae Association paid tribute to him when a cloistered walk from the art building to the gymnasium was named Woodward Way.

He was active in the promotion of arts and crafts outside of Newcomb

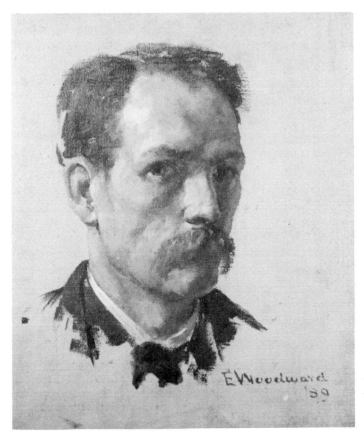

Oil self-portrait of Ellsworth Woodward done in 1889, when he was about twenty-nine. (Collection of Dr. James W. Nelson)

141

College. One of the founders of the New Orleans Art Association, he led the group for thirty years and was president at the time of his death. For more than twenty-eight years he was on the Board of Administrators of the Isaac Delgado Museum of Art (now New Orleans Museum of Art). He became its acting director in 1925, and was president from 1934 to his death. He was elected to Phi Beta Kappa by the Tulane chapter in 1922. He was a member of the Round Table Club of New Orleans, and an active member of the Southern States Art League, serving as the first president for a term of sixteen years.

His artistic endeavors were in oil, watercolor, etching, and pen drawing. He illustrated many books and did the murals in the Criminal Courts building at Tulane Avenue and South Broad Street, New Orleans. His works are in many major museums and private collections in the United States and other countries. He used the Raffielli method, which involves a solidification of oils and the application of them in pastel fashion.

The Woodwards maintained a household at 2703 Camp Street, one block from the Washington Avenue campus of Newcomb, from 1890 to 1918. When the college moved to the Broadway campus, they moved to 1316 Pine Street (one block away from the campus), where they resided at the time of his death. The Woodwards loved people and enjoyed opening their home to both students and faculty for tea and for meals.

He was in great demand as a lecturer and for many years was a lecturer for the Bureau of University Travel, speaking for travel groups in European museums and galleries. He received many awards, medals, and honors for his artistic works in a career that spanned fifty-four years. His work is widely collected today, and shows are held in museums on a regular basis. He was the driving force that created the Newcomb Art School and gave birth to the crafts of the Newcomb style.

He died at 1:45 A.M. on Tuesday, February 28, 1939. Funeral services were held at Trinity Episcopal Church on Jackson Avenue, and he was interred in Metairie Cemetery in New Orleans.

### William Woodward (1859–1939)

William Woodward was born in Seekonk, Bristol County, Massachusetts, on May 1, 1859. He was educated at the Massachusetts Normal Art School in Boston and at the Rhode Island School of Design. He was a pupil of Boulanger and Lefebvre in Paris. As a young man of twenty-four, he began his association with Tulane University as professor of drawing and painting in Newcomb College, and on the faculty of graduate studies; as professor of drawing in the schools of architecture, dentistry, and arts and sciences; and as professor of art in the summer schools.

He organized the Tulane free evening art classes for women, held three times a week in the manual training building, which formerly stood at

Lafayette and Dryades (now O'Keefe) streets. Out of these classes came the classes at the Cotton Centennial and the Ladies' Decorative Art League, which founded the manufacturing Art Pottery in New Orleans. William brought his brother, Ellsworth, to Louisiana to help with these classes. William Woodward is known principally as a painter. Both the Woodwards had a love affair with the French Quarter. It is said that William's paintings of French Quarter buildings rank as his best of the urban fabric of New Orleans.

His memberships included the American Institute of Architects; Art Association of New Orleans; Louisiana Art Teachers' Association; American Official Committee to the Third International Congress for the Advancement of Drawing and Art Teaching, London, August, 1908; Board of Directors of the American Federation of the Arts, Washington, D.C.

When he retired from Tulane, he became a resident of Biloxi, Mississippi, where he continued to paint and do graphics. He died on November 17, 1939, at the age of eighty.

### Lotta Lee Troy (1874–1963)

Lotta Lee Troy was born November 14, 1874, in Pleasant Garden, Guilford County, North Carolina, the daughter of a Methodist minister. She pursued her education at Greensboro College from 1888 to 1902, when she received a Diploma in Art. She then attended Teachers College, Columbia University, for two years, 1906 to 1908, when she was awarded a B.S. degree. Later she attended the University of North Carolina and the Chicago Art Institute, where she was a pupil of Arthur Dow. She studied bookbinding under William Mason, and also studied under Walter Roach.

Her academic positions included instructor of mathematics and art at Littleton College from 1895 to 1904. She came to Newcomb College as instructor in normal art from 1909 to 1912; from 1912 to 1931 she was assistant professor of art. In 1928 she was made assistant director of the Newcomb School of Art and retained this position until 1931. She was acting director of the School of Art from 1931 to 1935, and director from 1935 to 1940. From 1931 to 1940, when she retired, she was professor of art.

Memberships included the New Orleans Art Association, Southern States Art League, Southeastern Art Association, and Guild of Bookworkers, New York. Her speciality was bookbinding. She died December 10, 1963.

### Robert Durant Feild (1893–)

Robert Durant Feild, born in London on September 8, 1893, studied at the Julian Academy in Paris, the University of Chicago, and Harvard University. He is a member of the American Association of University Professors, the Southeastern Art Association, and the Society for Advancement of Education.

He is the author of *Courbet and the Naturalistic Movement* (1938) and *The*

*Art of Walt Disney* (1942). Positions include assistant, 1927–30; instructor, 1930–32; assistant professor, 1932–39; all at Harvard. He became director and professor of art at Newcomb in 1940 and remained through the war years.

In an article in the *Item* on February 4, 1947, Mr. Feild's philosophy about the pottery was stated: "Newcomb pottery of today is superior to that of bygone years, Professor Feild believes, but it has not yet caught the favor of the New Orleans public as did the old pictorial designs which had an appeal for the tourist trade as old fashioned mantelpiece ornaments. 'The purpose of the new pottery is to be useful as well as decorative,' he said. 'The vases are made to hold bouquets, the water carafes and tumblers to be of benefit to thirsty people, the ash trays to hold the tobacco ash and cigarette stubs deposited by smokers.'"

# 6

# THE CERAMISTS

**Jules Gabry** (d. 1895)

Jules Gabry was the first potter at Newcomb. He came via Brazil from Sevrès, in France, bringing with him a box of butterfly drawings to incorporate into designs. In December, 1895, he committed suicide by jumping into the Mississippi River.

**George Wasmuth**

George Wasmuth was a potter at Newcomb after Jules Gabry. He remained only a short time before George Ohr and Joseph Meyer came.

**George E. Ohr** (1857–1918)

In 1886 George Ohr came to work in the New Orleans Art Pottery with Joseph Meyer from the Biloxi Art Pottery, where both had served an apprenticeship as potters with the father of Meyer, François Antoine Meyer. The Biloxi Art Pottery was destroyed by fire in 1893.

As has already been established, the New Orleans Art Pottery closed after a few years because of financial difficulties. When Newcomb opened its doors, the two men moved to the new college. Joseph Meyer remained for thirty-five years, but George Ohr had a short stay of only about five years, as his teaching of young ladies was not to be admired. He then established his own firm, Ohr Pottery.

Records of the time picture him as very eccentric in appearance, but extremely gifted and most prolific. His pottery varies in size from thimble height to man height. He sold almost none of it, and upon his death his family inherited around six thousand pieces. It is said that he could draw up the clay wall to paper thinness on the potter's wheel. His glazes were of many and varied colors, and the form of his pottery varies in shape and style, making it unique in structure.

**Joseph Fortune Meyer** (1848–1931)

Joseph Meyer, born in Alsace-Lorraine on February 18, 1848, came to America with his father, François, in a sailing vessel at age nine. The family settled in Biloxi, Mississippi, where the elder Meyer, a potter, established a pottery works. Joseph and his childhood friend, George Ohr, were apprenticed to him.

The Meyers, father and son, came to New Orleans in the 1860s. They operated both a shoe store and a pottery, selling their wares at the French Market. On December 29, 1870, the elder Meyer died of congestive fever, and the son continued to operate both the pottery and the shoe store until well into the 1890s. Simultaneously, Joseph Meyer and his friend George Ohr were potters at the New Orleans Art Pottery, located on Saint Joseph and Baronne streets, from 1886 until 1890.

Ellsworth and William Woodward knew and appreciated the work of Joseph Meyer through their association with the New Orleans Art Pottery, and in 1893 Meyer was called in to help set up the operation of the Newcomb pottery. From this time until 1928, when he retired, he directed or actually threw all the ware and glazed and fired the work that the women decorated.

At the time of his death, the pottery world was high

in its praise of this man. "His hands were uncannily deft," said one. "Every piece was familiar in every large city of the country and it sold," said another. His friendly disposition and gentle manner, plus his desire to please his associates, endeared him to all. He had little or no formal education and practically no technical knowledge, but he read constantly and had a retentive memory. He worked diligently and helped experiment. At one point when he refused to mark  on a piece, Woodward took the piece and was successful in producing copper red, a color whose secret had been held by masters in Asia and Europe. All the medals won at fairs and expositions were for pottery he had thrown.

Joseph Meyer and his wife, Felicie L. Pineau, had no children, but they adopted the orphaned daughter of their housekeeper. With her, Mrs. James E. Walther, he made his home after retirement, and with her he entrusted his memorabilia. He died at his residence, 1202 Felicity Street, at 2:45 A.M. on Monday, March 16, 1931.

Portrait of Joseph Fortune Meyer by Ellsworth Woodward; 15" x 11". (Collection of Dr. James W. Nelson)

## Robert Miller

Robert Miller was hired as a potter to assist Joseph Meyer when the latter had a cataract operation and could no longer see well enough except to do the wheel work. In 1910, while working in the pottery, he caught his hand in the blunger machine and was forced to leave.

## Paul Ernest Cox (1879–1968)

A native of Crawfordsville, Indiana, and a veteran of the Spanish-American War, Paul Cox joined the pottery on Washington Avenue in 1910, went to Broadway with the move to the uptown campus in 1918, but remained only a short time. He left to go to Iowa State College, and was still in the Department of Ceramic Engineering there in 1934.

In 1941 he helped in the establishment of the Angell pottery in Harahan, Louisiana. The Angells had become interested in pottery because of Mrs. Angell's association with Newcomb College. Paul Cox made and fired some pots there that are marked "after the Newcomb style."

In one of a series of letters, dated December 24, 1951, to Louisiana historian John Smith Kendall, Paul Cox stated that he designed the big kiln to make hard stoneware at Newcomb. He observed, however, that it was difficult to make enough stuff to fill it, although Francis Ford used it for three years and did excellent work.

At age seventy-four and living in Baton Rouge, he wrote to Mr. Kendall, with whom he had lived in New Orleans, that his wife, Jeanne (Fortier), was ill and he was doing the housework. He also stated that he had made a cartoon in clay, a turtle, titled "Them Tide Lands," which he had shipped to the American Ceramic Society president. There is a series of letters written to the Angells during the 1960s, one upon the death of Mrs. Angell in 1966.

Paul Cox died Saturday, June 22, 1968, at 8:30 P.M. at Baton Rouge General Hospital. Burial was in Port Hudson National Cemetery. His wife survived him; they had no children.

## Fred E. Walrath (d. 1922)

Fred Walrath was hired at the pottery when Paul Cox left in 1918. He died in 1922, while he was on the faculty.

**Vincent Axford**

Vincent Axford was at Newcomb between 1922 and 1927. He was a ceramic engineer and taught on the faculty as instructor in chemistry in 1925.

**Harry Rogers**

Harry Rogers came to Newcomb in 1927 as a potter and instructor in ceramic chemistry. He remained until 1930.

**Jonathan Bowne Hunt** (1876–1943)

Jonathan Hunt was born August 5, 1876, in Flemington, New Jersey, the site of the Fulper Pottery established in 1805, where he received his early training. He had already had a career with the Rookwood Pottery in Cincinnati and the Orlando Potteries in Orlando, Florida, when he replaced Joseph Meyer as master potter at Newcomb in 1928, when the latter's eyesight began to fail seriously.

Hunt's tenure at Newcomb was six years. In 1934–35, at the Century of Progress in Chicago, he demonstrated for the Haeger Potteries in Dundee, Illinois, which had an exhibit at the fair. According to his daughter, Blanche (Mrs. Elmer Niehaus), after the fair closed her father, with his wife, traveled about the country visiting potteries, often remaining as consultant or demonstrating his craft as a fine wheel technician for a short period of time.

His last position was with the Broadmoor Pottery Company in Denver, Colorado, as designer-craftsman. He died on November 12, 1943, in Denver.

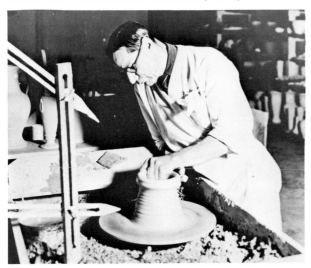

Photograph of Jonathan Bowne Hunt in Broadmoor Pottery, Denver, Colorado, December 1, 1937, at the potter's wheel. (Niehaus Collection)

**Kenneth E. Smith** (1907–), potter and director of the Newcomb Guild (1931–46)

Kenneth E. Smith was born July 16, 1907, in Scio, New York, and graduated from the Elmira Free Academy. He holds a Bachelor of Science degree in ceramic engineering from the New York State College of Ceramics, Alfred University, Alfred, New York, awarded in 1929, and a Master of Fine Arts degree in ceramics from Ohio State University, Columbus, awarded in 1939.

From 1929 to 1945 he was a professor of ceramics at the Newcomb School of Art. In June of 1931 he became the manager of the Newcomb Guild, taking over from Miss Mary G. Sheerer. He retained that position until he left Newcomb College in 1946. He spent the year 1945 as a special consultant for the U.S. State Department and professor of ceramics at La Escuela de Bellas Artes, Tegucigalpa, Honduras. In 1946 Kenneth Smith assumed the responsibility of ceramic division manager of the American Art Clay Company in Indianapolis. In 1949 he started the AMACO summer workshop program offering refresher courses in ceramics to teachers and occupational therapists. Re-

Photograph of Kenneth E. Smith in 1975. (Property of the authors)

tired from the manager position, he now acts as a consultant to the firm and continues the summer workshops. He resides with his wife, the former Yvonne Roques of New Orleans, in Indianapolis.

During his years as a ceramist, Kenneth Smith was responsible for a number of exhibits of his own pottery and that of guild members. They exhibited and won prizes at the Jacques Seligman Gallery in New York in 1935, at both the Crafters in Cincinnati and the Syracuse Museum of Fine Arts in New York in 1938, and at the Golden Gate International Exposition in 1939.

### Francis A. Ford (1916–)

Francis Ford was born on June 30, 1916. He went to Newcomb when he was about fourteen years old, first on Saturdays to learn throwing on the wheel and the basics of ceramics. His home was in the Irish Channel area of New Orleans, and he had become interested in pottery at Kingsley House, a settlement house in his neighborhood where Juanita Gonzalez taught. She told him to go to Newcomb, where Jonathan Hunt was the ceramist.

He worked at Newcomb part-time as a potter, then began working full-time in 1945, when Kenneth Smith left. Newspaper accounts of the time relate that Newcomb pottery made by Sadie Irvine, instructor of ceramics, and Francis Ford, ceramic technician, was shown at the Metropolitan Museum of Art in New York in the Eleventh National Ceramic Exhibition. The winning pieces, flower bowls, were chosen for a competitive exhibition in Syracuse, New York, and later to travel for a year.

Ford left New Orleans in 1948 to move to the University of Washington in Seattle. There, for three years, he was a ceramic technician in the School of Engineering. His next work was with Boeing, aircraft manufacturers, as pattern maker and later as ceramic technician. He left there in 1961 to go to North American Aviation in Los Angeles. In 1966 Ford went back to the Northwest to work for Tektronix in Beaverton, Oregon, where he is at present; he makes oscilloscopes for space ships. He has a thirty-three-year-old son who works for North American Aviation in photographic reproduction processes, and three grandchildren.

Recent photograph of Francis A. Ford. (Property of the authors)

# 7

# THE CRAFTSMEN

The college catalogs published a list of art craftsmen each year until 1927. All have been included in the biographies, but for the years after 1927 we have had to rely on interviews with living relatives and friends of the craftsmen themselves. Where we could build a biography by consulting alumni/alumnae records, university archives, press notices, correspondence, and personal or telephone interviews, we have done so. Especially, we have taken note of those craftsmen represented in the collections of Newcomb College and the Louisiana State Museum, and in the possession of private individuals when these have come to our attention.

After 1941 very little of the ware produced was signed. Some craftsmen continued to use their cipher, as did Sadie Irvine, but for the most part, except sometimes that of the potter, no mark appeared. At this time the Newcomb Guild was barely functioning. Newcomb pottery was developing new wares that were given names descriptive of their color tones, such as lichen, rain, spindrift, gulf stream, warbler, and monks ware. These were not of solid color but of harmonizing combinations of color.

The following names are those of women who attended Newcomb Art School prior to 1918 but for whom no further information is available:

Anderson, Mrs. Walter. Diploma in Art, 1900. Anderson Potteries, Ocean Springs, Mississippi.

Atkins, Florence Elizabeth. Normal art graduate, May 24, 1905.

Avery, Mrs. D. D. Special art, 1896–97.

Barnett, Zelia. Normal art graduate, May 24, 1905.

Barringer, Anna Maria. Of Charlottesville, registered in special college classes in 1902–3.

Belden, Josephine. Special art student, 1888.

Blocker, Frances Ware. Normal art graduate, June 20, 1900.

Denham, Lucy Endt. Normal art graduate, May 24, 1905.

Farwell, Nellie. Special art student, 1890–91.

Freret, Emily Mary. Won Holley Medal in 1909 and Neill Prize in 1910.

Gerard, Finette. Matriculated in special art, 1887; graduated in 1891.

Gibbs, Jane Irwin. Normal art graduate, May 24, 1905.

Gillespy, Rose Sadler. Diploma in Art, 1914; Bachelor of Design, 1925.

Hester, Harrison Palmer. Diploma in Art, 1918.

Howe, Frances Lawrence (Mrs. Charles P. Cocke). Diploma in Art, 1897.

Howe, Louise Eugenie. Normal art graduate, May 24, 1905.

James, Ethel Mayhew. Normal art graduate, May 25, 1904.

Johnston, Margaret. Matriculated January 7, 1888. Attended in 1889 and 1890. Daughter of President William Preston Johnston.

Kelly, Anita Porter. Normal art graduate, May 25, 1904.

LaBarre, Marguerite. Normal art graduate, May 24, 1905.

Leonard, Daisy. Member of the first class in pottery decoration, 1895. Special art, 1896–97.

McConnell, Annette. Normal art graduate, June 20, 1900.

McKee, Frances Powers. Normal art graduate, June 14, 1899.

Randolph, Leila Peirce. Diploma in Art, 1914.

Reed, Edna Lyman. Normal art graduate, May 24, 1905.

Reinfort, Mary. Graduate in normal art, 1894. Died in 1894.

Riggs, Kate L. Normal art graduate, June 14, 1893.

Robbin, Emma Bates. Won Holley Medal in 1914.

Sessums, Mrs. Davis. Special art student, 1890–91.

Sharp, Bemis. Normal art graduate, May 24, 1905.

Shelby, Margaret. Won Holley Medal in 1906.

Thomason, Mary Edith. Normal art graduate, May 24, 1905.

Van Der Weyde, Gertrude (Mrs. Richard McCall). Diploma in Art, 1892.

Walker, Katie R. Special art student, 1887–91.

Woodward, Mrs. William. Born in Kenner, Louisiana. Matriculated November 7, 1887.

Wright, Pauline. Diploma in Art, 1913; degree, 1925.

---

**Arbo, Aurelia Coralie**

Aurelia Arbo received her Bachelor of Design in 1931, in the last class to have that degree. She then was an art craftsman until 1940, when she started teaching in the Orleans Parish schools. When Mr. Feild came, Miss Troy, then director of the art school, agreed with him that the pottery and other crafts were not representative of Newcomb, and since he was slated for the directorship, what he wished was sure to be carried out. Miss Arbo was assistant to the ceramic chemist for three years, which gave her the required three years' experience and qualified her for a Louisiana teacher's certificate.

After Newcomb stopped selling blue ware in 1938–39 and the crafts shop was closed down, Mr. Cox opened a pottery in Harahan, Louisiana, and asked Miss Arbo to decorate for him. She owns that ware. On the bottom is stamped "Paul Cox ware after the Newcomb style," and it was sold at Hausmann's on Canal Street, where Newcomb pottery had formerly been sold. The venture was not a success, and she received the pottery in lieu of salary. As a craftsman at Newcomb she was paid fifty dollars a month, supplemented by orders for pottery for which she received one-third the selling price.

Her pottery piece titled "Elephant" was exhibited in the Contemporary Crafts Exhibition in Philadelphia in 1937, and was selected to be included at the Paris Exposition in 1938. Two ceramic bowls titled "Peacock Feathers" and "Butterfly Wings" were exhibited in the Seventh National Ceramic Exhibition at the Syracuse, New York, Museum of Fine Arts, and later in the 1939 Golden Gate International Exposition in San Francisco. A piece of ceramic sculpture was exhibited at the annual Art Alliance Ceramic Exhibition, another at the Crafters Company in Cincinnati, and still another at the opening of the Shreveport, Louisiana, Art Museum in the Louisiana State Exhibit.

**Arena, Lucia Cecelia**

Lucia Cecelia Arena was an art craftsman from 1923 to 1928.

**Augustine, Leontine Esther** (d. 1949)

Leontine Augustine (Mrs. David Walker Godat) received a Diploma in Art on June 7, 1916, and a Bachelor of Design on June 8, 1921. She died June 25, 1949.

**Baccich, Eunice**

Eunice Baccich received her Diploma in Art on June 5, 1918, and her Bachelor of Design on June 12, 1919. She was an art craftsman from 1921 to 1929, concentrating on filling orders for bookbinding. After Miss Troy's retirement, Miss Baccich taught bookbinding until Mr. Feild became director of the art school.

When war was declared, Eunice Baccich went to work for the U.S. government at La Garde Hospital as an occupational therapist. Later she worked at the public library. She frequently exhibited her bindings and won many prizes.

**Bailey, Henrietta Davidson** (d. 1950)

In the summer of 1938 Miss Bailey, on her letterhead and in her own hand, wrote upon request to the Delgado Museum: "I entered Newcomb Pottery in 1902 while a student in the Art School. Graduated June 1903, worked as decorator 1904 and in June 1905 received the Ipswich Scholarship to study with Arthur Dow in Ipswich, Massachusetts. Session 1908–1909 taught pottery decoration for Miss Mary G. Sheerer who was absent on leave. Taught pottery decoration and making again session 1913–1914 and 1914–1915.

Received first prize at Southern States Art League Exhibition, Savannah, Georgia 1931 for best collection of decorated pottery."

Records show that Henrietta Bailey received a Diploma in Art in 1903, and was a normal art student in 1901–2. She is listed as an art craftsman in 1909–14, 1915–24, and 1925–27. She was on the art faculty regularly from 1926 to 1938, although she was a substitute teacher of art from 1908 until 1926. Independent of her duties as a teacher, she decorated pottery from 1904 until her retirement in 1938.

News accounts show she exhibited ceramics at Houston's Museum of Fine Arts during December, 1930, and blockprints at the twenty-third annual exhibition and sale of artwork during the same time. At the Alumnae of the Art School of Newcomb College exhibit and Christmas sale in 1931, she chose to exhibit blockprints featuring misty, overcast Louisiana swamps and bayous and beautiful effects with moonlight, sunlight, and early morning overtones. Henrietta Bailey died November 10, 1950.

**Baker, Mary Frances** (d. 1943)

Mrs. Mary Baker Willcox attended Newcomb College Art School in 1897–99. Since no college catalog was published for the year 1899–1900, no record of her attendance was found until 1902, when she was awarded the traveling scholarship for the Wadabury Summer School in Ogunquit, Maine. The amount of the anonymously given scholarship was $125.

In 1903 she won the Neill Medal, and in 1905–6 she was listed in the catalog as a member of the pottery design class. After college she taught related art and costume designing in the public schools of New Orleans for thirty-three years. She was noted also as the designer of many Carnival floats. The *Times-Picayune* of August 26, 1943, carried her obituary.

**Ballard, Mary**

Mary Ballard (Mrs. Allen Tupper) lived at 257 Josephine Street and went to Newcomb as a special literary student, according to the catalogs of 1889–90 and 1890–91. She made a pierced brass lamp, had a loom in her home and did some weaving, and also made a crash runner with Japanese plum design.

She went to live in Switzerland after her husband's death in the early 1930s. She returned to spend the war years at home but soon after returned to Europe.

**Bancroft, Emma Claire** (d. 1969)

Claire Bancroft (Mrs. George Alfred Mayer) received a Diploma in Art in 1918 and a Bachelor of Design on June 12, 1919. She died August 18, 1969.

**Bartlett, Gladys** (d. 1953)

Gladys Bartlett (Mrs. James Cornelius Jones) received her Diploma in Art from Newcomb in 1911. She died October 21, 1953.

**Bate, Eunice Lea**

Eunice Bate (Mrs. Donald Wharton Coleman) was awarded a Bachelor of Design degree the first time that degree was given, in 1919.

**Beauregard, Alice Toutant** (d. 1956)

Alice Toutant Beauregard (Mrs. Edward C. Morse) received a Diploma in Normal Art in 1912, and was an art craftsman in the college year 1916–17. She died May 4, 1956.

**Benson, Maria Levering**

She is listed in the 1905–6 catalog as a student in special art, a course of study designed to prepare teachers. The course united study of fine and industrial art and gave special attention to the methods of public school art instruction, awarding a certificate at the end of each year of study.

In 1906 Miss Benson won the traveling scholarship to the Dow Summer School. Miss Sheerer commented, "Miss Benson is fast rising to the first rank." The 1906–7 catalog lists her as one of the students in the normal art course, a four-year course of study. She is deceased.

**Bettison, Alix**

Alix Bettison (Mrs. Ralph Colby) attended Newcomb from October, 1908, until May, 1911. She received her Diploma in Art in the spring of 1911. There is an exhibit of a watchfob in the crafts show at Newcomb pictured in the *Daily Picayune*, Sunday, April 2, 1911.

**Blethen, Grace** (d. 1950)

Grace Blethen (Mrs. Grace B. Dunn, formerly Mrs. James Frederick Dunn) is listed among the normal art graduates on the commencement program of Newcomb College, May 25, 1904. She was an art craftsman in 1909–10. She died April 29, 1950.

**Bres, Selina Elizabeth** (1870–1953)

Selina Bres (Mrs. William Benjamin Gregory) was born in New Orleans on January 1, 1870. In 1884 she had her first drawing lesson with Ellsworth Woodward, and was a member of the first class in pottery decoration, which opened at Newcomb in the fall of 1895. In 1896 she was awarded a Diploma in Art. She married William Gregory, at that time a member of the faculty of the College of Engineering, Tulane University, on June 21, 1898, in Newcomb Chapel. President Johnston sent his carriage for the bride.

In the printed catalog of 1898–99 Selina Bres Gregory is listed as a graduate in normal art; in 1900–1901, as a graduate art student; in 1901–2, as graduate in normal art; in 1909–10, as an art craftsman. While at Newcomb, Mrs. Gregory is said to have sold for a private collection the first piece of pottery ever sold. She published the first souvenir postcard in the South, and exhibited often with the New Orleans Art Association and the Arts and Crafts Club, having been an organizer and charter member of the latter.

Mrs. Gregory was a person of many interests. She studied voice and piano for several years and was soloist for twenty-five years at the First Unitarian Church, along with Clayton Nairne and Armand Kreeger, and she assisted in the first New Orleans Christmas Caroling. She directed a Realization Day kitchen for the first Realization Day of Tulane University for the benefit of the stadium, raising over five thousand dollars in one day. She founded both the Lend-a-Hand Club, an early volunteer teaching organization, and the Louisiana Engineering Society, becoming its first president.

Her specialty was pottery decoration. She died in Paris, France, on November 6, 1953, and was buried in New Orleans.

**Bultmann, Ruth Ernestine** (d. 1975)

Ruth Bultmann received a Diploma in Art in 1917 and a Bachelor of Design on June 12, 1919. From 1932 to 1934 she was listed as a craftsman at Newcomb.

Her exhibition on May 6, 1917, showed her special ability in one line of work—calligraphy. All the logos for the Bultmann family business (which uses the spelling Bultman), from the sign in front of the mortuary to the stationery and cards used by the business office, were designed by her.

During the 1920s Miss Bultmann, along with Sadie Irvine, designed the lettering appearing on the greet-

ing cards that for so many years delighted the purchasers at the Newcomb Art Alumnae Christmas show and afterward. She died October 10, 1975.

**Burgess, Emma Ruth**

Ruth Burgess (Mrs. Charles R. Higbee) first came to New Orleans in January, 1900, with her uncle, Ellsworth Woodward. After that she studied at Newcomb from September to June each year through 1906–7 with the exception of one year. She is now ninety-four years of age and does not recall which winter that was.

The Mary L. S. Neill Book Club founded a medal to be awarded by the faculty of the art department at Newcomb to a student of the department for excellence in watercolor painting. The first recipient was Ruth Burgess.

She was married in September, 1907, and according to her daughter did not return to Newcomb. However, records show that a Ruth Burgess Highby enrolled in a special art class in the year 1910–11. She and her husband both worked in metal, some copper and brass but mostly silver. She made many lampshades of perforated brass, but her specialty was embroidery, which she did during her Newcomb days and afterward.

**Butler, Mary Williams** (1873–1937)

Mary Williams Butler was born, reared, and educated in New Orleans. After studying art in private schools of the city, she entered Newcomb College and received her Diploma in Art in 1901.

She accepted a position in the newly founded art school at Newcomb, then on Washington Avenue. In 1918, when the present buildings were erected, she transferred to the new school and was made professor of drawing and design. She was active in promotion of exhibits and contests among students and influential in acquiring fellowships and scholarships for many students.

Jewelry craftsmanship was her specialty, and she completed a pictorial file of jewelry and silverplate, one set of which was exhibited April 2, 1911, at the crafts show at Newcomb. She died October 20, 1937.

**Chalaron, Amelie**

Amelie Chalaron (Mrs. Arnold W. Yeargain) received her Bachelor of Design degree in 1931. After graduation she was connected with Newcomb College Nursery School teaching the youngest children, some

as young as eighteen months old. Afternoons she went to Newcomb as an art craftsman in leatherwork. Bookbinding was her specialty and Miss Troy was her teacher. She attended the Columbia School of Education in the summer of 1939.

**Chalaron, Corinne M.**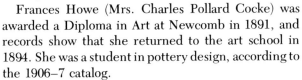

Corinne Chalaron graduated from Newcomb Art School with a Bachelor of Design degree in 1920 and from the architecture school of Tulane University in 1926. She is listed as an art craftsman at Newcomb in 1923–25 and again in 1926–27. She taught at the state college in Denton, Texas.

**Cocke, Frances Lawrence Howe** (d. 1951)

Frances Howe (Mrs. Charles Pollard Cocke) was awarded a Diploma in Art at Newcomb in 1891, and records show that she returned to the art school in 1894. She was a student in pottery design, according to the 1906–7 catalog.

The Newcomb art department exhibited a set of her booklets with covers in 1926. She died January 16, 1951.

**Cramer, Mrs. Sophie Quinette**

Sophie Cramer studied under Ellsworth Woodward and later attended the Silvermine Guild School of Art in Connecticut, the Wallinford Art Center in Pennsylvania, and the Pennsylvania Academy of Fine Arts. She was married to a Tulane professor when she attended Newcomb. In the catalog she is listed as an art craftsman in 1922–23 and 1924–25.

Her work is exhibited at the Smithsonian Institution in Washington and at the American Artists' Professional League in New York. In 1972 she was living in Asheville, North Carolina.

**Crumb, Ethel Canney**

Ethel Crumb (Mrs. Frank Norris Brett) received her Diploma in Art in 1916, and went back the following year for further study. Of her Newcomb days, she says: "I made books and books of plant studies in sections, from every angle. We took apart the plant and drew the pieces—like studying anatomy. We could take any part and incorporate it into a design—the stem, the leaf, the petal, the stamen." She did pottery, jewelry, and embroidery, sometimes using a magnolia design.

After Newcomb she worked at a shipping company doing mechanical drawings of ships. In 1920 Le

Petit Théâtre du Vieux Carré employed her as a designer of sets and costumes. From then on she spent almost every summer in New York studying every angle of the theater business.

For eight years she was on the Tulane University faculty in the theater department, teaching technical courses such as lighting, costuming, scenery building, and makeup. Then, as now, she was responsible for the makeup of New Orleans Carnival queens.

**Davis, Elizabeth**

Betty Davis (Mrs. Clyde M. Warner) received her Bachelor of Design degree in 1924. At that time an art school graduate could go back free of tuition for two years, and Miss Davis took advantage of this. Her craft was pottery decoration, which she did for pure pleasure, under Sadie Irvine and Fannie Simpson. Except for a few pieces still in her possession, she gave away all she produced.

**De Grange, Beatrice** (d. 1920)

Beatrice De Grange (Mrs. Robert Turnell Burwell) received an A.B. in 1905. She was interested in the crafts and settled on embroidery, a craft in which Newcomb blazed the trail. She died August 9, 1920.

**Delavigne, Marie Odelle** (d. 1963)

Marie Delavigne appears in the catalog as a student in special art in 1892–93 and 1895–96. She received her Diploma in Art in 1896. Pottery design as a course of study appears for the first time in 1901–2, with thirteen students, among them Marie Delavigne. She is listed in the catalogs as a student in 1902–3 and 1903–4.

She was an art craftsman from 1909 to 1912, and from 1913 to 1926. Her specialty was embroidery as student, craftsman, and instructor. She died February 25, 1963.

**Dodd, Olive Webster**

In the 1900–1901 college catalog, Olive Dodd (Mrs. C. Himel) is listed in the normal art section, and in the 1901–2 catalog in the graduate art section. She was first listed in the handwritten record of 1897–98. Since yellow fever had caused a falling off in demand for catalogs, the catalog of 1898–99, the first printed catalog, was repeated in 1899–1900. Her attendance at Newcomb may have been continuous for five years. The commencement program of June 19, 1901, lists her as a normal art graduate. In the spring of 1930 she

attended one semester for a graduate course in jewelry. She came from Lauderdale, Louisiana, at that time, and is now deceased.

**Dunn, May Louise** (d. 1964)

May Louise Dunn received a Diploma in Art in 1910. She died June 1, 1964.

**Elliott, Esther Huger**

Esther Elliott, born in Sewanee, Tennessee, matriculated in Saturday art on November 27, 1887. This course consisted of object drawing and cast drawing. In the printed catalog of 1890–91 she is listed in special art, and in 1895 she was selected as one of the nine members of the first class in pottery decoration, most of whom were graduates of the normal classes of Newcomb Art School.

**Favrot, Carmen Freret**

Carmen Favrot received her Diploma in Art in 1913. As an art craftsman at Newcomb from 1918 to 1929, her specialty was making small silver and gold jewelry. She is still designing jewelry for sororities and fraternities as well as for Carnival organizations. Her niece, Gaile Richardson, executes the designs on order, mostly for necklaces and monograms in gold.

In the summers Miss Favrot taught brasswork and silversmithing at Quinibeck Camp in Vermont and Merriewood Camp in North Carolina. In 1929 she exhibited three pieces of her jewelry enameled in dark blue at the Junior League Exhibit in New York.

Her designs are largely in the traditional manner but not of any place or time; rather, they are abstract. She has made tieclasps, rings, earrings, and bracelets in gold and silver, doorbells and mailboxes in brass, but she has also decorated pottery with flowers.

**Ficklen, Bessie Alexander**

Bessie Ficklen (Mrs. Thomas Hilton) attended Newcomb from 1906 to 1910. In 1912–13 she was a special domestic art student. She withdrew February 18, 1913.

A book by her, *A Handbook of First Puppets*, published in 1935, states that puppet making was her lifelong hobby and tells of the original method she evolved for modeling her troupe of puppets, people and animals.

As one of the first workers in Newcomb pottery, she

experimented with various methods of modeling puppet faces of clay. The art was revived at Newcomb College in 1939, when Xavier Gonzalez, professor of design, made the first Punch and Judy. Bessie Ficklen Hilton is deceased.

**Fredericks, Helene Oemichen**

Helene Oemichen Fredericks received a Diploma in Art in 1917, a Bachelor of Design in 1919, and was an art craftsman from 1919 to 1922. The *Jambalaya* of 1919 says about her:

> She dabbles in jewels semi-precious
> She works hard on silver and gold
> If orders keep flowing as now they are coming
> Helene will be rich when she's old.

**Gasquet, Martha**

Martha Gasquet (Mrs. George Gustaf Westfeldt) had one year of study at Newcomb, when she attended classes with her freshman daughter, Metha. She later had a fellowship in ceramics from Alfred University in New York.

Upon her return to New Orleans, she worked at Newcomb with Miss Sheerer. She was particularly interested in glazes, notably copper red and cobalt, and fired her pottery pieces in the Newcomb kiln. Later she had her own kiln at 633 Royal Street on the first floor of a building that she owned. She also fired on a wood kiln in North Carolina, where she spent summers.

**Gastrell, Ethel Ruby**

Ethel Gastrell (Mrs. Daniel Davis Warren) was awarded a Bachelor of Design degree in 1923. She was an art craftsman in 1925–26.

**Godchaux, Adele**

Adele Godchaux (Mrs. Harry Eckles, Mrs. Bradley Smith, Mrs. Adele Godchaux Dawson) was awarded a Bachelor of Design degree in 1926. She studied pottery design at Newcomb, after which she won critical acclaim as a painter in New York (New York Critics' Award). She has written a book on Vermont painter Frank Gilman.

At present she is doing woodcarvings that are exhibited at all Vermont craft fairs—bowls, plaques, and so on. She is reputed to be one of the leading craftsmen in Vermont.

## Gonzalez, Juanita (d. 1935)

Juanita Gonzalez came to Newcomb on a scholarship and was soon recognized for her unusual talent and ability. Mr. Woodward mentioned to other students that Juanita was the most talented girl he had ever known. She earned a Bachelor of Design in 1925, along with a prize in drawing, and soon went to New York to study under Archipenko. Her work reflects that training.

Pottery, ceramic sculpture, woodcarving, architectural ornament, and teaching claimed her attention. When she returned to New Orleans from the East, she established herself in a studio on Governor Nicholls Street. It was here that some of her best work was done: notably, portraits in sculpture of several governors of the state.

She designed doll heads for a New York manufacturer. She also designed furniture and fixtures. The architectural ornament on both the Louisiana State Medical School in New Orleans and the Louisiana State Capitol building in Baton Rouge is her work.

She was twice appointed to teaching positions in Newcomb Art School, shortly after leaving school and again in 1931–33. Both appointments were to the pottery department as a teacher of design.

All records show her as a thoroughly competent, independent, individualistic, and daring artist. In January, 1935, she exhibited a group of the newer designs in Newcomb pottery in an exhibition of American prints and crafts in the Jacques Seligman Gallery in New York, one of the better-known galleries in this country. She died July 8, 1935.

## Graham, Hannah Seymour

Hannah Graham (Mrs. Pendleton E. Lehde) studied special art from 1910 to 1914. She was interested in pottery, began making it, and had the ⓝ seal stamped on all her pieces. She made a piece of embroidery with hollyhock design. Some colors she used were made by certain families in the Far East and imported. She also did china painting.

## Grainer, Rosa Rainold (d. 1962)

Rai Grainer (Mrs. Leonard Somers Murray) received her Bachelor of Design degree from Newcomb College in 1926. She was an art craftsman in 1928–29. At the age of twenty-five she was awarded two prizes offered jointly by Ellsworth Woodward, Mrs. Joseph Hume, and Miss Mary G. Sheerer, one for the best group of ceramics (individuality, form, and glaze) and the other for the best single piece (glazed).

In 1930 she sent an exhibition to the Museum of Fine Arts in Houston along with work of other craftsmen. She belonged to the Arts and Crafts Club and exhibited there. She was also a member of the Southern States Art League.

She studied under Enrique Alferez. In 1944 Mrs. Murray conducted art classes at the United Seamen's Service at 3628 Saint Charles Avenue. She died August 16, 1962.

## Gray, Matilda Geddings (d. 1971)

Matilda Gray kept house for her father and brothers in Lake Charles, Calcasieu Parish, before she went to Newcomb to study art. She produced pottery and embroidery. Had she remained the full time, she would have received her diploma in 1908.

Her interests were many and varied. In January, 1927, the John Geddings Gray Memorial Expedition left Tulane University expecting to discover important ruined cities once inhabited by the vanished Maya Indians. Leader of the expedition was Frans Blom, archaeologist and director of the department of Middle American research (now the Middle American Research Institute). The funds for the expedition were donated by Henry, William, and Matilda Gray, children of John Geddings Gray, in his memory. Matilda badly wanted to join the expedition, but for her to spend eight months in the bush was not considered feasible.

In 1933 she acquired her first Fabergé piece, while visiting Chicago's Century of Progress exposition. Subsequently, the Matilda Geddings Gray Foundation added to the collection of art from the Russian monarchy, which now reposes in New Orleans.

*Guatemala Textiles*, according to the foreword, is a book about the techniques employed by tribal weavers, dyes used, and customs connected with Indian dress, for which the Guatemalan natives have been famed since before the Spanish conquest. Matilda Gray organized an expedition to Guatemala and went herself, with Dolores Morgadanes as interpreter, in order to assemble a similar collection of costumes for Tulane. As a result, a fine collection is now in the possession of the Middle American Research Institute.

Between 1935 and 1945 Matilda Gray produced bronze figures and sculptures, after having studied with a Greek sculptor. She had a house in Buc, in

France, and spent four months of each year there, where she studied bookbinding. After the war she bought an apartment in Paris and spent summers there, while maintaining a residence at the corner of Royal and Esplanade in New Orleans. She died June 8, 1971.

**Gregory, Angela**

Angela Gregory, sculptor, earned a Bachelor of Design from Newcomb School of Art in 1925, and a Master of Art in architecture from Tulane University in 1940. She studied at Parson's School of Design, in Paris and in Italy, with Charles Keck, and at Bourdelle's private studio and Académie de la Grande Chaumière in Paris.

Awards while at Newcomb included the Neill Medal for proficiency in watercolor in 1924, and a scholarship to Parson's in 1925. She took first prize in sculpture, Louisiana State Exhibit in Baton Rouge in 1928; the Fine Arts Club prize for sculpture, Southern States Art League in New Orleans in 1930; and the Five Business Men Prize in Savannah in 1931.

She is a fellow of the Sculpture Society of New York and a member of the American Artists' Professional League, the Southern States Art League, the New Orleans Arts and Crafts Club, and the Art Association of New Orleans.

Although Miss Gregory's very successful work has taken the form of architectural sculpture on many public buildings in this country and abroad, she started her training by studying all the crafts—pottery, silversmithing, and copperwork—and has produced candlesticks, bowls, and pots that she still owns. Angela Gregory is the daughter of Selina Bres Gregory, an early craftsman at Newcomb.

**Guedry, Lilyan A.**

Lily Guedry (Mrs. Henry Garic) was a normal art graduate at Newcomb in 1903. She was a china painter, an art she practiced at home as well as at school. She is deceased.

**Hawthorne, Mrs. C. C.**

Mrs. C. C. Hawthorne was a graduate in normal art on June 16, 1891. She was a special student in art in 1889–90, 1890–91, 1891–92, 1892–93, 1893–94, and 1895–96.

**Heller, Cecile Mathilde** (1890–1920)

Cecile Heller (Mrs. Edward Lasker) was awarded a

Diploma in Art in 1911. The year before she had received the Holley Medal for highest excellence in watercolor throughout the session. Her father was Rabbi Max Heller, head of Temple Sinai in New Orleans for forty years.

She married a U.S. chess champion and went to live in Chicago. She had been married only six months when she died at age thirty, leaving a portfolio of watercolor paintings of every room of the mansion in which she lived.

She exhibited a bookplate in the crafts show at Newcomb on April 2, 1911, according to the *Times-Picayune* of that day.

**Henderson, Sarah**

Sallie Henderson is listed in the 1890–91 catalog as a special art student. The New Orleans Arts and Crafts Club had a loan collection exhibition of ceramics, glassware, silverware, pewter, and ivories assembled by Miss Sarah Henderson, according to an account in the New Orleans *Morning Tribune* of November 30, 1927. In a letter from abroad to a friend in New Orleans, she told of a most interesting collection of modern French art she had gathered from the artists themselves, often seeking them in out-of-the-way workshops and studios. This letter is dated February 23, 1927, so apparently she was referring to the same collection.

**Hill, Rosemonde Agnes** (1890–1966)

Rosemonde Hill (Mrs. Oscar Schneidau), born in Hamilton, Ontario, Canada, September 25, 1890, came to Chicago when she was eight years old. She moved to New Orleans when she was nine. While still at school, she won two second prizes in competition: one for an outline drawing of a water spout, a trademark for the A. M. Lockett Company; the other for a design showing the primitive method of raising water.

She received a degree from Newcomb College in 1914, and was an art craftsman in the school year 1916–17. Pottery and silver jewelry making were her crafts. She was married August 26, 1919, and died December 17, 1966.

**Hoerner, Julia** (d. 1968)

Julia Hoerner (Mrs. Julia Michel, Mrs. Douglas Black) received a Diploma in Art in 1907, and was an art craftsman from 1913 to 1916. She died June 20, 1968.

**Hohn, Edith** (1903–)

Edith Hohn (Mrs. Julius A. Shanklin) was born July 13, 1903, in New Orleans. She went to the art school in 1921 and received her Bachelor of Design degree in 1925. For three years she made jewelry, pottery, and embroidery, some of which was sold through the Newcomb Guild, some of which was used for gifts.

She taught school until her marriage on December 25, 1930. She now resides in Raleigh, North Carolina.

**Holley, Fannie Estelle** (d. 1905)

A student in normal art, she would have graduated with the class of 1906 but died before that time. Her father, Bert Ennis Holley, gave a medal in her memory to be awarded to an art student for proficiency in watercolor painting. She died March 5, 1905.

**Holt, Sally S.** (d. 1965)

Versatile Sally Holt was a member of the first class in pottery decoration, which opened in 1895. She exhibited ceramics at the Newcomb Art Alumnae Association show in 1910, decorated china in 1913, and leaded glass shades later.

According to Miss Sheerer, the shades Miss Holt fashioned took the form of large domes to be suspended from the ceiling. She was particularly proficient in making bead shades, which are an entirely original product of the Newcomb pottery, and won much admiration.

The catalog lists her as an art craftsman for the years 1910–13 and 1915–17. She remained until 1918, chiefly in the bookbinding area of work. She died August 20, 1965.

**Huger, Emily Hamilton** (d. 1946)

According to handwritten records of the time, Emily Huger was in I Normal in 1897–98. The printed catalog of 1900–1901 lists her as a normal art student, that of 1901–2 as a graduate art student. She received her Diploma in Art in 1901.

Her application for active membership in the Southern States Art League produced this information: "Student of: William Chase, John Connah, William A. Bell, New York; Hugh Breckenridge, Philadelphia; summer work, University of Wisconsin, 1913, Columbia University, 1906, 1922; American Institute of Architects, Art Institute of Chicago, 1926, Harvard, 1927. Teacher, Newman Manual Training School, New Orleans, Louisiana, 1904–1918; Reconstruction aide, Medical Department, U.S. Army, 1918–1921;

Instructor, Summer Normal, Southwestern, 1911; Louisiana State University, 1913; Virginia Polytechnic Institute, 1915; Southwestern Louisiana Institute, 1921–." Miss Huger was the recipient of a Carnegie scholarship for advanced work for art teachers.

She painted landscapes in oil and chose the subjects in southern Louisiana with which she was most familiar—live oaks and Spanish moss. She held membership in the Art Association of New Orleans, the American Federation of the Arts, the College Art Association, and the Southern States Art League, and was a charter member of the Arts and Crafts Club of New Orleans. She died February 2, 1946.

**Hughes, Helen Elizabeth** (d. 1962)

Helen Hughes (Mrs. Frederick Nash Ogden) received a Bachelor of Art in 1925. She was an art craftsman in 1928–29, and a law student from February, 1935, to April, 1936. She died November 19, 1962.

**Irvine, Sarah Agnes Estelle** (1887–1970)

Sadie Irvine was born in New Orleans on July 21, 1887, the year and the month that Newcomb was founded. She began there as a student at age fifteen in 1903, received her Diploma in Art in 1906, and remained until her retirement in 1952. She was decorator, craftsman, instructor, and at the last headed the pottery department. She studied at the Art Students League in New York City.

According to past and present reports, she was the best known of all the decorators. Her talents ranged from pottery decoration to watercolors, blockprints, pastels, pen and ink drawings, book illustrations, bookplates, Christmas cards, and portraits. Of all the Newcomb artists in the Art Nouveau movement, she was the most artistically accomplished in the other fine arts media.

She received the following awards: the Holley Medal traveling scholarship, the Neill Medal, a scholarship to the Pennsylvania Academy of Fine Arts, the Ellsworth Woodward prize for pottery, the New Orleans Art Association prize for blockprint, and the Binns Medal nomination. She won prizes at many exhibits, including two of the annual exhibits of the New Orleans Art Association, and the Three Man Show, Delgado Art Museum.

Following her retirement from Newcomb, she taught art at the Academy of the Sacred Heart for fifteen years. A reviewer in the *Times-Picayune* stated

on July 20, 1930, "There are three outstanding ones, Angela Gregory the sculptor, Ella Miriam Wood the painter, and Sadie Irvine whose pottery is considered the best example of the nationally known distinctive Newcomb ceramics." She died September 4, 1970.

### Janvier, Lois (d. 1960)

Lois Janvier (Mrs. George Marsh Lester) received a Diploma in Art in 1910. She made pottery, embroidery, and jewelry. She worked at D. H. Holmes, New Orleans, in the personnel department until she went to Germany in canteen service with the YMCA in 1919. She married when she returned in February, 1920. She died October 27, 1960.

### Jardet, Florence M.

According to the commencement program of May 24, 1905, Florence M. Jardet was a normal art graduate. In 1907 she won the Home Study Prize, a competitive prize for art students for promotion of independent art practice. In 1908 she was awarded the Neill Medal.

### Jones, Frances Deveraux

Frances Jones (Mrs. H. W. Hall) was awarded a Diploma in Art in 1894.

### Joor, Harriet Coulter (d. 1965)

According to a handwritten record, Hattie Joor matriculated in special art in 1887. She is listed among the nine members of the first class in pottery decoration in the fall of 1895, having received her B.S. that year. The printed catalog of the school shows her as a graduate art student in 1900–1901. That summer she was awarded the traveling scholarship, $125, given anonymously for the Dow Summer School at Ipswich, Massachusetts. She returned in the fall of 1901 as a normal art student. In 1904 she received the Neill Medal for proficiency in watercolor painting.

In a letter from Harriet Joor in Lafayette, Louisiana, to the Delgado Museum of Art Project in reply to inquiries about herself, she said:

. . . many memories of those beginning days of Newcomb pottery in the tiny vine-covered brick building that housed the college heating plant! We were so like a little family group the few of us working at our tables with Mr. Meyer thumping out his vases at the wheel beside us, and the big round kiln looming up in the other corner of the room, with the splashed glazing table beside it! I loved it so I used to linger on and on, forgetting everything but the jar under my hand. . . .

Since then I have taught in Chicago U.; worked on the staff of *The Craftsman*; free lanced (in writing and design); homesteaded on the Dakota Plains; for two years at Walter Reed Hospital, taught our disabled men after the war; and for the past fifteen years have taught art in SLI college.

According to Miss Sheerer, Miss Joor was a prolific and talented worker, though her pieces were of very unequal quality. She was successful in literary work and in illustration. Proof is found in two articles, "The Art Industries of Newcomb College," *International Studio*, 1911, and "Our Potter and His Clay," *Harlequin*, which depicts the early days of the pottery. She died March 28, 1965.

### Jordan, Mable Paul (d. 1962)

Mable Paul Jordan (Mrs. George Grant Woodbridge) received a B.A. degree in 1905 and an M.A. in 1932. She was an art craftsman in the school year 1914–15. She died April 22, 1962.

### Keep, Irene Borden

The printed catalog of 1897–98 lists Irene Keep in the I Normal Art course. She was a member of the special art class in 1901–2.

### Kennon, Roberta Beverly

Roberta Kennon (Mrs. Luther E. Carruth) received a Diploma in Art in 1898. In the catalog of 1898–99 she is listed as a graduate in normal art. Pottery design as a course of study appears for the first time with thirteen students listed, among them Miss Kennon, in the catalog of 1901–2. She is also listed in the catalogs of 1902–3, 1903–4, and 1904–5.

Six years of study was not overlong, because the course of instruction leading to pottery decoration included drawing, painting, and design. When instruction was no longer necessary, the payment of fees was remitted and the designer continued on a basis of independent production. So it was with Miss Kennon.

Miss Mary N. Bates gave a hundred dollars for a traveling scholarship to the Dow School in Ipswich, Massachusetts, which was awarded to Roberta Kennon in 1902.

### King, Nina Ansley

Nina Ansley King was an art craftsman from 1917 to 1920.

**Kohlmeyer, Eleanor B.** (1904–)

Eleanor Kohlmeyer started at Newcomb High School on Washington Avenue, then moved uptown in 1918 and was a member of the last high school class. She attended Newcomb Art School and received her Bachelor of Design degree in 1925. Bookbinding taught by Miss Troy and embroidery taught by Mrs. Smith were her disciplines. She also studied painting with Ellsworth Woodward and Will Stevens.

She founded and operated for thirty-five years an exclusive women's apparel shop, the Dress Circle, and is now engaged in painting. She has had three one-man shows in recent years, one at the Glade Gallery, another at the Three Three One Gallery, and another at the Circle Gallery, in New Orleans.

**Kopman, Katharine** (d. 1950)

Biographical records show that Katharine Kopman received a Diploma in Art from the normal art course in 1895, and that in the fall of the same year she was selected as a member of the first class in pottery decoration.

She was on the faculty of special and normal art as instructor of drawing from 1896 to 1906. The 1910–11 catalog lists her as a teacher of drawing and design in Newcomb High School, and the 1913–14 catalog shows her to be on the art faculty at Newcomb as a supervisor of practice. During the 1918–19 school year, she was a supervisor of art instruction. She exhibited a series of Red Cross posters at the art school of Newcomb College, November 4, 1917. She died March 11, 1950, in Biloxi, Mississippi, at the age of eighty.

**Labouisse, Catherine Priestly**

Kitty Labouisse took a special normal course at Newcomb that she completed in 1910. She was an art craftsman in 1916–17 and 1922–23. For a great many years she owned and operated a shop in New Orleans that sold fine silver, china, and crystal. She is now deceased.

**Le Beuf, Jeanne Louise** (1907–52)

Jeannette Le Beuf (Mrs. Charles L. Dufour) was born January 3, 1907. She first went to Newcomb in 1925, but left at the end of the year to go to Europe with her family for a two-year period. Upon her return, she taught in private schools in New York and New

Orleans, won an art scholarship for pottery study in New York, and remained there a year.

She returned to Newcomb and won her Bachelor of Design degree in 1941, concentrating on jewelry making. She again taught crafts in Louisiana and Mississippi private schools and at Kingsley House, a settlement house in the Irish Channel of New Orleans, where she received an honorarium of one cent a year, because the Irish are so proud they didn't want anyone teaching them free. She died November 4, 1952.

**LeBlanc, Marie de Hoa** (d. 1954)

Of all the early Newcomb potters, Marie de Hoa LeBlanc seems to have been awarded the greatest number of prizes. She received her Diploma in Normal Art in 1898, and her Bachelor of Design in 1921. Between the two dates she was the recipient in 1902 of a hundred fifty dollars given anonymously to be used to travel to Harvard for the Ross lecture series; in 1904 she received five hundred dollars for European travel and study, also given anonymously; she was the third recipient of the Ipswich, Massachusetts, summer scholarship; she received a medal at the Saint Louis Exposition from the fine arts jury.

She is listed in the school catalog as an art craftsman in 1909–14. Miss Sheerer said of her in 1938: "Her work was characterized from the beginning by care and thoughtfulness and her close application to it, her continued study from nature during the summer vacation, as well as her travels have meant a steady growth for herself and an increased value to the pottery." She died April 16, 1954.

**Le Breton, Mireille**

Mireille Le Breton (Mrs. Lloyd J. Cobb) was awarded a Bachelor of Design in 1931. Her specialty was bookbinding, with Miss Troy as teacher. She made a prayer book of tooled leather with the Newcomb stamp on it. All her work was thus stamped. She was interested in watercolor but only on her own time.

After graduation she went to work as a social worker, met her husband, and married in 1934. After he had a stroke, she devoted her time to the art of decorating eggs while staying at home during his long convalescence. Her art training was useful in this respect, and she is still pursuing the hobby.

She is a cousin of Amelie and Desirée Roman and a niece of Mrs. Dagmar Renshaw Le Breton.

**Levy, Miriam Flora** (d. 1975)

Miriam Levy, a jewelry designer born in Franklin, Louisiana, came to Newcomb and took academic subjects, notably English literature, along with her art subjects. She received a Diploma in Art in 1916. She described her years at Newcomb ecstatically: "Mr. Woodward, Miss Mary Butler and everyone was so helpful and yet they let you do just what you wanted. I used to go there at 7:30 in the morning and I'd have to be put out when the janitors closed the building in the evening."

Newcomb was her only source of instruction. All through the 1920s she was listed in the catalogs as an art craftsman. Though she had a completely equipped workroom in her own home, she still preferred to spend time in the Newcomb workroom. She made constant contributions to alumnae exhibitions and exhibited at the National Alliance of Art and Industry, where she won first prize in jewelry. She also won one of three prizes in a national contest conducted by Cartier's. Her memberships included the New Orleans Art Association, the Arts and Crafts Club, and the Boston Arts and Crafts Club.

Tiny leaves and berries such as those familiar at her home in the Bayou Teche country were her favorite motif design. She made bookplates for the Orleans Club and Dominican College, among others, and designed and made on order picture frames, shoe buckles, ecclesiastical artifacts, and jewelry.

In 1937 Miriam Levy went to work for Hausmann's, the jewelry store that was the New Orleans outlet for Newcomb pottery. Her assignment was to design handmade jewelry. Before long she became assistant manager, and she retired from that position after nineteen years' association with the store. She died August 11, 1975.

**Levy, Sarah Bloom** (d. 1955)

A handwritten record shows Sarah Levy at Newcomb in the III Normal class, 1898–99. A Diploma in Art was awarded her in 1899. She is listed in the printed catalog of 1900-1901 as a graduate art student, in the 1901–2 catalog as a graduate in normal art, and in the 1909–10 and 1911–12 catalogs as an art craftsman.

For three years she was a member of the pottery design class, 1904–5, 1905–6, and 1906–7. She died November 3, 1955.

**Liddell, Mary Louise Jordan**

Louise Liddell (Mrs. Frank S. Hemenway) was awarded a Diploma in Art in 1911. In 1924–25 she was listed as an art craftsman. The Alumnae of the Newcomb School of Art issued invitations to attend the nineteenth annual exhibition and sale of artwork, including handwrought jewelry by Louise Jordan Liddell, December 1–3, 1926.

One critic wrote: "She is one of those art students who retain their inspiration through all sorts of difficulties. When war necessitated she followed her husband to army camps and fashioned exquisite jewelry over a chafing dish flame—chains, brooches, rings and pins."

**Lines, Emily Frances** (d. 1969)

Emily Lines (Mrs. Philip Gensler) received her Diploma in Art in 1901. Records show her attending Newcomb in 1897–98 as a normal art student. In 1901–2 she was a graduate art student. She died March 1, 1969.

**Littlejohn, Cynthia Pugh** (d. 1959)

There were eight young women receiving a Diploma in Art in 1906; among them were Sadie Irvine and Cynthia Littlejohn, who remained friends and neighbors throughout their lives.

Miss Littlejohn was enrolled in graduate art in 1906–7, as art craftsman in 1909–10, in special art in 1910–11. She received a traveling scholarship for the year 1908–9 and studied at Columbia University during the summer of 1910.

Exhibitions include the Newcomb Art Alumnae Association show of December, 1910, where she exhibited tooled leather and leaded glass objects. She died July 1, 1959.

**Livaudais, Louise**

Louise Livaudais and her twin sister received their Bachelor of Design degrees in 1931. Pottery was Louise's major craft.

After graduation, she returned to Newcomb for one year of further study in crafts. Kenneth Smith arranged for the Livaudais twins, Clara May Buchanan, and Marcelle Leverich to go back for pottery study. There was no teacher. They threw on the wheel or made pots by hand, and left their pieces to be fired and glazed. She produced some pieces in white, yellow, and blue colors, all undecorated. She exhibited and sold some pieces but still has others in her possession. She also made silver tableware.

**Livaudais, Lucille** (d. 1971)

Lucille Livaudais, like her twin sister, Louise, received her Bachelor of Design degree in the spring of 1931. The following year she went back to take classes in weaving and embroidery, taught by Gertrude Roberts Smith. Mrs. Smith had been teaching weaving since 1902, and the classes continued in popularity. The textile woven was embroidered in the design similar to the design on the pottery. Lucille Livaudais succeeded in executing many of the flower designs typical of New Orleans—crepe myrtle, magnolia, wild white Cherokee rose, and chinaberry bloom.

With her sister, Louise, she was able to do independent work in pottery during the time Miss Troy was director. She was also interested in jewelry making and exhibited and sold this craft. She died February 8, 1971.

**Lonnegan, Ada Wilt** (d. 1963)   *Lonnegan*

A Diploma in Art was awarded Ada (Mrs. George F.) Lonnegan in 1900. In the fall semester she matriculated in graduate art, following four years of exclusive artwork as given in the normal art department, for which the diploma had been granted. Graduate art was regarded as professional work. Mrs. Lonnegan along with other students was allowed to elect a specialty and pursue it without interruption for two years.

She was one of thirteen students selected for a first course in pottery design in the 1901–2 session. She pursued the same program in 1902–3, 1903–4, and 1905–6. Since design was her major, drawing and painting supplemented that choice.

Calligraphy was her specialty, and she continued with it throughout her working life. It carried over to her pottery design. She died October 15, 1963.

**Luria, Corrina Morgiana**

Corrina Morgiana Luria was a graduate of Sacred Heart Academy and Newcomb School of Art, getting her diploma and the Neill Medal in 1913. She reentered in graduate school, 1913–15; summer school at Tulane, 1953, 1955, 1956, 1957; and University College, 1953–54.

Her father, Abraham Luria, vice-president of the Louisiana National Bank, had served in the War between the States as dispatch runner and had been captured by Federal troops. He married Mary Scannell, whose father owned Cate Sugar Plantation in the Bayou Teche country. Mary Scannell's grandfather

was Martin Swarthou, who served under Napoleon and later emigrated to Cuba, where he was consulting engineer at the building of the cathedral and later married into the De Coya family, who were in Cuba by appointment of the king of Spain. Soon Swarthou and his wife came to New Orleans.

Miss Luria is said to have been the outstanding watercolorist of her time. Her exhibitions and honors include:

1.  Newcomb Art Gallery display of the work of the cosmopolitan class, including a moonlight study of rooftops, March 26, 1916.

2.  Paintings of Attic Treasures, 7303 Elm Street, April 24, 1925.

3.  Design of the symbol used by the Community Chest, for which she won a two-hundred-fifty-dollar first prize out of two hundred entries, October 29, 1928.

4.  "Beauregard House on Chartres Street," included in a group of pictures sent to Washington by southern painters for exhibition at the Corchran Galleries, was bought by the federal government and now hangs in the Treasury building. "Bayou Black," exhibited in American Country Life held at the University of Pennsylvania, attracted favorable reviews in New York dailies and art magazines.

5.  Handmade Christmas cards in 1929 and 1940, the latter of Saint Louis Cathedral.

6.  A decorated map, showing the spread of the Order of the Sacred Heart over the world, was sent to Rome.

7.  "Calla Lillies," exhibited in the international watercolor show in Canada in 1939, for which she was awarded a medal.

8.  Painting of the lower Pontalba Building presented to British War Relief to be auctioned, proceeds going to BWR.

9.  Her watercolors featured in a one-woman exhibition that opened the million-dollar Museum of Art building at Stanford University.

10.  She executed for the Harvard Law School the courthouse from Royal Street in New Orleans so that the statue of Chief Justice White is included.

She still lives in Chalmette, Louisiana.

**McCullough, Lucerne**

Cernie McCullough (Mrs. Charles Ernest Robert, Jr.), with her twin sister, painted a series of six murals depicting the evolution of books in the McMain High

School library in 1932. She continued painting murals during her years at Newcomb. She won first prize in the Junior League poster contest in October, 1936.

Before receiving her Bachelor of Design degree, Cernie was declared, with her twin sister, a joint winner of the 1914 prize for the best portfolio of animal drawings (in her sophomore year), the Home Study Prize in Art (in her junior year), and (in her senior year) a scholarship awarded for entered pieces including watercolor, charcoal, and pastel studies, pottery, and portraits. She received the Bachelor of Design degree in 1937, and the Art Students League scholarship in the twenty-second annual scholarship competition.

In New York she studied fine arts under William C. McNulty, and both she and her sister studied under Howard Trefton, advertising teacher. In 1938, back in New Orleans, she got a commission to paint a mural for the Bonneville, New York, post office. She decided to work with her sister on the Thomaston mural too and sign the works jointly.

### McCullough, Suzanne

Sudie McCullough (Mrs. Theodore M. Plonder) painted murals with her twin sister during high school, at Newcomb, and afterward. She won only a first honorable mention in the Junior League poster contest in October, 1936, but she won first place for French book cover designs.

Each year at Newcomb she and her sister jointly won prizes: in their sophomore year, the 1914 prize for animal drawings; in their junior year, the Home Study Prize; and in their senior year, a competitive scholarship for study at the Art Students League in New York. She was awarded her Bachelor of Design in 1937.

In New York she studied illustrations under Morris Kantor. In 1938, in New Orleans, she had a commission to paint a mural for the Thomaston, Connecticut, post office and returned to New York.

### McDonald, Anna Laura

Laura McDonald (Mrs. L. Moise Thibodeaux) was awarded a Bachelor of Design degree in 1924. Her major subject was pottery building by hand, taught by Miss Sheerer. She also made jewelry, rings, pins, and napkin rings. Following graduation she studied figure drawing with Boardman Robinson in the Art Center of Colorado Springs, Colorado.

From 1924 to 1935 Miss McDonald was engaged in commercial artwork. From 1935 to 1944 she taught art in the Orleans Parish public schools, taking time out to earn a degree of Master of Arts in art education in 1943. From 1944 to 1967, when she retired, she was supervisor of art for the public school system of New Orleans.

Since retirement she has done much oil painting. Two of her portraits hang in the law library of Loyola University, that of her husband and that of Lionel Adams, both attorneys.

### McDonald, Ida Florence (d. 1964)

Ida McDonald was born in Louisville, Kentucky, attended Newcomb, and was awarded her Diploma in Art in 1908. Later she studied at the Art Institute of Chicago. In the embroidery line she succeeded in creating designs of plants around her. She made beadwork on leaded lampshades and produced some pottery. She exhibited in the crafts show at Newcomb in 1911, and thereafter in Louisville, Lexington, Cincinnati, and Jackson, Mississippi.

Art memberships included the Art Club of Louisville, the Louisville Art Association, and the Brush and Pencil Club of Lexington, Kentucky. She taught painting to the son of Adlai Stevenson, knew Woodrow Wilson, spending some time in the White House, and made costumes for Carnival queens. She died May 29, 1964.

### Maddox, Floy

Floy Maddox was at Newcomb studying bookbinding under Miss Troy during the school years 1927–28 and 1928–29, and was awarded a Bachelor of Design degree in 1929. She had carried academic subjects, English and psychology, for one year each, and French for two years. She also studied art history for all four years. Life drawing and mechanical drawing were required, and she had to make twenty-five or more plant drawings and twenty-five to fifty drawings of hands and feet, outside of class. Her electives were pottery and bookbinding. Her teacher, Ellsworth Woodward, required her to submit an original watercolor, which she did. It was of a sycamore tree at night. She also studied oil painting under Will Stevens.

In 1932 Miss Maddox was awarded a certificate of social work from the Tulane University School of Social Work. In 1938 she received her Bachelor of Art degree.

**Maddox, Ruth** (d. 1966)

Ruth Maddox received her Bachelor of Design degree in 1930. She was required to make twenty-five to fifty drawings of hands and feet, and won the prize for this in her senior year. She was an athlete, and won a silver cup at Field Day, also in her senior year.

Her specialties were silversmithing and pottery. She exhibited a silver chain at the Louisiana State Museum show sponsored by the Louisiana Crafts Council. She died December 5, 1966.

**Maes, Mrs. Gertrude**

Gertrude Maes was an art craftsman from 1926 to 1929.

**Magruder, Evangeline**

Eve Magruder (Mrs. Joseph U. Folse, Jr.) received her Newcomb degree in 1919. She was an art craftsman in the school year 1924–25.

**Marice, Elsie Jung** (d. 1971)

Elsie Marice (Mrs. August V. Baumgartner) received her Bachelor of Design degree in 1927. Silversmithing was her major field of interest. She worked at it during college days and for ten years thereafter, producing among other items a table set, a silver service, bread trays, and trivets. She married in 1937 and moved to California, where she died May 28, 1971.

**Mason, Alma Florence** (d. 1970)

Alma Mason (Mrs. B. F.) Burke's biographical record shows that she attended Newcomb's normal art department in 1905 and 1906, and received her Diploma in Art in 1907. From 1910 to 1912 she was working as an art craftsman, decorating china that she exhibited at the annual exhibition and Christmas sale at 2828 Camp Street. She died April 12, 1970.

**Mauras, Juanita Marie** (d. 1952)

The college catalogs list Juanita Mauras as a student in normal art in 1905–6, graduate art in 1906–7, and as an art craftsman from 1909 to 1929. She was appointed assistant in the Newcomb pottery from October 12, 1925, until the close of the school year in 1937. On December 14, 1937, she was appointed a studio assistant in silversmithing and jewelry. She retained this position until her retirement on October 15, 1945.

In the Newcomb Art Alumnae exhibition in December of 1910, her leatherwork was outstanding. She had gone to Columbia University during that summer and had observed, studied, and perfected her craft with visible results. Among the items shown were books bound in hand-tooled leather, others bound in paper with watercolor decorations, and still others in linen with embroidery ornamentation. Besides books, there were large desk blotters, envelope cases, and purses. And having been privileged to visit Tiffany's while in New York, she showed the result of that influence—objects of leaded glass.

At the annual exhibition and Christmas sale in December, 1913, she wore a gown that she had made of soft crepe de chine embroidered in typical Newcomb design. She died October 16, 1952.

**Mayfield, Marie Marcia**

Marcia Mayfield (Mrs. Joseph J. Matthews) received her Bachelor of Design degree in 1926. She studied pottery and bookbinding and exhibited in a large exhibition of Newcomb pottery at New Orleans' Delgado Museum. She taught painting and crafts in Laurel, Mississippi, before undertaking further study at Wellesley, where she obtained a graduate degree in 1935. She then did graduate work in art history at the Sorbonne.

Since her marriage in 1938, Mrs. Matthews has devoted her time almost exclusively to writing for both general and scholarly magazines, mostly on art subjects. She has published three books, has just completed a fourth, and hopes to write one about her father, Robert B. Mayfield, a New Orleans painter, in the near future.

**Miller, Dora Janfroid**

The Tulane alumni records and the Newcomb alumnae records have failed to produce any entry for Dora Janfroid Miller. That she made Newcomb embroidery is evident from the piece illustrated.

**Miller, Rose Laura**

Rose Laura Miller (Mrs. Edwin Hayes) was awarded a Diploma in Art and the Neill Medal in 1912.

**Modinger, Hilda**

Hilda Modinger (Mrs. Daniel Montgomery Lewis) was a studio art student who received a degree of Bachelor of Design from Newcomb College in 1922.

## Moise, Alice Leigh

Alice Moise was awarded a Bachelor of Design degree from Newcomb in 1928. In her junior year she won a prize in design in the Newcomb Art Alumnae Christmas show. After 1928 she was an art craftsman. From that time she has never stopped producing whatever is ordered. She has set stones on silver, designed and made mailboxes and doorbells in brass, applied silver to wood on tableware, and made fashionable jewelry.

During the war years she worked at Higgins in the sheetmetal department, making templets from blueprints. Later she went to Marietta, Georgia, where Bell Aircraft was located. This is where B-29s were made, and Miss Moise became an inspector in the sheetmetal department. When tools became available at Newcomb, she acquired a set that she used in her war work and is using to this day.

## Moore, Lisette Sylvia

After receiving her Bachelor of Design degree from Newcomb in 1933, Lisette Moore (Mrs. James John Meyers) studied with Andre l'Hôte in Paris, and with Dan Whitney and Alfredo Galli in New Orleans. During her student days she won awards in perspective and senior composition, which she attributes to the fact that Ellsworth Woodward, whom she considered a dynamic artist, had taught her as a freshman in 1929–30. She studied pottery but was allowed to take portrait painting in her junior and senior years, since hers was a special talent. Normally it was a senior subject only, taught by Will Stevens. She was president of the art school in her senior year.

She embarked on her portrait painting career immediately after returning from Paris and has not stopped yet. She painted a series of portraits of past deans of the Law School of Tulane University that now hang in the law building. The series includes Dr. Rufus Carrollton Harris, who later became president of the university.

## Morel, May Sydney

May Morel was awarded a Diploma in Art in 1908, after having been listed in the school catalog in normal art during the 1905–6 and 1906–7 sessions. She received the Home Study Prize in 1908 and the Neill Medal in 1909.

She graduated from Newcomb College in 1910, became an independent decorator, and is listed as a postgraduate in the 1911–12 session. She was an art craftsman during 1912–13 and 1914–16. In the Panama-Pacific Exposition, her pottery was represented in the exhibit sent by Newcomb College, which was awarded the medal for the best exhibition of applied design from an educational institution. She was the first Newcomb pottery decorator to break tradition and use human figures on pottery. Her jewelry also won prizes, and she designed Christmas cards and bookplates. She is now deceased.

## Morgan, Calista Airey

Calista Morgan (Mrs. Joseph M. Rault) received her degree from Newcomb Art School in 1919. Mechanical drawing, bookbinding, and silversmithing were her most important subjects. During her college years she produced some fine tooled-leather bindings as well as a silver butter knife, a napkin ring, and sugar tongs, which she still possesses and now considers heirlooms.

After graduation, her mechanical drawing training was useful in her job, which was making plans and maps in the city planning architectural office, where the location of public buildings was determined. She worked with Anne MacKinne Robertson.

She has designed costumes and developed themes and sets for Carnival krewes. She considers that her Newcomb training has been of greatest value to her, however, in giving her a sense of design, color, and composition balance in her home and her appearance.

## Negueloua, Francesca (d. 1972)

Francesca Negueloua (Mrs. Wayland Fry) received a Bachelor of Design from Newcomb College on June 9, 1937. She exhibited a watercolor at the 1937 annual show of the Pennsylvania Academy of Fine Arts in Philadelphia, and represented the U.S. Post Office in Tallulah, Louisiana, in the Section of Fine Arts, Public Buildings Administration, U.S. Federal Works Agency. She died February 1, 1972.

## Nicholson, Leona (1875–1966)

Born April 11, 1875, in Saint Francisville, West Feliciana Parish, where her grandfather owned Afton Villa, Leona (Mrs. Bentley W.) Nicholson was sent away to school at Hollins Institute in Virginia, then moved with her family into a house at the corner of Chestnut and Sixth streets, across from the Newcomb campus. She entered as a freshman extra and was allowed to take up pottery decoration. Much later she wrote to a

friend, "Those of us who grew up with Joseph Fortune Meyer and the Newcomb pottery cannot but be enthusiastic in recalling this extraordinary genius."

She married in her sophomore year but returned to complete her course leading to a Diploma in Art in 1901, and later took two postgraduate years in pottery. The college catalog lists her as an art craftsman in the 1909–10, 1913–14, 1923–27, and 1928–29 sessions. Later she studied at Alfred University.

She was the first New Orleans woman to receive the distinction and title of "Master Craftsman" given by the Boston Society of Arts and Crafts. In 1927–28 she was included in the International Exhibition of Ceramic Arts that went from the Metropolitan to all important museums of the country. In 1930 she exhibited in the Currier Museum of Manchester, New Hampshire, and at the end of the year at the Museum of Fine Arts, Houston, Texas. A group of her pieces was purchased by the American Federation of Women's Clubs for its permanent collection. She was awarded the New Orleans Art Association Prize.

Nora Morel said of her: "Leona Nicholson is more than a potter—she is a pioneer, experimenting with copper reds and Persian blues in her workshop at the Newcomb kiln." Paul E. Cox observed: "Professor Mary G. Sheerer was an individualist and resented the need for the services of Joseph Meyer in production of ware by a college for women. Therefore, she developed modelled pottery placing emphasis on this form of craft. Mrs. Nicholson carried this development forward, doing the modelling in her home studio and using Newcomb College for firing the wares." Her output was not large, but she did a considerable amount of special work for individuals. She specialized in tiles, her theme being fairytale rhymes.

In January, 1941, the Young Men's Hebrew Association received a grant from the WPA to put in a ceramic department for underprivileged children. Leona Nicholson taught there. In 1947 the name changed to Jewish Community Center when the "Y" moved to Saint Charles Avenue at Jefferson Avenue, where it is today. There she started a ceramic department with about a hundred students, teaching clay modeling and decorating until 1958, when she retired. She died in 1966.

**Nolan, Anita Marinoni**

Anita Nolan (Mrs. Henry Clement Pitot) was awarded a Bachelor of Design degree in 1929 and was president of the art school that year. Leather bookbinding was her speciality. In 1933, when Woodward Way was dedicated, she was president of the Art Alumnae Association.

**O'Ferrall, Gladys Moulton** (d. 1973)

Gladys Moulton (Mrs. John Tolson) O'Ferrall received her B.A. from Newcomb in 1910. She died December 25, 1973.

**Oliver, Ellen Theresa Hughes Garic** (d. 1954)

Ellen (Mrs. Norwin P., Sr.) Oliver was awarded a Diploma in Art in 1910, and was an art craftsman in the year 1916–17. She died April 10, 1954.

**Palfrey, Mary Harrison** (d. 1929)

Mary Harrison Palfrey was awarded a Diploma in Art in 1909. Records show that she was an art craftsman in 1912–13 and 1915–16. She died May 24, 1929.

**Parkerson, Alice Sterling** (1897–1961)

Alice Parkerson was awarded her Bachelor of Design degree in 1919. Like so many before her, she came under the spell of the Ellsworth Woodward teaching.

After a time when she was involved as a volunteer social worker, she returned to Newcomb Art School in 1933 as a teacher of decorative design and art appreciation. In 1937 she received a master's degree from Columbia University, having completed the required work in successive summers.

On two occasions Miss Parkerson was called upon to assume the responsibility of acting chairman of the art school, from 1949 to 1950 and again from 1952 to 1955. She remained as a faculty member until her death on May 8, 1961.

**Parkerson, May Sterling** (d. 1914)

May Parkerson was awarded a Bachelor of Arts in 1903. At that time, embroidery as a subject of study was open to academic seniors as well as to art students.

There is an illustration of her embroidery accompanying an article, "The Art Industries of Newcomb College," in *International Studio*, July, 1910. It is a crash runner with a motif of cedar trees in spring. She died October 30, 1914.

**Parsons, Maude Alexandria**

Maude Parsons (Mrs. J. Wallace Paletou) was a special student carrying academic subjects at Newcomb.

The hundred dollars given by Miss Mary N. Bates for study at the Dow School in Ipswich, Massachusetts, was awarded to her in 1904. The college catalog for the year 1913–14 lists her among the twelve faculty-staff members as a pottery clerk and sales agent. Newcomb records show that she remained in this position until 1934–35. She died August 26, 1950.

**Rosenblatt, Mary Lillian** (1906–43)

Mary Rosenblatt was born on March 11, 1906, in Greeneville, Tennessee. In 1915 she moved to Atlanta, Georgia, where she went to preparatory school. She came to Newcomb in 1924 and received her Bachelor of Design degree in 1928. Her major subjects were pottery and bookbinding.

She pursued further study in 1931–32 at the University of Georgia, in landscape architecture; in 1932 with George Elmer Brown, whose drawing and painting classes were held in Provincetown, Massachusetts; and again in 1935–38 at the University of Georgia, in education.

She held teaching positions in the city systems of Birmingham and Atlanta, and at the University of Georgia, where she was first an assistant professor and later an associate professor of applied and fine arts. She was a member of two professional organizations, the Southeastern Art Association and the Atlanta Art Teachers Club.

She exhibited pottery on many occasions and was quite innovative with a puppetry project. Her art classes designed and made the puppets, backdrops, and costumes. Other classes composed the dialogue and manipulated the puppets so that the project became interdepartmental.

Mr. and Mrs. William Leopold Ferdinand Rosenblatt established through the University of Georgia Trust Fund a Mary Rosenblatt Art Scholarship in memory of their daughter. The scholarship is for the purpose of aiding outstanding students majoring in art. Miss Rosenblatt died March 6, 1943.

**Ross, Marie Medora**

Handwritten records in Newcomb Hall show that Medora Ross matriculated in special art on October 22, 1887, under the name Marie E. Ross; place of birth, Saint James Parish.

In 1889–90 and 1890–91 catalogs she is listed as having registered in special art. Later, after spending the intervening years in study of design, she was listed as a member of the first pottery decoration class, which opened in the fall of 1895. She was in the pottery design class in 1901–2, 1902–3, 1903–4, and 1904–5. She is deceased.

**Ryan, Mazie Teresa** (d. 1946)

Mazie Ryan (Mrs. Donald Eugene McDonald) was in Newcomb Art School in 1898 and 1899; the handwritten record at Newcomb Hall verifies the fact. She received a Diploma in Art on June 14, 1899. The college catalog of 1900–1901 lists her as a graduate art student; that of 1901–2 as a graduate in normal art; those of 1901–2, 1902–3, 1903–4, and 1904–5 as a member of the pottery design class; and those of 1910–14 as an art craftsman.

A letter in her own hand to the Delgado Museum from East Pass Christian, Mississippi, dated October 20, 1938, says: "Following is the data which you requested in your letter of October 14: Did much hand made pottery and became an independent designer of pottery. Made the piece of pottery now on display in the Delgado Art Museum between 1903 and 1905. Interested in all art work including architecture and embroidery. Received travelling scholarship 1903 for pottery. Studied from life under George W. Maynard in the National School of Design, Columbia University, New York."

Besides pottery, she fashioned pierced metal and beaded lampshades, fire screens of leaded glass, and embroidery. She died July 31, 1946.

**Scudder, Alice Raymond** (1879–1957)

Alice Scudder (Mrs. Ray G. Coates) attended Newcomb Academy in 1896–1900, receiving a certificate for a full course in English in 1900. At Newcomb College she received a Diploma in Art on June 19, 1901, and in 1901–2 she was listed among students in graduate normal art.

She was a special student in the arts and science school in 1906–7, 1907–8, 1908–9, 1909–10, and 1910–11, and graduated with a B.A. degree on May 17, 1911. She died in 1957.

**Seago, Georgia Maxwell**

Georgia Seago (Mrs. Georgia Seago Fischer) received a Bachelor of Design degree in 1925. Jewelry was her major craft. She became executive secretary of the Newcomb Alumnae Association in 1949, and retired from that assignment in 1971.

**Sheen, Ann Evelyn**

Ann Evelyn Sheen (Mrs. Daniel A. Carney) received a Diploma in Art in 1911. She was represented in an exhibition of stencil design and bookplate at the crafts show at Newcomb on April 2, 1911, according to the *Daily Picayune* of that day. The ex libris is of Clarence Sheen. The stencil design is signed.

**Sheerer, Mary Given** (d. 1954) 

In his book, *A Brief History of H. Sophie Newcomb Memorial College*, Dr. Dixon, first and only president of Newcomb College, states: "In the spring of 1894, while on a visit to Cincinnati I investigated the work done by the Rookwood Pottery, and the display of ceramics in the Museum of Fine Arts. On expressing my desire that some work of this kind might be started at Newcomb, I was advised to see Miss Mary G. Sheerer who lived in Covington, Kentucky, and who had been interested in the Rookwood enterprise. After several conversations with the lady, I secured an agreement with her to come to New Orleans, and take charge of the pottery decoration. This addition to the School of Art excited considerable interest at once."

Craftsman, painter, writer, Miss Sheerer had been a pupil of the Cincinnati Art Academy, the Pennsylvania Academy of Fine Arts, Denman Ross, Arthur W. Dow, and Hugh Breckenridge. Her name appears on the faculty list of 1894–95 as instructor of china decoration; in 1895–96 as assistant professor in the art department; in 1904–5 as professor of ceramic decoration. The last position she held until her retirement.

She was a member of the Hoover Commission as a delegate of the American Ceramic Society at the International Exposition of Modern Decorative and Industrial Art in Paris in 1925. Through her lectures and writings, she was recognized all over America as an authority on ceramics.

"My guiding influence," she once told an interviewer, "has been to always keep the mind plastic. . . . Keep it plastic. Not too dry, for clay then hardens and cracks. Tragedies result. Not too soft, for it will then sink and fall. To hold its shape, clay must be plastic. So, the mind." She constantly brought out the importance of cooperation between art and trade. To her goes the credit for a successful development of a distinctive ware. In later years she encouraged more and more an individual product, hand-thrown work along individual lines as opposed to work turned on the wheel and thus not an individual product.

Her memberships included the New Orleans Art Association, Cincinnati Woman's Art Club, Crafters' Club, and Cincinnati Museum Association. She was a fellow of the American Ceramic Society, for which she published several articles. She died December 3, 1954.

**Shepard, Effie** (d. 1917)

Effie Shepard received her Diploma in Art from Newcomb Art School in 1903. The catalogs for the school years 1900–1901 and 1901–2 show her to be a normal art student; that of 1905–6 a graduate art student; and those of 1911–12 and 1912–13 an art craftsman. In 1905 Effie Shepard was awarded the Mary L. S. Neill Medal for watercolor painting.

She exhibited jewelry and metalwork in December, 1910, at the Newcomb Art Alumnae Christmas show. She again exhibited necklaces, pins, and watchfobs at the December, 1913, show. She died December 8, 1917.

**Simpson, Anna Frances** (d. 1930) 

Fanny Simpson, as she was known by her co-workers, received her Diploma in Art in 1906. Her family called her Coonie, hence the name Conner appearing in some lists of Newcomb potters. Records show she was a student in normal art in 1905–6, graduate art in 1906–7, and an art craftsman in 1909–24 and 1925–29. She was active until the end of her life.

She exhibited wherever Newcomb pottery was exhibited. "Español" was awarded the silver medal offered by the San Antonio Art League for the best piece of pottery in the ninth annual exhibition of the Southern States Art League. A pottery bowl and embroidered runners were exhibited April 2, 1911, at the crafts show at Newcomb, and landscape calendars were exhibited at the annual Christmas crafts show in December, 1913. An exhibition of her pottery at the Museum of Fine Arts in Houston took place on June 26, 1930, six months after her death.

**Sliger, Carrie** (d. 1949)

Carrie Sliger (Mrs. William H. Millspaugh) was a member of the first class in pottery decoration, which opened in the fall of 1895 with nine members. She received her Diploma in Normal Art in 1895. She died February 9, 1949.

**Smith, Gertrude Roberts** (1869–1962) GRS

Born in Cambridge, Massachusetts, May 11, 1869, Miss Gertrude Roberts (Mrs. Frederich Smith) came south as a young girl to help build up the new art school in Louisiana. She became Mrs. Gertrude Roberts Smith in 1893, and remained at Newcomb for thirty-five years.

Her education was pursued at the Massachusetts Normal School, Chase School in New York, and the Colorossi Academy in Paris. At Newcomb she was listed as an art craftsman in 1912–13 and 1918–19. On the faculty, she taught drawing and painting from 1889 until 1899, when she became assistant professor of drawing and painting. In 1904–5 she was professor of drawing and painting.

In addition to teaching on the first faculty and afterward, she traveled extensively in Mexico, Central America, the Caribbean islands, the Carolina mountains, and New England villages. Scenes inspired by what she saw in these faraway places characterized the bulk of her output. Unlike most of her contemporaries, she painted in a very modern style with brilliant color and bold technique. One of these paintings, "My Mandarin Orange Tree," won her a gold medal and two hundred fifty dollars.

She helped organize the Brush and Pencil Club, the Artists' Guild, the Arts and Crafts Club, and the Art Association of New Orleans, and was an active member of the Southern States Art League and the Boston Arts and Crafts Club.

Painting in oil and watercolor was not her only work. Newcomb needlework, just as distinctive and almost as famous as Newcomb pottery, was her life work. In December, 1913, she exhibited a beautiful gown of soft crepe de chine embroidered in the typical Newcomb design. As late as December, 1928, the twenty-first exhibition and sale of artwork conducted by the Alumnae of the Newcomb School of Art featured paintings by Gertrude Roberts Smith. A viewer at Delgado Museum on March 12, 1922, said, "With my eyes still dazzled by the color in Mrs. Gertrude Roberts Smith's 'Garden Gate' I went into the room where the pastels hang."

The 1913–14 college catalog lists her as a full professor among the seven art faculty members headed by Ellsworth Woodward. Until her retirement in 1933–34, when she moved to Asheville, North Carolina, printed accounts of the times relate how her studio atop the art school of Newcomb College was a favorite interview spot, where she served tea, worked her embroidery, and carried on vivid conversation with her visitors. She died February 24, 1962.

**Summey, Mary Williamson**

Mary Summey (Mrs. Cleveland S. Smith) was awarded an A.B. in 1906, and was one of twelve art craftsmen from 1910 to 1912. She is the sister of Mrs. Dinwiddie, wife of the former president of Tulane University.

**Tanfrord, Miss D.**

In a tiny chamber back of the pottery classroom working designs—in floss of soft, rich oriental dyes that would not fade—the textile class held forth. Stitches were simple—darning, buttonhole, satin, and outline. This was the Newcomb embroidery growing in demand.

Miss Tanfrord designed a table cover illustrated in "The Art Industries of Newcomb College," *International Studio*, 1910. Wrought in olive and gold on natural-toned linen, the design is a china ball motif.

**Townsend, Cora**

Cora Townsend, born in New York, came to New Orleans to live at 285 Jackson Street, near Newcomb, where she matriculated in special art two months after the very first class opened on December 12, 1887. Her specialty was woodcarving. She was queen of Carnival in 1876.

**Urquhart, Alice Rosalie** (1854–1922)

Rosalie Urquhart, born in New York on September 27, 1854, came to New Orleans and lived at 84 Esplanade. She matriculated in Saturday art at Newcomb on November 1, 1887, and from then on took work at irregular times.

Records show that she received a Diploma in Normal Art in 1890; was enrolled in special art in 1890–91; was a normal art student in 1900–1901; received a Diploma in Art in 1901; was a graduate art student in 1901–2; was in pottery design during the sessions 1904–5, 1905–6, and 1906–7; and was an art craftsman in 1909–15 and 1916–17.

Her exhibitions included that at the crafts show at Newcomb in April, 1911, where her architectural drawing of a plantation house attracted much attention. At the Newcomb Art Alumnae Association show in December, 1910, and again in 1913, she exhibited

Louisiana calendars; one especially attractive set was an original account of the beauties of the Vieux Carré. As a matter of fact, she seems to have exhibited year after year in a style of archaic simplicity, as one of the reviews of that time stated. She died February 21, 1922.

**Urquhart, Emma** (1865–1929)

Emma Urquhart was an art craftsman in the years 1912–15 and 1916–17. She died December 8, 1929.

**Villere, Elizabeth Dunerje** (d. 1975)

Elizabeth Villere (Mrs. King L. Forsythe) received her Bachelor of Design degree in 1932. Her major subject was bookbinding. She was one of three partners in a bookbindery business at 633 Royal Street, and died July 30, 1975.

**Watkins, Lynne** (d. 1961)   LWATKINS

According to the 1905–6 college catalog, Lynne Watkins (Mrs. Rudolph S. Hecht) was a student in normal art. She received her Diploma in Art in 1908, and died June 15, 1961.

**Weil, Hermoine**   HWEIL

Hermoine Weil (Mrs. Julian E. Adler) was at Newcomb in 1917.

**Wells, Sabina Elliott**   S.E.W.  SEW  Sewells

According to Miss Henrietta Bailey, Sabina Elliott Wells from Charleston, South Carolina, lived in New Orleans with Corinne Chalaron's mother. She decorated pottery prior to 1903 and afterward for a few years.

An account in *Harlequin* of June 23, 1904, stated: "For originality and bold, vigorous, well constructed design, Miss Sabina Elliott Wells is most conspicuous. . . . She has the power to use living forms in design with a success not very usual, retaining the swing and movement of life in the lines of her composition as you see in those fish and wave and shell-fish plates of hers, where beyond question she has succeeded in a very difficult form of design."

In 1938 Miss Sheerer wrote, "Miss Wells did very scholarly and original work, but she found it impractical to live here—the climate did not agree with her so she connected with a pottery in Baltimore."

**West, Laura Boddie** (d. 1971)

Laura West (Mrs. Ben Hamlet Jones) received an A.B. in 1911. She designed, wove, and embroidered a piece that is illustrated here. According to the college bulletin, classes in embroidery were open to art students as well as to academic seniors. Mrs. Jones died July 13, 1971.

**Westfeldt, Metha Katheryn**

In the year 1929–30, Metha Westfeldt (Mrs. Benjamin Franklin Eshleman) was a Newcomb freshman in the art school along with her mother, Mrs. George G. Westfeldt. The daughter dropped out for two years, but went back and received her Bachelor of Design degree in 1935. Bookbinding was her major discipline, taught by Miss Troy and Eunice Baccich.

Following graduation, she opened a bookbindery on the ground floor at 633 Royal Street, along with Elizabeth Villere and Betty Kennan, and did a thriving business for a time. Between 1940 and 1950, with Francesca Negueloua, she made puppets and manipulated them at shows in public schools and libraries and for the Junior Philharmonic.

**Whipple, Jane Randolph**

Jane Whipple (Mrs. A. Donald Green) received her Bachelor of Design degree in 1931. In an article in the *Times-Picayune* of March 22, 1931, Miss Sheerer stated: "Jane Whipple, one of the most talented students, is planning to do the most original thing. Graduating in June, she intends to have her own kiln at home."

Following graduation she went to the Art Students League in New York City, where she studied sculpture under Robert Laurent and figure drawing under William Blackman. Upon her return, she started a class in modeling and sculpture at her studio in Baton Rouge, making use of a common clay found in West Feliciana Parish. Louisiana motifs were used in decoration, and the pieces were fired at the Louisiana State University kiln and at her home kiln.

In 1933 she exhibited a true original pottery piece, "The Mask of Barbara," which was well received as another example of her artistic talent. Since that time she has concentrated on painting in both watercolor and oil. She has exhibited at the Delgado Museum, Louisiana State University, the Fine Arts Museum in Chicago, and twice in group shows in the International

SEWELLS

Gallery in New York City and in Coburg, Germany.

She says that her three daughters grew up with arts and crafts around them, and that now, with families of their own, they are all successful in various art fields. She now lives in New Jersey.

### Wilson, Kate Lucinda

Kate Wilson (Mrs. Harold Elder) graduated from the home economics department of Newcomb in 1919. She studied with Gertrude Roberts Smith, who said of her, "Kate Wilson is so good that when she makes a piece of embroidery we put her stamp on both ends of the piece." She was especially proficient in mending and wove hair into the fabric to strengthen it. She designed her own pieces to embroider, and still owns all her embroidery threads.

She set up the home economics department at Saint Mary's Dominican School. She designed and embroidered a runner of her favorite oak tree from the old Newcomb campus on Washington Avenue; the runner is now framed and hanging in her home. She now lives on a rice farm in Crowley, Louisiana.

### Wogan, Caroline Spelman

At present, Caroline (Mrs. Pierre) Durieux is known as a painter, etcher, lithographer, and author, but her early training was partly in the crafts. She received a Bachelor of Design degree in 1916 and a Bachelor of Art in education in 1917. During her junior year at Newcomb she received the Neill Medal for proficiency in watercolor. She studied under Ellsworth Woodward, at the Pennsylvania Academy of Fine Arts in Philadelphia, and under Henry McCarter.

Originally appointed as a substitute instructor in design at Newcomb College on July 21, 1937, for the session 1937–38, Mrs. Durieux was promoted to assistant professor of design for the session 1938–39 and was reappointed for the 1939–40, 1940–41, 1941–42, and 1942–43 sessions. She resigned effective June 30, 1944.

On July 1, 1943, she joined the art faculty of Louisiana State University. LSU Press publishes her books. She exhibits frequently, and always in the modern manner.

### Wood, Ella Miriam

From 1905, the college catalogs list Ella Miriam Wood as a student in normal art. The 1907–8 catalog states that she was awarded the Fannie Estelle Holley Memorial Medal for proficiency in watercolor painting. She won her Diploma in Art in 1908.

She states that following graduation she attended the Philadelphia Academy of Fine Arts for one year, then a summer school near Philadelphia where a student had to work at some craft to pay his way. According to her, there was more tennis than art there, but she did meet Elizabeth Sargent, daughter of John Singer Sargent, whom she later visited at his home several times. She then returned to set up a portrait studio at home, where she painted a portrait of Dr. Dixon and one of Mrs. Ashton Phelps, among others.

The 1911–12 catalog lists her as a postgraduate student at Newcomb. She studied watercolor under Gertrude Roberts Smith, with the result that she did china painting, mostly working at home. She studied under both Ellsworth and William Woodward.

She was born in Birmingham, Alabama, where her father, a Philadelphia architect, had moved to in his line of work. Miss Wood is especially fond of doing portraits of children and has composed a book, *Notes on Portraits through the Years*. In her early days she traveled to other towns to stay ten days to do family portraits.

One of her outstanding designs is that for the Union Indemnity Company sign, "Sturdy as the Oak." Another is a mural for the permanent International Trade Exhibition in New Orleans.

### Wood, Katie Louise (d. 1919)

When the first class in pottery decoration was opened in the fall of 1895 with nine members, mostly graduates from the normal classes of Newcomb Art School, Louise Wood (Mrs. Oliver H. Van Horn) was among them. She was a graduate student in 1896–97.

In the *Art Education* issue of May, 1898, there is an article with illustrations of pottery by Louise Wood that states in part, "The Newcomb pottery has been established two years and a half—school years—and although the work is still tentative, the mechanical difficulties not being entirely overcome, it begins to exhibit traits of character and individuality that promise well for its maturity." The article is signed "E. W." Mrs. Van Horn died June 15, 1919.

### Wood, Mamie E. (b. 1869)

Mamie Wood was born May 18, 1869. She matriculated in the art course in the very first class at Newcomb on October 19, 1887, according to the handwrit-

ten records at Newcomb Hall. There were sixty-five young women and five faculty members in that first class; in 1975 there were fifteen hundred young women at Newcomb College with a faculty numbering a hundred twenty. Mamie Wood is deceased.

### Woodward, Mary Belle Johnson

Mrs. Ellsworth Woodward was born in New York. In New Orleans she lived at 393 South Rampart, from which address she matriculated at Newcomb on November 7, 1887, in special art. The handwritten record on which this is recorded is marked "Free." Other students paid ten dollars per quarter. This ad-

dress is the old municipal number between Calliope and Delord streets.

In the printed catalogs of 1889–90 and 1890–91 she is listed in special art; in 1893–94 she is listed in a special college course featuring German, French, and physical education. The Art Alumnae Association was organized on March 31, 1893; the record shows that Mrs. Woodward, '95, was the secretary.

### Wraight, Katherine Severance

In 1905 Katherine Wraight was listed in special art. She was an art craftsman in 1916–17.

# SOURCES CONSULTED

## Books

*The Arts and Crafts Movement in America, 1876–1916.* Edited by Robert Judson Clark. Princeton, N.J., c. 1972.

*Atlas of the City of New Orleans, Louisiana, Based upon Surveys Furnished by John F. Braun, Surveyor and Architect, New Orleans.* New York: E. R. Robinson, 1883.

Barber, Edwin Atlee. *The Pottery and Porcelain of the United States.* New York: Putnam, 1901.

*Chinese Collection of Exhibits for the New Orleans Exposition, 1884–5.* Catalog of the Inspector General of Customs. Shanghai, 1884.

Cline, Oscar Monroe. *Contemporary Art and Artists in New Orleans.* Reprinted from Biennial Report, Louisiana State Museum. New Orleans, 1924.

*Dictionary of American Painters, Sculptors, and Engravers.* Green Farms, Conn., 1926.

Dixon, Brandt V. B. *A Brief History of H. Sophie Newcomb Memorial College, 1887–1919.* New Orleans: Hauser Printing Co., 1928.

Dyer, John P. *Tulane: The Biography of a University, 1834–1965.* New York: Harper and Row, 1966.

Engelhardt, George W. *New Orleans, Louisiana, the Crescent City.* N.p., 1903–4.

Fairall, Herbert S. *The World's Industrial and Cotton Centennial Exposition, New Orleans, 1884–1885.* Iowa City, Iowa: Republican Publishing Co., 1885.

Kendall, John Smith. *History of New Orleans.* 3 vols. Chicago: Lewis Publishing Co., 1922.

*New Orleans Guide. Also Outlines of the History of Louisiana.* Compiled by James S. Zacharie. N.p., 1885.

*Report and Catalogue of the Woman's Department of the World's Exposition.* New Orleans: Rand Avery and Co., 1885.

*Soards' New Orleans Directory.* New Orleans: L. Soards and Co., 1887–95.

*Standard History of New Orleans, Louisiana.* Edited by Henry Rightor. Chicago: Lewis Publishing Co., 1900.

Tulane University, Howard-Tilton Memorial Library, Middle American Research Institute. *Guatemala Textiles.* N.p., 1935.

Tulane University, H. Sophie Newcomb Memorial College. *Art Records Sent Over from Art School, 1897 to 1899–1900.* (Handwritten.)

———. *Art Records Sent Over from Art School, 1900 to 1907–1908.* (Handwritten.)

———. *Matriculation Records, 1887–1888.* (Handwritten.)

Tulane University, H. Sophie Newcomb Memorial College for Young Women. *Announcements,* 1888–89, 1890–91, 1892–93, 1893–94, 1894–95, 1895–96, 1896–97, 1897–98, 1898–99.

Tulane University of Louisiana. *Bulletins,* 1900–1945. *Catalogues,* 1887–99.

*The Visitor's Guide to the World's Industrial and Cotton Centennial Exposition, and New Orleans.* Louisville, Ky.: Courier-Journal Job Printing Co., 1884.

*Who's Who in American Art,* vol. 1: *1936–1937;* vol. 3: *1940–1941.* Edited by Alice Coe McGauflin. Washington, D.C.: American Federation of Arts.

## Manuscripts and Collections

"Artists Guild Formed by New Orleans Painters. Public Gallery Is Aim." Louisiana State Museum Library, New Orleans. Scrapbook.

Hardy, Donald Cline. "The World's Industrial and Cotton Centennial Exposition." Master's thesis, Tulane University, 1964.

Louisiana State Museum Library, New Orleans. Craftsmen Index. (Vertical file.)

Meyer, Joseph Fortune. Personal Papers. James E. Walther, Jr., personal collection, New Orleans.

Newcomb College School of Art for Women. Brochure, 1920. (Vertical file.)

New Orleans Public Library, Louisiana Department. Obituary file.

"Orleans Boasts Many Artists of Wide Fame." Louisiana State Museum Library, New Orleans. Scrapbook.

Sheerer, Mary Given, and Woodward, Ellsworth. Letters to Mr. Glenk. Louisiana State Museum, New Orleans. Scrapbook.

Smith, Kenneth E. Personal correspondence, July 30, 1975.

Tulane University. Alumni Fund Records.

Tulane University, Alumni House. H. Sophie Newcomb Memorial College Alumnae Records.

Tulane University, Howard-Tilton Memorial Library, Humanities / Fine Arts Division. Biography Index. (Vertical file.)

Tulane University, Howard-Tilton Memorial Library, Special Collections Division.

Will of Julia Michel Black. New Orleans, January 26, 1960.

### Newspapers
(All newspapers listed are from New Orleans)

"Activity among the Southern Colleges." *Daily Picayune*, March 15, 1902, p. 12, cols. 1–3.

"Artists Today Don't Starve. Get Real Cash." No source, May 21, 1913.

"Arts in New Orleans." *Morning Tribune*, July 29, 1932, p. 6, col. 3.

Bailey, H. D. "How Block Prints Are Made." *Times-Picayune*, July 24, 1932, p. B-2, col. 6.

"Beautiful Art Work Is Shown Here." No source, December 21, 1914.

"Book Bindery at Newcomb." *Times-Picayune*, April 26, 1916, Stadium Section, p. 7, col. 5.

"Chinese Needle Art to Be Shown in New Orleans. Women's Collection to Be at Newcomb." No source, November 4, 1917.

Coleman, James P. "Old New Orleans Homes." *States*, June 24, 1923.

Comments from editorial page. *Morning Tribune*, June 5, 1931, p. 8, col. 3.

"Considers It an Honor to Newcomb." No source, May 1, 1915.

Cotton Centennial and Susan B. Anthony. *Daily States*, March 17, 1885.

"The Crafts Show at Newcomb." *Daily Picayune*, April 2, 1911.

"Dr. B. V. B. Dixon, Famed Educator, Taken by Death." *Times-Picayune*, September 7, 1941, p. 1, col. 4.

"Dr. E. Woodward, Art Director at Newcomb, Dead." *Times-Picayune*, March 1, 1939, p. 6, col. 1.

"Dr. E. Woodward Made Museum Board Head." *Times-Picayune*, March 16, 1934, p. 2, col. 4.

"Ellsworth Woodward." *Item*, March 1, 1939.

"Exhibition of Newcomb Art Is Splendid and Charming." *Times-Picayune*, March 26, 1916.

"The Exposition." *Daily States*, December 11, 1884, supplement, p. 4, col. 3.

"The Exposition." *Sunday States*, December 14, 1884, p. 2, cols. 2–4.

"Exposition—Final Touches on Eve of Opening." *Daily States*, November 10, 1885, p. 3, col. 7.

"Faculty Member Gets Promotion after 21 Years." *Times-Picayune*, June 5, 1931, p. 11, col. 1.

"Fine Pottery Exhibit by Newcomb." *States*, March 16, 1924.

"The Great Influx of Strangers." *Daily States*, December 11, 1884.

"How Block Prints Are Made." *Morning Tribune*, July 25, 1932, p. 8, col. 3.

Hutson, Ethel. "An Arts and Crafts Show." *Daily Picayune*, November 27, 1910.

"The Inability . . . of Pres. Arthur to Attend. . . ." *Daily States*, December 13, 1884, p. 1, col. 4.

"Letters from the People." *Daily States*, December 11, 1884.

McGregor, Georgette. "One of Mankind's Oldest Arts Gets Its Face Lifted." No source, 1944.

Mayfield, Selby N. "New Orleans Takes Front Rank in Pottery." *Times-Picayune*, May 22, 1927, Magazine Section, p. 5, cols. 4–5.

"Mrs. Newcomb's Will." *Times-Democrat*, April 9, 1901, p. 3, cols. 5–6.

"Newcomb Art Alumnae Pay Tribute to Retiring Director, E. Woodward." *Item-Tribune*, June 7, 1931, p. 15, cols. 2–4.

"Newcomb Art Wins First Place at Frisco Expo." No source.

"Newcomb Director, Dr. Woodward, Dies." *States*, February 28, 1939.

"Newcomb Makes a Wide Variety of Pottery Designs." *Times-Picayune*, May 3, 1936, section 2, p. 5, cols. 1–7.

"Newcomb's Art Is Viewed by Hundreds." *Item*, December 2, 1913.

"Opening Day." *Daily States*, December 12, 1884, p. 2, col. 2.

"Orleans Makes Steady Advance as Art Center." *Times-Picayune*, January 15, 1930, p. 23, cols. 5–6.

"Orleans Makes Steady Advance as Art Center." *Times-Picayune*, January 25, 1937.

"Pieces by Biloxi's 'Mad Potter' Trickling into N.O. Collection." *Times-Picayune*, September 14, 1975.

"Pottery Making in New Orleans." *Times-Democrat*, March 9, 1913.

"Romance Spirit in Jewelry Room." *Times-Picayune*, April 26, 1916, Stadium Section, p. 2, col. 5.

Simpson, Anna Frances. Obituary notice. *Times-Picayune*, June 27, 1930, p. 2, col. 7.

"Von Ehren Talks on Lithographs." *Times-Picayune*, July 31, 1932, p. B-2, cols. 4–5.

"Welcome to the World." *Daily States*, December 16, 1884, p. 1, cols. 4–7.

Woodward, E., and Bailey, H. D. "Talks on Etchings Today." *Times-Picayune*, July 17, 1932, p. B-2, col. 2.

"The World's Exposition Asks for Their Property." *Daily States*, December 16, 1886.

### Periodicals

Bennett, Charles A. "Newcomb School of Art: Its Relation to Art Industries." *Vocational Education*, November, 1913.

"Cotton Centennial Financial Difficulties." *Harper's Weekly*, January 17, 1885, p. 39.

Cox, Paul E. "Notes and News—Newcomb Pottery Active in

New Orleans." *Bulletin of American Ceramic Society*, 13, no. 5 (May, 1934).

—————. "Potteries of the Gulf Coast." *Ceramic Age*, 25, nos. 4, 5, and 6 (April-June, 1935).

Crowley, Lilian H. "It's Now the Potter's Turn." *International Studio*, 75, no. 304 (September, 1922).

"Exposition, 1884." *New Orleans Magazine*, October, 1970, pp. 17–19.

Joor, Harriet. "The Art Industries of Newcomb College." *International Studio*, July, 1910.

"Newcomb Pottery." *Antiques*, July, 1968, pp. 73–77.

"Newcomb Pottery." *Harlequin*, September 25, 1901, p. 5.

*Official Catalog of U.S. International Exhibit*, 1876, pp. 106–7, 240–41, 244–45.

"Our Potter and His Clay." *Harlequin*, June 23, 1904.

Reed, Edna Lyman. "Arts and Crafts as Shown in College Pottery." *Good Housekeeping*, June, 1905.

Sheerer, Mary G., and Cox, Paul E. "Newcomb Pottery: History of Newcomb Pottery." *Journal of American Ceramic Society*, 1, no. 1 (January, 1918).

Smith, Kenneth E. "Colored Jewelry Enamels for Art School Use." *Journal of American Ceramic Society*, 14 (August, 1931).

—————. "The Origin, Development, and Present Status of Newcomb Pottery." *Bulletin of American Ceramic Society*, 17, no. 6 (June, 1938).

Woodward, Ellsworth. "An Experiment with Applied Art in Newcomb College, New Orleans." *Art Education*, May, 1898.

—————. "Newcomb Pottery." *Art Education*.

# INDEX

179